PORTRAIT AND CANDID PHOTOGRAPHY

PHOTO WORKSHOP

Erin Manning

1 8 0 7 • WILEY 2 0 0 7

Wiley Publishing, Inc.

Portrait and Candid Photography Photo Workshop

Published by Wiley Publishing, Inc. 111 River Street Hoboken, N.J. 07030 www.wiley.com

Copyright © 2007 by Wiley Publishing, Inc., Indianapolis, Indiana

Published simultaneously in Canada

ISBN: 978-0-470-14785-6

Manufactured in the United States of America

1098765432

No part of this publication may be reproduced, stored in a retrieval system or transmitted in any form or by any means, electronic, mechanical, photocopying, recording, scanning or otherwise, except as permitted under Sections 107 or 108 of the 1976 United States Copyright Act, without either the prior written permission of the Publisher, or authorization through payment of the appropriate per-copy fee to the Copyright Clearance Center, 222 Rosewood Drive, Danvers, MA 01923, (978) 750-8400, fax (978) 750-4744. Requests to the Publisher for permission should be addressed to the Legal Department, Wiley Publishing, Inc., 10475 Crosspoint Blvd., Indianapolis, IN 46256, (317) 572-3447, fax (317) 572-4355, or online at http://www.wiley.com/go/permissions.

Limit of Liability/Disclaimer of Warranty: The publisher and the author make no representations or warranties with respect to the accuracy or completeness of the contents of this work and specifically disclaim all warranties, including without limitation warranties of fitness for a particular purpose. No warranty may be created or extended by sales or promotional materials. The advice and strategies contained herein may not be suitable for every situation. This work is sold with the understanding that the publisher is not engaged in rendering legal, accounting, or other professional services. If professional assistance is required, the services of a competent professional person should be sought. Neither the publisher nor the author shall be liable for damages arising herefrom. The fact that an organization or Web site is referred to in this work as a citation and/or a potential source of further information does not mean that the author or the publisher endorses the information the organization or Web site may provide or recommendations it may make. Further, readers should be aware that Internet Web sites listed in this work may have changed or disappeared between when this work was written and when it is read.

For general information on our other products and services or to obtain technical support, please contact our Customer Care Department within the U.S. at (800) 762-2974, outside the U.S. at (317) 572-3993 or fax (317) 572-4002.

Wiley also publishes its books in a variety of electronic formats. Some content that appears in print may not be available in electronic books.

Library of Congress Control Number: 2007933283

Trademarks: Wiley and the Wiley Publishing logo are trademarks or registered trademarks of John Wiley and Sons, Inc. and/or its affiliates. All other trademarks are the property of their respective owners. Wiley Publishing, Inc. is not associated with any product or vendor mentioned in this book.

About the Author

Erin Manning is a professional photographer, teacher, and television personality living in Los Angeles, California. Television viewers know Erin best as the host of *The Whole Picture*, the Telly Award—winning digital photography show from HGTV-HD and DIY Network. She helps people understand photography and technology by translating technical mumbo-jumbo into everyday words and facilitating their learning with a clear, friendly teaching style.

Erin first fell in love with photography at age seven when she discovered Edward Steichen's book *The Family of Man*. That early encounter with images of people from all over the world shaped the direction she was to take with her photography — capturing moments with and between people.

Whether Erin is in front of the camera or behind it, photography has always been a part of her life and combines her experience and education in art, technology, and entertainment. She specializes in lifestyle imagery for clients such as AT&T, Bank of America, Disney, as well as various lifestyle magazines and healthcare organizations. Erin spent several years honing her craft by working as a commercial, portrait, and stock photographer, in addition to working for Getty Images and completing a degree in Studio Art/Graphic Design from Loyola Marymount University.

Erin is a member of the Advertising Photographers of America, the National Association of Photoshop Professionals, Women in Photography International, and the Los Angeles Digital Imaging Group, whose purpose is dedicated to advancing the art and science of digital imaging.

Credits

Senior Acquisitions Editor Kim Spilker

Senior Project Editor Cricket Krengel

Copy Editor
Lauren Kennedy

Technical Editor Stacy Wasmuth

Editorial Manager Robyn Siesky

Vice President & Group Executive Publisher Richard Swadley

Vice President & Publisher Barry Pruett

Business Manager Amy Knies

Senior Marketing Manager Sandy Smith Book Designers LeAndra Hosier Tina Hovanessian

Project Coordinator Adrienne Martinez

Graphics and Production Specialists Jennifer Mayberry Ronald Terry Erin Zeltner

Quality Control Technicians Jessica Kramer Todd Lothery

Cover Design Daniela Richardson Larry Vigon

Proofreading and Indexing Laura Bowman Sherry Massey

Wiley Bicentennial Logo Richard J. Pacifico

Acknowledgments

This book was written with the caring support and assistance of a few very important people. First, I must thank my mom, who has always inspired my creativity and supported my ideas, and was instrumental in helping me organize my thoughts as I wrote this book. Thank you also to Michael for his vision, talent, and tireless effort on my behalf. A special thank you goes out to Kim Spilker, my acquisitions editor who discovered me, encouraged me, and introduced me to the world of publishing.

I also need to thank Steve Vance, a master prepress artist who coaxed my images to look their best, and my contributing photographers — Denise George, Robert Holley, Stephen Poffenberger, and Stacy Wasmuth.

My attractive subject examples each participated in support of this book; thanks to all of you. Some of the main subjects are my mom, my dad, Michael Welch, Stephanie Norwood, the Kullers, the Monroes, the Poliquins, the Tainters, the Youngs, the Friskes, the Peternels, the Shahs, the Georges, the Langsteins, the Schwartzs, the Boldts, Olivia Tracy, Victoria Coleman, Carm Goode, Teresa O'Neill, Terrence McNally, Bryan Kent, Cortnee Kornegay, Tabitha Brown, and Kris Kristoffersen.

My teachers over the years all deserve credit for sharing their knowledge and kindling my curiosity: Bobbie Leslie, Bobbi Lane, Charles O'Rear, Lee Varis, John Stewart, Carm Goode, Lawrence Manning, and Joyce Tenneson.

I'm very thankful for my devoted friends who patiently listened, waited, and stood by me when I disappeared for months on end in order to write this book. And one final thanks to the entire Wiley team: they have been an inspirational breath of fresh air. I am extremely grateful to be associated with people of this caliber.

i			

For my mother, who has encouraged me and believed in me from the beginning, and Michael, my inspiring, supportive visionary.

Contents

CHAPTER 1 What You Must Know About Photographing People	2
Observe and Connect with People Who are you photographing? Capture a special moment Directing people	4 4 4 4
Compose Your Picture Learn creative techniques to compose your picture Tell a story	8 9 9
Understand Light Flattering light What our eyes see	11 12 13
Know Your Equipment Megapixels Memory cards Batteries	13 14 14 14
Compact Digital Cameras	15
dSLR Cameras	16
Choose Lenses for Your dSLR Depth of field (DOF) Lens aperture Lens focal length	17 17 17 20

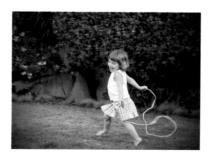

CHAPTER 2 Accessory Equipment	24
Lenses and Filters Lens speed Types of lenses Lens focal lengths Lens filters	26 27 27 28 30
Batteries	31
Tripods Tripod features Mini-tripods Monopods	32 33 34 34
Reflectors and Diffusers	35
Lights and Flash External flash Flash slaves and transmitters Continuous lights	36 37 38
Backdrops	38
Camera Bags	39
Media Storage and Viewing Memory cards Photo-viewers	39 40 40
Odds 'n Ends Dioptric adjustment lenses Photography vest Underwater camera housing LCD viewfinder caps Remote shutter release Lens cloths, pens, and tissues Multi-tool knife Powder	41 41 42 42 42 43 43 44

CHAPTER 3 Wor	king with Light	46
Recognize the Character	ristics of Light	48
Quality		48
Direction		49
Intensity		55
Color		55
Control the Light		56
Reflecting light		56
Diffusing light		57
Using a flash		58
Meter for Exposure		59

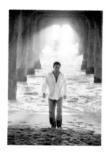

CHAPTER 4 Composing Your Pic	ture 62
Learn the Basics of Composition	64
Simplicity	64
Rule of Thirds	64
Line	67
Framing	69
Complementary color	73
Pattern and repetition	74
Change Your Perspective	77
Shift Your Point of View	78
Use Selective Focus	80

CHAPTER 5 Taking Portraits	82
Create the Look Do your homework Choose a background Select a location Adjust wardrobe, hair, and makeup Add props	84 84 86 88 88 89
Explore the Light Planning for the light Finding the light Manipulating the light	92 92 92 93
Work with Your Subject Gain your subject's trust Share on-camera techniques Try different positioning Capture candid moments	95 95 96 97 101
Experiment Change your point of view Take a self-portrait	102 102 104

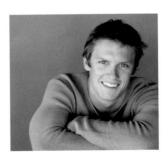

CHAPTER	6	Families, Groups, and Parties	108
Prepare Y	ours	self	110
		it your subjects	110
		desired result	110
		ocation	111
Consid	der th	he light	112
		surprises	113

Direct and Position the Group	113
Explore posing techniques	114
Plan a casual shoot	117
Candids	120
Get Creative	123
Optimize Your Equipment for Group Settings	127

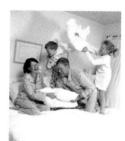

CHAPTER 7 Kids	130
Direct the Kids Different ages, different stages Get them involved	132 133 134
Keep It Real Encourage real moments Observe and capture real moments	137 137 138
Frame the Shot Experiment with angles Get down on their level Get close	140 140 141 142

CHAPTER 8 Babies	146
Get Comfortable with the Baby Plan your timing Create the right environment Accommodate for the age	148 148 150
Keep It Simple Prepare the background Prepare the baby Choose the right clothing Position the baby Play with props	154 154 156 156 157 158
Use Soft Light Find soft light Create soft light	160 161
Seize the Moment Capture something meaningful Focus on the eyes Use continuous shooting mode Remember the details	162 163 164 164 164

CHAPTER 9	Action Shots	168
Use Your Cam	era and Lens	170
Compact ca		170
dSLRs		172
Lens speed		174
Lens focal l	ength	175

Freeze the Action Fast shutter with flash	175 178
Blur the Motion	179
Slow shutter with tripod	180
Panning	181
Zooming	182
Slow shutter with flash	182

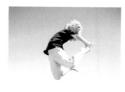

CHAPTER 10	Enhancing and Sharing Your Photos	188
Manage Your	Images	190
Image-organizing software		191
Image-edit	ring software	191
Enhance and	Repair Your Images	195
Quick Fix		195
Full Edit w	rorkspace	196
Editing bas	sics	197
Cropping		200
Adjusting	the color balance, saturation, and contrast	201
	ls to adjust contrast	203
Whitening		205
Removing		206
_	imperfections	208

CONTENTS

Share Your Images	212
Slideshows	213
E-mail	215
Photo sharing Web sites	217
Printing	217
Back up your digital photo collection to a DVD	219

APPENDIX A	Resources	222
Periodicals		224
Books		224
Organizations		225
Photography W	/orkshops	226
Photographic I	ographic Equipment and Review Sites	
Photo-Sharing	Web Sites	226
Image Organiz	ing and Slideshow Software	227
Online Learnin	g	228
Glossary		230
Index		239

Introduction

Photography is a synthesis of so many things I care about — art, technology, creative expression, and connecting with people.

As a child, photography books like *The Family of Man* and pictures in the old family photo box mesmerized me. I didn't have an understanding of the mechanics of a camera and wasn't aware of basic composition, but I was drawn to the people in the photographs — their expressions, emotions, and relationships.

Inspired to create my own images, as an adult I began the journey toward becoming a photographer. The image shown here resonates with my sense of that journey — reaching out to explore the world of creativity and expression and connecting with it on a personal level. Along the way I've educated my "eye" in design, learned to "see" light in a different way, and now use my camera and equipment as tools for creating photographs that capture parts of people's lives.

This book is my effort to help you understand the technology and the basics for developing an artistic eye and to give you real-life techniques for connecting with, and photographing, people. Whether you are a beginning digital photographer with a compact camera or a more seasoned photo enthusiast with a dSLR, you will find the information you need to help advance your photography skills when photographing people in any situation, and those skills can take you far beyond just snapshots in any genre of photography!

My goal is to inform, inspire, and provide you with the skills and confidence to successfully use the digital camera as a tool to create and capture meaningful moments.

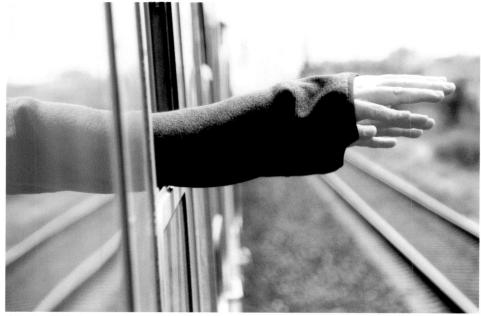

© Stephen Poffenberger

OBSERVE AND CONNECT WITH PEOPLE
COMPOSE YOUR PICTURE
UNDERSTAND LIGHT
KNOW YOUR EQUIPMENT
COMPACT DIGITAL CAMERAS
DSLR CAMERAS
CHOOSE LENSES FOR YOUR DSLR

Before you dive headlong into your pursuit of photographing people, it is helpful to know some basics about how to best approach your subject, compose the photo, recognize the lighting, and use the equipment you have at your disposal. This chapter outlines these basics to get you started right as you begin to photograph people — whether a candid shot or a posed portrait.

OBSERVE AND CONNECT WITH PEOPLE

A person's appearance, personality, and relationships are interesting and unique, but how do you capture any of this in a photograph? Take the time to notice a person's special qualities, observe how they react, and make an effort to authentically connect. People want to feel respected, appreciated, and comfortable, and if you show an interest in them, they will respond to you and your camera. When you are photographing people, you are in a relationship, whether it lasts for a few minutes, a few hours, or a lifetime.

WHO ARE YOU PHOTOGRAPHING?

Decide what interests you about the person. Maybe the person has bright red hair and freckles, piercing green eyes, or a furrowed brow-of-experience. In addition to noting the unique physical attributes of your subject, ask yourself the following questions:

- What is the relationship you have with this person?
- What is the relationship between the people you are photographing?

- What message are you trying to convey?
- What is the intent of this image?

These are all questions to think about when you plan to take pictures of people. Everyone interprets the world a little differently; show the world what you see in this person. For example, in 1-1, you'd never have known that Dylan was shy at first and quite serious. After a few funny stories, we laughed, and he felt comfortable enough to let me get up close and photograph his great freckles.

CAPTURE A SPECIAL MOMENT

A moment in time — that is what a photograph captures. But what is a special moment? How do you find it, and how do you encourage it?

One of my favorite photographers, Henri Cartier-Bresson, defines the decisive moment in a photograph as "the simultaneous recognition, in a fraction of a second, of the significance of an event as well as the precise organization of forms which gives that event its proper expression." Whew! My translation — in a nanosecond, you must identify a special moment, have an intuitive sense of composition, and express what you see by capturing it with a camera.

You as the photographer need to decide when that moment occurs, whether it's a glance, an emotion, or a gesture that you think is important. You find that moment by observing what is going on around you and capturing it with technical confidence.

DIRECTING PEOPLE

There are two "directing" extremes when photographing people. One is to observe and be stealth-like in your approach; however, your

PORTRAIT AND CANDID PHOTOGRAPHY / What You Must Know about Photographing People

ABOUT THIS PHOTO An authentic personality is easy to catch if you and your subject share a laugh. Taken at ISO 400, f/3.5, 1/60 sec. with a Canon Macro EF 50mm f/2.5 lens.

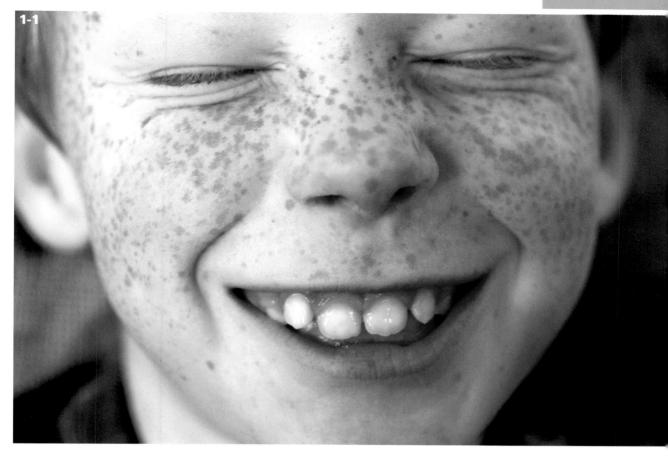

subjects may never know you are photographing them and have no connection to you or the camera. The other extreme is to pose people and demand a certain look, which may result in an unnatural-looking photograph with no depth of character or personality. I think there are many shades of gray between these two extremes, and choosing the best approach depends on what you intend to capture. Throughout this book I share some ideas, stories, and techniques that I have used to connect with people and encourage that special moment.

The following is a story about how I directed and connected with a four-year-old named Sophia,

who initially was not too happy about having her photograph taken, as shown in 1-2.

When I arrived at Sophia's house to photograph her family, she was intimidated by the activity, the photo equipment, and the presence of two people she didn't know: my assistant and me. She ran from us as we walked in the door. I had my camera, lenses, a tripod, diffuser, and reflectors along with some props: bubbles, a mirror, and long swaths of fabric netting. My goal was to create special family photographs depicting relationships and capturing special moments.

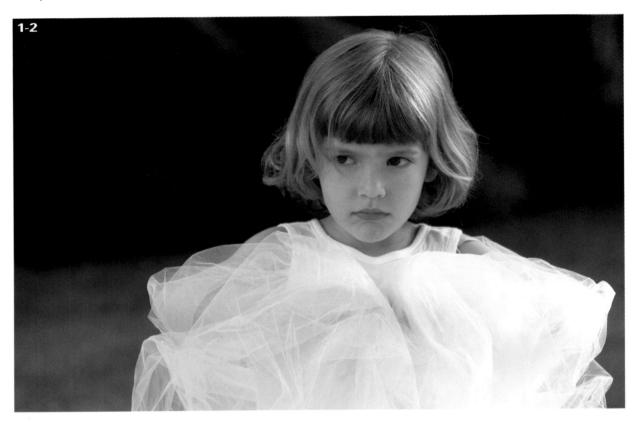

I began the shoot by talking with everyone and gathering them all together for various shots where they were casually positioned, both standing and sitting. We laughed and conversed between the shots. When I was shooting the pictures, I kept talking and gave them feedback about how they looked and direction on what to do.

I moved the family to the backyard, turned on some music, and helped Sophia blow bubbles in an effort to gain her confidence. I gave her some fabric netting to play with, and still defiant, she gave a sourpuss look off-camera. It took a while to build the trust, but eventually I was able to capture some great action shots of Sophia running around in the backyard, oblivious to being photographed, as shown in 1-3 and 1-4, capturing the kind of special moments I'd hoped for.

tip

When you're having your picture taken, you can't see how you look,

which makes some people very self-conscious. People need feedback from their photographer. Encouraging comments and direction really help your subjects loosen up in front of the lens.

ABOUT THESE PHOTOS Kids love action and movement. It takes their mind off being photographed and possibly having to say the word "cheese." Taken at ISO 200, ft4.0, 1/250 sec. with a Canon EF 70-200mm f/2.8L

lens.

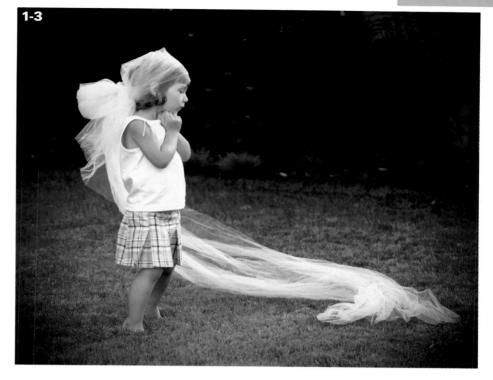

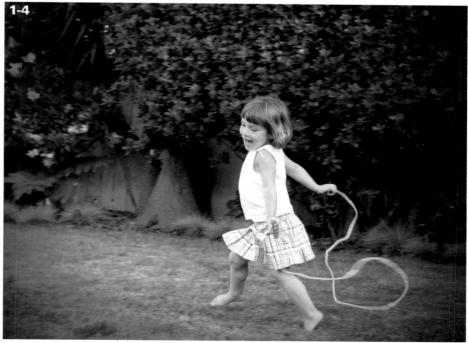

The poignant, "decisive moment" occurred after all the activity waned and the photo shoot was officially over. I told Sophia I wanted to roll around in the grass, and asked if she would show me how. The beautiful resulting shot is 1-5.

COMPOSE YOUR PICTURE

What is a well-composed photograph? There are rules to follow and rules to break, but thoughtfully composing your photograph makes the difference between a mediocre image and an amazing image.

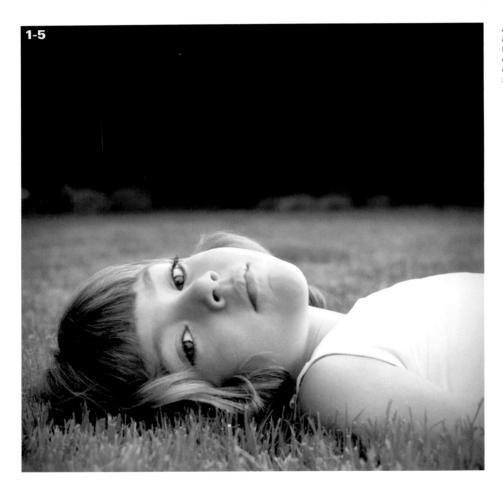

ABOUT THIS PHOTO Here is the magical moment that was captured. Taken at ISO 400, f/5.6, 1/180 sec. with a Canon macro EF 50mm f/2.5 lens.

1

To compose your shot is to look through the viewfinder and interpret what you see. Keeping some basic rules in mind and recognizing certain design elements prior to pressing the shutter button enables you to create an image as opposed to just taking one.

LEARN CREATIVE TECHNIQUES TO COMPOSE YOUR PICTURE

When you're beginning to learn the basics about composing your image, remembering everything while you're looking through your viewfinder can be difficult. Start with one technique per situation, and, with practice, composing your photograph will become second nature.

The following are a few techniques to practice when taking photographs:

- Experiment and take a lot of photographs. Even after you think the picture taking is over, you never know when that magical moment will happen. Be prepared to capture unexpected moments.
- Fill the frame with your image. Look at the background and get rid of any distracting elements. Seeing people up close provides immediate impact and a feeling of intimacy.
- Include a natural frame in your photographs. Using an overhanging tree branch, doorway, or archway in the foreground creates more visual interest.

- Place your subject off-center. A face right in the center of an image is great for a driver's license or passport photo, but when it comes to artfully composing a shot, consider the Rule of Thirds. Think of your entire scene as a tic-tac-toe board, and place something of interest at one or more of those intersections.
- Incorporate basic design elements in your photographs. These basic elements include perspective, focal point, line, repetition, pattern, texture, color, symmetry, and contrast.

For more details about all the elements of composition and basic design elements, see Chapter 4.

TELL A STORY

Interesting and meaningful portraits are created by telling a story visually, as shown in 1-6, 1-7, and 1-8. If you watch a great movie or TV show and notice how it's edited together, you might see a wide shot of a room, then a medium shot of someone's face, then a close-up of a foot or hand or other detail in the scene. A series of images like this, when presented together for the viewer, tells a story, creates interest, and draws us in. The same principle applies when telling a story with still images.

ABOUT THESE PHOTOS Each image in the series of 1-6, 1-7, and 1-8 is a progression in the process of telling a story. If you did not speak English, you would still be able to "read" the story visually. Taken at ISO 400, f/4.0, 1/125 sec. with a Lensbaby selective focus lens.

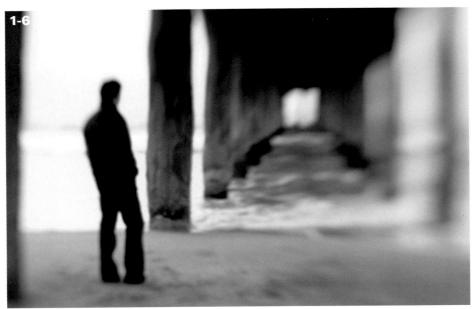

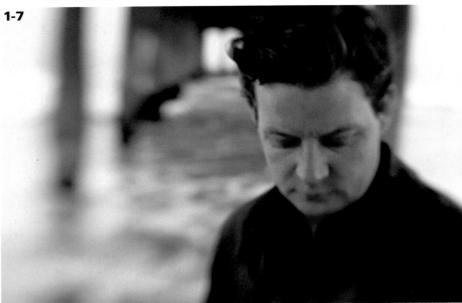

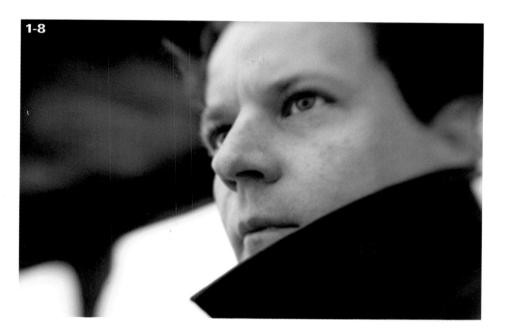

UNDERSTAND LIGHT

Over the centuries, artists have translated their visions and impressions of light with a brush on canvas; you as the photographer have an opportunity to express yourself and capture light in a photograph. To understand and "see" light, it's important to know about the variations of light and how to identify those differences.

There are many types of light, both natural and artificial, but to see light as a photographer is to recognize the quality and direction of light and how it falls upon your subject. The source of light, the intensity, the angle, the color, the shadows and highlights that light creates, and where you place your subject all affect the look of your final image. Consider the following:

- Is your light source large (sun) or small (flashlight)?
- How intense is the light harsh or soft?
- What color is the light; is it a gray overcast day or a golden sunset?
- Is the light directly overhead or hitting your subject at an angle?
- How can you modify the light to enhance your subject?

Searching for and creating flattering light is possible when you know what to look for. Once you learn this new language of light, the world opens up with many more photographic opportunities, and your images dramatically improve.

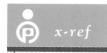

In Chapter 3, I cover the subject of light in more detail, but these are the basic considerations.

ABOUT THIS PHOTO Photographing people during the golden hours is an easy way to capture a beautiful portrait. Taken at ISO 400, f/5.6, 1/90 sec. with a Canon EF 70-200mm f/2.8L lens.

FLATTERING LIGHT

One way to create flattering portraits is to shoot during the *golden hours*, generally the first hour and last hour of sun during the day. At these times, your subject can face the sun without squinting, because the light is diffuse and soft and it's easy to capture a sparkle in the eye. After just a few photographs, you will begin to notice how the low angle of the sun and the soft intensity of the light make a big difference in the quality of your images — and everyone will love the photos. In figure 1-9 it was a late summer sunset at the beach and I knew that by facing my subject towards the soft, setting sun, it would illuminate her face with a beautiful golden glow.

If you don't have soft, afternoon light, another way to flatter your subject's features is to use a whiteboard or soft, gold reflector to reflect light back into the dark areas of the face, as demonstrated in 1-10. Given most people aren't thrilled

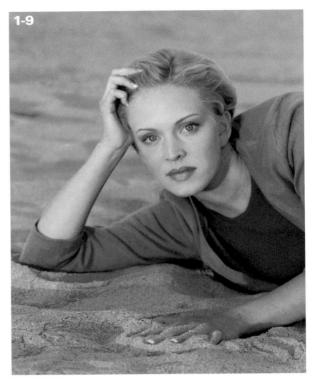

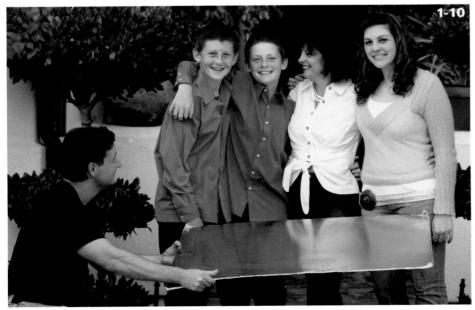

ABOUT THIS PHOTO A gray day required using a gold reflector to help brighten up the faces in the family photo. Taken at ISO 200, f/4.5, 1/125 sec. with a Canon EF 24-105mm f/4L IS lens.

to see pictures of themselves with under-eve shadows and wrinkles, reflecting soft, even light back into the face will make them much happier with the resulting photograph, as you can see in 1-11.

Now you can begin to search out flattering light in every situation. After learning that reflected light brightens my face, fills in shadows, and camouflages wrinkles, I have taken to standing near large white walls and understand the many benefits of restaurants with soft light and white tablecloths. As a result, I look better!

WHAT OUR EYES SEE

It's frustrating when your images don't convey what you intended to capture. If you've taken a high-contrast digital photograph and noticed that the shadows and highlights in the image have little to no detail, you are not alone. Many people don't realize that our eyes recognize a broader range of light than a camera is capable of recording. We can see the details in dark shadows and

bright highlights that our cameras cannot capture. Keeping this in mind when you are composing your scene enables you to choose the best locations for a shot and gives you a better chance of correctly exposing your image.

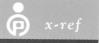

In Chapter 3, I provide more technical information to help you meas-

ure the difference between the light you see and the light the camera records.

KNOW YOUR EQUIPMENT

The light is beautiful, your subjects are positioned and comfortable, and you are composing your shot — this is not the optimal time to learn the basics about your equipment. If you are floundering with the technical fundamentals, you might miss that magic moment. Using the camera and lenses needs to become second nature to you, so you can concentrate on creating the best image. Learning about the basics in increments and

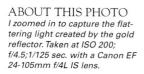

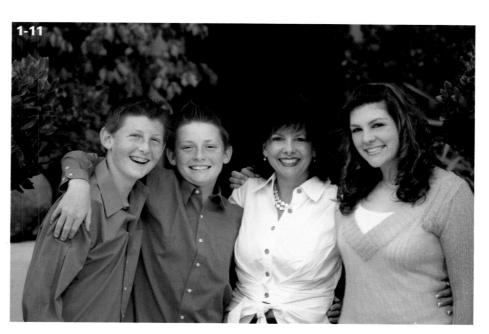

practicing along the way is a good recipe for success. Following is a brief overview of some basic equipment essential to beginning your photographic journey.

MEGAPIXELS

A digital image is made up of thousands of tiny, tile-like, colored squares called *pixels*, and one million pixels equals one *megapixel* (MP). This is important to know because digital cameras measure *resolution* (the quality of the image) in megapixels. For example, a 7MP camera produces an image capable of being printed at 11" × 14" or possibly larger, while still retaining sharpness and detail. Think about your final product: If you need to print out large images, make sure you are using a camera with the appropriate number of megapixels.

MEMORY CARDS

Memory cards are the recording medium for digital cameras — the digital camera writes the image data to the removable memory card as you shoot. Because memory cards are available in many shapes, sizes, and speeds, and some are proprietary to the manufacturer's camera, refer to your camera

manual, or to the memory card itself, to identify which variety your camera accepts. When you purchased your camera, a small-capacity memory card was probably included, typically 16MB (megabyte); however, I'm sure you quickly discovered that a 16MB memory card does not hold very many images.

Pay attention to the memory card capacity and make sure you purchase at least one 1GB (gigabyte) memory card. For example, a 7MP camera set at the highest resolution with a 1GB memory card holds approximately 280 images — Table 1-1 outlines the general capacities of various memory card sizes, based on camera pixels. Having a 1GB media card enables you to shoot images continuously without running out of room, and you avoid having to download your images to a computer in the middle of a shoot. Memory cards are also very fragile, so be careful when you take them out of the camera. Keep them away from magnetic sources and curious dogs that enjoy chewing on plastic — these could damage your card and result in lost images.

BATTERIES

Digital cameras use either a rechargeable battery pack or traditional batteries. And, digital cameras

Table 1-1

Approximate Memory Card Capacities*

Memory Card Size	5MP Camera	6MP Camera	7MP Camera	8MP Camera	10MP Camera	12 MP Camera		
Number of images								
512MB	280	232	140	120	116	90		
1GB	560	464	280	240	280	232		
2GB	819	640	560	480	409	320		
4GB	1,628	1,280	1,120	960	814	640		

^{*}These numbers are approximate. Check your digital camera manual and LCD viewfinder to confirm the number of images your memory card holds in relation to your camera's resolution settings.

use significantly more power than traditional film cameras. Although traditional cameras need their batteries replaced after approximately every 15 rolls of film shot, your digital camera may run out of batteries before you've filled up the media card, especially if you view multiple images on your LCD screen in between shots. Constantly viewing your images on the LCD screen reduces battery life quickly.

I recommend buying an extra battery pack or investing in rechargeable batteries and always having extras on hand.

COMPACT DIGITAL CAMERAS

Compact digital cameras are better than ever now with improved sensors, bigger LCD screens, and lots of features — some can even capture video. The main appeal is that you can carry them with you everywhere so you never miss a shot. In spite of their small size and lack of an interchangeable lens, it is possible to capture some fantastic images of people with these cameras just by learning a little about the basic functions. Given that there is not a standardized design for the functions and features on different manufacturers' cameras, you may need to consult your camera manual to find the following modes:

■ A and P. Automatic (Auto) and Program (P) modes are the most common modes people use when shooting with a compact digital camera. Automatic is fully automatic: The camera makes all the decisions. Program is an advanced automatic setting that allows you to make decisions about the flash, white balance, and drive mode. When it is in these Auto modes, your camera makes its best guess in determining the exposure by focusing, reading the light in the scene, and automatically choosing a shutter speed, aperture, and white balance.

Using the automatic modes can result in acceptable images, and they are a good place to begin, but you won't have much control over the outcome unless you use some of the scene/creative modes too.

- Portrait mode. Likely represented as a head icon on your mode dial. When you select the Portrait mode, the camera adjusts the aperture and shutter speed for you, minimizing the depth of field (DOF) for a soft background effect that isolates your subject from the background.
- Sports mode. By setting the camera to Sports mode, usually indicated with a runner icon, your camera automatically chooses the fastest shutter speed possible, given the situation. Some cameras also activate Continuous Shooting mode (instead of Single Frame) and disable the flash. This setting also works well for capturing active subjects and candid moments.
- Macro mode. Using the Macro mode, which is usually represented by a flower, enables you to focus closer to your subject and capture details in your images that were previously too small or out of focus. Just because the Macro mode is represented by a flower doesn't mean that flowers are the only allowable subject. With Macro mode you can take close-up photos of people and capture every freckle and eyelash in perfect detail.
- an icon that looks like a mountain range,
 Landscape mode (also known as *Infinity mode*)
 automatically uses a small lens aperture that
 provides maximum sharpness for distant and
 wide-vista scenes. This mode is also useful when
 photographing groups of people that are positioned at various distances from the camera.

Here are a couple of ways to control the light on your subject:

- Flash mode. A lightning bolt icon is located on the back of your camera representing the Flash mode. Set your Mode dial to P, which allows you to cycle through all your flash options. Some compact cameras require you to use the Manual mode in order to use the full features of your flash. Selecting the forced flash option enables you to use the flash outside in bright light, filling in harsh shadows on faces.
- Exposure compensation. Digital cameras have an additional feature that controls the amount of light hitting your camera's sensor; it's called *exposure compensation*. Adjusting your exposure compensation to add more light (+) or reduce light (−) is a quick, semi-automatic way to adjust how the camera records the light in your scene. By using exposure compensation, you still don't have total creative control over your camera, but you can make your image appear lighter or darker.

Have you wondered what zoom on a compact camera really means? Camera manufacturers often refer to digital zoom and optical zoom when marketing a compact digital camera. Optical zoom is the important feature because it refers to the lens optics and results in getting you closer to your subject without sacrificing image quality a true zoom. The lens is not removable on a digital compact camera or a larger super-zoom variety, but both cameras refer to focal length as "X." For example: From your location, 3X optical zoom gets you three times closer to your subject, and 10X optical zoom gets you ten times closer to your subject. Digital zoom doesn't actually result in a closer shot, the camera is simply zooming and cropping so the image you are focused on appears larger, but the result is a lower-quality image than if you were zooming with an optical zoom.

dSLR CAMERAS

The d stands for digital and the SLR for single lens reflex. The camera's reflex mechanism is a series of mirrors and prisms inside the body that reflect the image coming through the lens to your optical viewfinder. Digital SLR cameras are similar to traditional film SLR cameras, except that an image sensor captures your images and records them onto a media card instead of film.

In addition to the compact camera scene modes listed in the previous section, a dSLR also includes two more modes that are helpful when shooting pictures of people:

- Shutter priority. Referred to as Tv. You set the desired shutter speed, and the camera automatically adjusts for the proper aperture exposure. This is a good setting to use when you need control over movement in your image. You can choose to freeze the action or blur it, depending on your shutter speed selection.
- Aperture priority. Referred to as Av. You set the desired aperture, and the camera automatically adjusts for the proper shutter speed exposure. Use this setting to control your depth of field. This is great for isolating your subject and blurring out the background with a wide aperture.

While compact digital cameras have some great uses, there are several big advantages that dSLRs have:

■ Image quality. A larger image sensor provides larger pixels, and more of them, for greater detail in your images. Enhanced ISO capability leads to faster shutter speeds and less noise (a grainy appearance at higher ISOs, usually 800 or higher) in your images.

- Speed. You experience faster start-up and focusing, less shutter delay, and more frames per second for shooting images in sequence; dSLRs are great for taking pictures of kids, animals, sports, or anything else that moves.
- Creativity. Manual modes allow for greater control. Manual mode is what most professional photographers use.
- RAW format capability. RAW files are uncompressed and therefore offer more options and control over your final image.

For more information on file formats and how to choose the best one for you, see Chapter 10.

■ **Lenses.** You have the ability to swap lenses for different perspectives and effects.

CHOOSE LENSES FOR YOUR dSLR

There are various lenses available for a dSLR camera, and each type of lens has different capabilities. The choice of a lens is based on the results you want to achieve in your images. Depth of field, lens aperture, and lens focal length are determining factors in the creation of your image.

DEPTH OF FIELD

Depth of field (DOF) refers to the zone of sharpness in your image. Your DOF is deep if most of your scene is in focus; it is shallow if a small area is in focus. The human eye is drawn to the part of an image that is sharp and in focus. As a photographer, you can creatively use DOF to direct the viewer's eyes to the important elements in your

photograph. There are three ways you can control DOF:

- Distance to your subject. An image taken in close proximity to your subject produces a shallow DOF. An image taken at a considerable distance from your subject will have a deeper DOF.
- **Aperture selected.** Aperture can be confusing because a large f-stop number (f/22) represents a small lens opening and a small f-stop number (f/2.8) represents a large lens opening. It's easier to think of it like this: A large aperture (f/2.8 or f/4) provides a shallow DOF; for example, your subject is in focus but the distant mountain range is blurred. A small aperture (f/16 or f/22) provides a deep DOF; for example, both the subject and the distant mountain range are in focus. Using a small aperture is a good way to ensure the environment surrounding your subject is in focus. In images by Ansel Adams, he used a very small aperture to capture sweeping vistas of the environment in minute detail.
- Lens focal length. Short focal length lenses (for example, 17-35mm) have a large field of view. Long focal length lenses (for example, 70-200mm) have a narrow field of view.

LENS APERTURE

Measured in f-stops, a *lens aperture* is a mechanical iris inside of the lens that opens and closes to varying degrees to control the amount of light hitting the digital camera's sensor. Think of the aperture of your camera lens as the pupil in your eye. In a dark room, your pupils enlarge and open up to let in more light — in bright light, your pupils constrict to let in less light. The aperture f-stops on your lens control light in the same manner, as shown in figure 1-12.

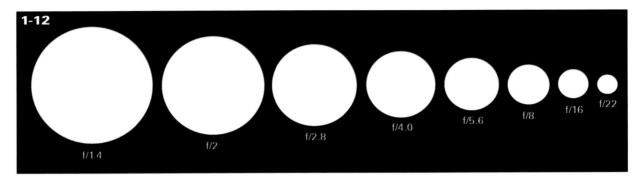

If it starts to get confusing, just remember, a larger aperture (for example, f/1.4, f/2, f2.8, or f/4) lets in more light and gives you a shallow DOF. Use a larger aperture to isolate your subject and blur the background, as shown in 1-13.

A smaller aperture (for example, f/16 or f/22) lets in less light and gives you deeper DOF. Use a smaller aperture to render your entire scene in focus, as shown in 1-14.

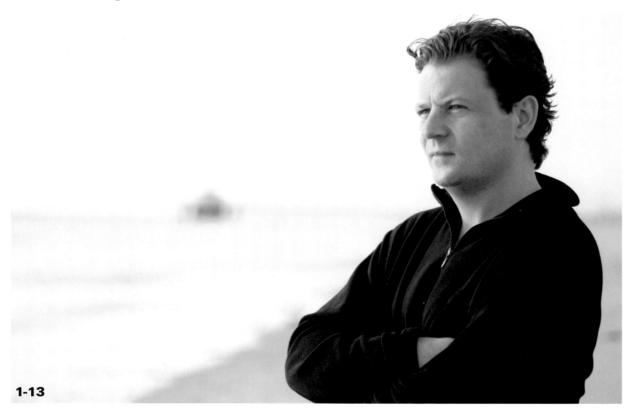

ABOUT THIS PHOTO An example of shallow DOF using a large aperture. Taken with a Canon EF 70-200mm lens at f/2.8.

ABOUT THIS PHOTO An example of deep DOF using a small aperture. Taken with a Canon EF 24-105mm lens at f/22.

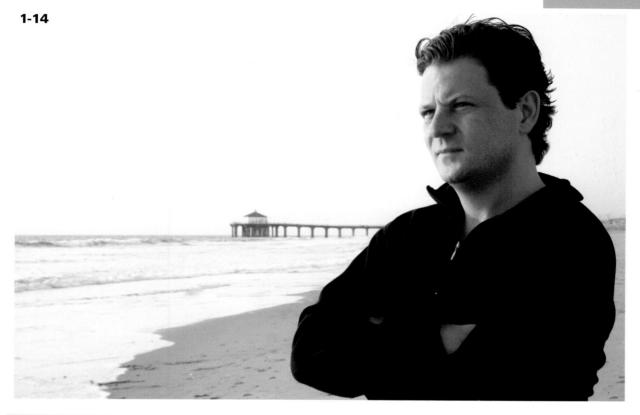

Learn how aperture, shutter speed, and ISO combine to create a good exposure in Chapter 3.

A lens with a larger maximum aperture (for example, f/2.8) is considered a "fast" lens because more light passes through the lens, allowing a faster shutter speed. A lens with a smaller maximum aperture (for example, f/5.6) is "slow" because less light passes through the lens and requires a slower shutter speed. A fast lens is optimum when shooting in low-light situations

and for creating a shallow DOF. Due to the highquality optics, these lenses are heavier and more expensive.

Made of optical glass or plastic, a lens attempts to duplicate the human eye by seeing an image, focusing, and transmitting its colors, sharpness, and brightness through the camera to the digital sensor. Many types of lenses are available for your dSLR, and understanding how they work helps you gain creative control over your image. Choosing the right lens is a tradeoff between cost, size, weight, lens speed, and image quality.

Before you purchase a lens, know that lenses are not interchangeable

between camera brands. A lens mount is the point of connection between the lens and your dSLR, and these connections are proprietary to the camera manufacturer. A lens designed for a Canon camera will not work on a Nikon camera. If you're interested in purchasing a third-party lens, manufacturers do produce lenses with mounts to fit all the major dSLR cameras manufactured.

LENS FOCAL LENGTH

The focal length of a lens, which is displayed on the barrel of the lens, establishes the field of view for the camera. The following is a description of the various lenses and their focal lengths:

- Standard lens. A lens with a focal length of 50mm is considered a normal, all-purpose lens because it closely approximates what your eyes see. With its natural angle of view and perspective, a standard lens captures the subject plainly, with no special effects; but you can use standard lenses in creative ways by varying the subject's distance, aperture, and angle.
- Telephoto lens. The focal length of a telephoto lens ranges anywhere from 60 to 1000mm; acting like a telescope, it magnifies your subject and narrows the field of view. Images taken with a telephoto lens have a flattened perspective and a shallow DOF. This lens is ideal for portraits because you can isolate your subject from the background and the perspective is very flattering.
- Wide-angle lens. The focal length of a wideangle lens is any measurement less than 50mm, but is typically 17-28mm. Traditionally used for environmental portraits or special-effect images, this lens exaggerates

- or stretches perspective and distorts the view if your subject is too close to the camera. At close range, a wide-angle lens can produce comical, distorted images, and it is not considered a flattering choice for portraits.
- Macro lens. Macro lenses have various focal lengths, (for example, 50mm, 65mm, and 100mm), and unlike other lenses, enable you to photograph your subject from a very close distance without distortion. Shooting with this lens not only produces images with a different scale, but it also focuses your viewer's attention on details that might otherwise go unnoticed your images will have a close-up, intimate feel.
- Selective focus lens. Traditionally used to correct the converging lines of buildings as you composed your shot from the ground, selective focus lenses provided a solution to the unnatural perspective problem. Now these lenses and other selective focus lens variations are also used for a contemporary effect. You can manually control the lens to find a sweet spot of focus in your image and artfully blur other elements, producing a dreamlike aesthetic. See 1-6 for an example of selective focus.
- Focal length multiplier. This is also known as the dSLR *crop factor*. Now that I've told you all about lens focal lengths, here is one more factor that can affect the perceived focal length in your final image. In the beginning, a 35mm SLR camera and lens would capture images and record them onto film. Now with dSLRs, the image is captured by the camera's sensor and recorded onto a media card. Many dSLR cameras have a sensor smaller than the

35mm photographic film frame and only capture part of the information projected by a lens. This results in a cropped field of view, which makes images appear as though you are shooting with a longer lens. To compute the focal length, you must know your dSLR crop factor or multiplier; this information is included with your camera. The three most common multipliers are 1.5, 1.6, and 2.0. For example, if you attach a 100mm lens to a dSLR with a 1.5 crop factor, it captures images as a 150mm lens ($100 \text{mm} \times 1.5 = 150 \text{mm}$).

More expensive dSLRs have a full-size sensor, capable of capturing images without a crop factor; however, unless your image requires a wide-angle look, shooting with a longer focal length can be very flattering to your subject.

note

An *f-stop* is a fraction that indicates the diameter of the aperture. The f

stands for the focal length on the lens, the slash (/) means divided by, and the number represents the stop in use.

Assignment

Capture an Authentic Expression

Find a person you consider interesting and take a series of portraits of this person, concentrating on capturing an authentic expression. Use your newfound connection techniques to engage him or her.

To complete this assignment, I decided to photograph Jack. He is one of my favorite kids to photograph; he's animated yet capable of thoughtful moments. The picture I chose as most representative was taken in the open doorway of a car — after one of his basketball games. His expression shows that he's a kid with depth, and you can tell that we have a special connection. The photo was taken at ISO 1600, f/11, 1/640 sec. with a Canon EF 24-105mm f/4.0L IS lens.

Remember to visit www.pwsbooks.com after you complete this assignment and share your favorite photo! It's a community of enthusiastic photographers and a great place to view what other readers have created. You can also post comments and read encouraging suggestions and feedback.

Lenses and Filters

BATTERIES

TRIPODS

REFLECTORS AND DIFFUSERS

LIGHTS AND FLASH

BACKDROPS

CAMERA BAGS

MEDIA STORAGE AND VIEWING

Odds 'n Ends

After the photography bug has bitten, your life changes in many ways due to your new passion. You see the light in a different way, compositional elements are much more obvious, your direction skills are enhanced, and last but not least, you begin researching and planning for camera accessory purchases. Although the quality of photographs depends more on the vision and creativity of the photographer than on the equipment, you need some basic accessories to begin, and you need to plan for other accessories as your photographic skills increase.

When I began photographing, I had very little money, but I did possess a lot of desire and passion to capture life moments and express my unique creativity in a photograph. I thought that if I only had the very best equipment, I could be a better photographer. I quizzed my instructors and my peers on what to purchase and was overwhelmed with the varying opinions and the astronomical costs associated with becoming a "good" photographer. I soon discovered that photography is an evolving process; your knowledge increases, your creative vision changes, technology transforms, and the world is constantly in flux. I could dream about, plan for, rent, or borrow what I could not afford at any given time and still take amazing photographs with minimal equipment.

Desire, dream, and diligently pursue your vision. Start with the basics and build on your equipment cache. Get creative and use inexpensive items and tools to give your images a unique look. If you can afford to buy a good camera and many accessories, do so sparingly at first while you get used to your equipment. As your photographic experience grows, you can add more accessories.

After you begin building your accessory reserve, you may discover that what you once considered a techno-nerd equipment purchase is now something worth getting excited about, because it's a

means to help you create and interpret your vision. Every time you add something new to your photography accessory collection, the excitement builds: a lens, a reflector, a light — it's so exciting!

Reading this chapter should help you identify what basics you require on your photographic journey, what to improvise, and what to put on your wish list.

LENSES AND FILTERS

When your photography skills begin to mature, you also become more aware of the creative and technical accomplishments of other photographers. Learning about the tools others use when creating their masterpieces and researching the online reviews about these photo accessories can help you make informed decisions when you decide to add more equipment to your own photo accessory cache.

Interchanging lenses on your digital single lens reflex (dSLR) camera is a great way to exercise your creative options and technical abilities. If you would like your weekend soccer-match images of the kids to look more like *Sports Illustrated* than just a regular snapshot, you need to change your lens (which is one of the major benefits of using a dSLR camera — the option to change your lens).

You may have lenses that you used on your prior film camera and now you want to use them with a compatible digital camera body. That works out very well when you switch from shooting with film to shooting with digital, except for one little thing. Remember the focal length multiplier, or dSLR crop factor, mentioned in Chapter 1? Depending on which camera and lens combination you use, this phenomenon can affect the perceived focal length in your images. For example, if you attach a 28-80mm zoom lens to a dSLR

CHAPTER 2

with a 1.5 crop factor, it captures images as a 42-120mm lens ($28\text{mm} \times 1.5 = 42\text{mm}$). This alteration may work out just fine, especially if you prefer longer focal lengths. However, if you intend to capture a 28mm wide-angle appearance in your image, you will have to upgrade to a "full-size" sensor digital camera or purchase a lens with a significantly increased wide-angle capability.

Now it's possible to purchase lenses exclusively designed for digital cameras that lack a full-size sensor. These lenses are sold with digital camera lens specifications noted in the lens description.

LENS SPEED

A lens with an aperture of f/2.8 is considered a fast lens because it allows for a wider aperture setting and it lets more light pass through the lens, which results in a faster shutter speed. A lens with a smaller maximum aperture (for example, f/5.6) is slow because less light can pass through the lens, and it requires a slower shutter speed.

Most basic, inexpensive zoom lenses have a varying lens speed of approximately f/3.5 to 5.6. The lens speed changes as you zoom closer or farther away from your subject with the wide or telephoto capability of your lens. These lenses are wonderful to use when you're beginning your photographic journey. They are constantly improving and produce excellent images, but they do have limitations. For example, you can't shoot handheld in most low-light situations — you can capture the action in only bright light or by using a flash, and rendering a very shallow depth of field is not attainable.

A fast lens is considered a high-quality lens; it contains more glass so it's heavier, and it has an enhanced lens coating to reduce flare. A fast lens is more expensive, but the image results can be amazing. With a high-quality lens, you can capture more action because you don't need as much

light in your scene for a proper exposure, and you can use a faster shutter speed. A fast lens also enables you to open up your aperture to f/1.4 or f/2.8 and create images with a very shallow depth of field — perfect for beautiful portraits and transforming your weekend soccer snapshots into professional-looking images.

TYPES OF LENSES

Professional photographers use various types of lenses to achieve different effects in their images. You can build your lens collection over time to include the basic options and perhaps add other unusual lenses for a completely unique effect in your images. It's important to understand that different types of lenses affect how you approach your subject and the resulting image.

note

Because 35mm film focal length measurements are standardized

and familiar to most photographers, the millimeter (mm) measurement is also used to describe digital focal length.

- **Zoom lenses.** Zoom lenses have a range of focal lengths (for example, 24-70mm) and allow you to quickly increase or decrease your lens focal length, including more or less of your scene, in seconds, without changing your physical distance to your subject.
- Prime lenses. Prime lenses have a single focal length (for example, 50mm), are generally less expensive than zoom lenses, and produce sharper images, but you miss the convenience of quickly changing your focal length with one lens.

For more information on the focal length, focal-length multiplier, and depth of field, see Chapter 1.

LENS FOCAL LENGTHS

Lenses are available in a multitude of focal lengths, with varying levels of quality. Technically, the *focal length* of a lens is defined as the distance from the middle of the lens element to the digital camera's imaging sensor, and is measured in millimeters. The focal length of a lens is usually displayed on the side of the lens barrel.

The Canon lens in 2-1 has a focal length of 50mm with a maximum aperture of f/1.4. This lens is called a *standard* or *normal* lens because 50mm approximates the perspective of the human eye, maintaining the spatial relationship of objects in your image very closely to the way you see the world.

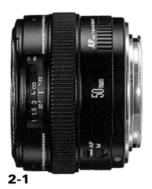

ABOUT THIS FIGURE A 50mm normal lens approximates the perspective of the human eye. Photo courtesy of Canon.

A telephoto lens technically can range from 60 to 1000mm, but a common telephoto zoom lens example is 70-300mm. A telephoto lens is similar to a telescope; it magnifies your subject and narrows your field of view. Capturing candid shots is easier with this lens because you can zoom in and photograph your subject from quite a distance. This is also a great lens for shooting sports, wildlife, and people.

A telephoto lens is great for portraits because it provides a flattering perspective and allows you to isolate your subject from the background. The spatial relationship in the scene is flattened, so noses don't look larger than normal (as with wide-angle lenses), and a long focal length combined with a wide aperture enables you to blur out everything behind the subject. The Canon telephoto lens in 2-2 has a zoom capability of 70-200mm.

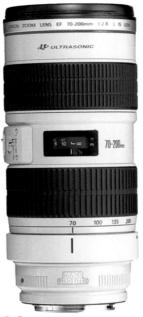

2-2

ABOUT THIS FIGURE A 70-200mm telephoto zoom lens allows you to shoot from farther distances. Photo courtesy of Canon.

A wide-angle lens exaggerates the spatial relationship of objects in your image. Typically denoted by any measurement less than 50mm, a common wide-angle lens is 17-28mm. This lens perspective is fantastic for capturing the interior of a room or large, expansive environmental portraits.

CHAPTER 2

Besides including a wider field of vision, a wideangle lens is shorter than a telephoto lens and can render a deeper depth of field. This lens is a favorite with landscape photographers who intend to capture detail from the foreground to the background of their images.

Be aware that anything close to the wide-angle lens appears a good deal larger than life. Although this is often not a flattering perspective for portrait photography, you can create some very interesting effects by shooting with a wide-angle lens in close proximity to your subject.

An example of a wide-angle lens is shown in 2-3.

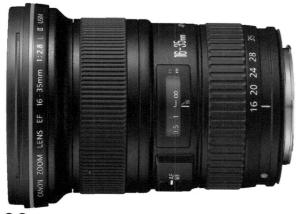

2-3

ABOUT THIS FIGURE A 17-35mm wide-angle lens can capture a wider field of view and increase your depth of field. Photo courtesy of Canon.

Macro lenses are available in various focal lengths, (for example, 50mm, 65mm, and 100mm), and unlike other lenses, allow you to photograph your subject from a very close distance without distortion. Shooting with this lens not only produces images with a different scale, but it also focuses your viewer's attention on details that might otherwise go unnoticed and gives your images a

close-up, intimate feel. For example, you can use a macro lens when photographing babies and kids. Soft little features on babies can go unnoticed in portraits taken at a typical distance, and close-up images can create a more intimate connection with your viewer.

Compact digital cameras have a macro modes feature that enables the camera lens to capture images up close. Although the results are not as magnified as a dSLR lens, this setting can help you produce beautiful close-up images. An example of a macro lens for a dSLR camera is shown in 2-4.

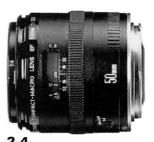

Z-4

ABOUT THIS FIGURE A 50mm macro lens allows you to capture close-up images without distortion. Photo courtesy of Canon.

Selective focus lenses are used to correct the converging lines of buildings as you compose your shot from the ground, providing a solution to the unnatural perspective problem. These lenses and other selective focus lens variations are also used for a contemporary effect. You can manually control the lens to find a sweet spot of focus in your image and artfully blur other elements, producing a dream-like aesthetic. An example of a selective focus lens is shown in 2-5.

p tip

A *lens mount* is the point of connection between the lens and your

dSLR, and these connections are proprietary to the camera's manufacturer. Before you purchase a lens, ensure that it works with your particular camera brand.

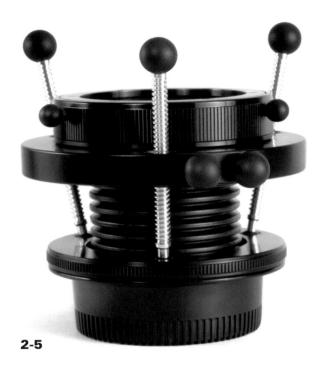

ABOUT THIS FIGURE Selective focus lenses can help you create an image with a dream-like aesthetic. Photo courtesy of Lensbabies LLC.

LENS FILTERS

A digital camera's white balance now replaces the need for most color-balancing optical filters that were required for film images. Computer software also reduces the need for effect filters, such as the softening filter or a starburst filter. Now, a well-stocked camera bag includes just a few essential filters for your lens.

A UV filter is a clear, glass filter that attaches to the front of your lens and helps cut down on atmospheric haze, producing a clearer shot. This filter also serves as a protective shield against scratches and dings on the front of your lens glass. The logic behind using this protection is that a \$20 filter is easier to replace than an \$800 lens. Another school of thought states this filter

interferes with your focusing sensors and results in a blurry image. (I have personally never experienced this focusing issue with filters and believe that protecting your lens glass against scratches and nicks is very important.)

A polarizing filter is a dark glass filter that is used to darken blue skies, enhance color contrast, and reduce glare and reflections on water and glass. Linear and circular polarizers are available, but you should use the circular polarizer — a linear polarizer can confuse your camera's metering and autofocus systems. A circular polarizer allows you to rotate the circular ring on the front of the filter and adjust the polarizing effect for the desired effect. Because they are darker glass, polarizing filters reduce the amount of light entering your lens, and, therefore, require a slower shutter speed or wider aperture setting. The polarizing effect achieved in your images depends upon the time of day, the reflective qualities in your scene, and the angle of light in your scene. An example of a polarizing filter and a comparison of before and after using a polarizing filter are shown in 2-6.

A neutral density (ND) filter does not affect the color in your scene, but it does reduce the amount of light entering your lens. These filters are available in varying degrees of strength, and you use them when you want to achieve a certain effect but the light is too bright to allow the exposure effect you want; for example, you would use them to blur action in your scene by using a slow shutter speed, or to produce a very shallow depth of field by using a wide-open aperture.

Graduated neutral density filters are dark on one end and then gradually fade to clear in the middle of the filter. This filter is typically used in landscape portraits in which the sky is much brighter than the land beneath the horizon. With a graduated ND filter, a more balanced exposure is possible.

2

ABOUT THIS FIGURE Polarizing filters reduce the amount of glare from reflective surfaces, enhance color contrast, and darken blue skies. Photos courtesy of Tiffin.

2-6

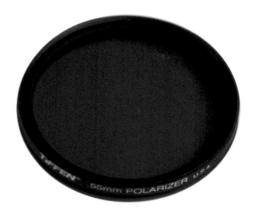

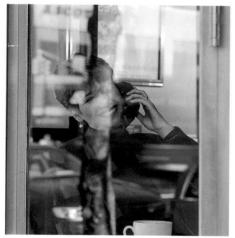

With polarizing filter

BATTERIES

It's a terrible feeling to look through the viewfinder, compose a stunning image, and press the shutter button only to discover you don't have enough battery charge to capture the image — and you don't have an extra battery anywhere nearby. Missed photo opportunities are frustrating and disappointing, but you can save the day by carrying extra batteries with you on all photographic adventures.

Batteries are relatively inexpensive, and every photographer should carry a minimum of one extra charged battery or set of batteries (depending on what type your camera uses) at all times. Read your camera manual and determine which type of battery your camera requires. When you're traveling, make sure to pack your camera battery charger and any associated cords needed to plug in and charge the batteries.

idea

When I'm traveling and on the go during the day, I carry a few batter-

ies with me and leave at least one in the room charging. When I return to the room, I charge up my used batteries and have one extra battery to bring with me for the evening festivities.

A battery grip is a device that you can mount on the bottom of your dSLR that extends your battery life because it provides more power (see 2-7). Because a grip typically uses two camera batteries, it doubles your shooting time, increases the speed of your shots, and helps you avoid shutter lag. These grips also have a duplicate shutter release, enabling you to take vertical shots with greater ease. The only downside to using a battery grip is that it adds weight and bulk to your camera, but sometimes this inconvenience is worth the added benefit a battery grip provides.

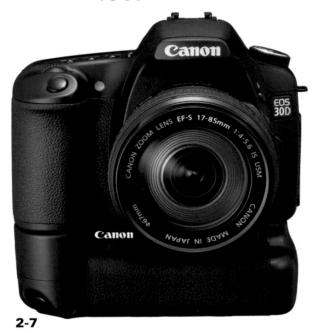

ABOUT THIS FIGURE A battery grip doubles your shooting time and increases the speed of your shots. Photo courtesy of Canon.

A card reader enables you to transfer your images from your memory card to your computer (see 2-8). Instead of connecting your camera to the computer to download your images, you simply plug a card reader into your computer's USB or firewire port, insert the media card, and import the images onto a designated folder on your computer. This is also an inexpensive way to protect

your camera from unnecessary battery usage and general wear and tear.

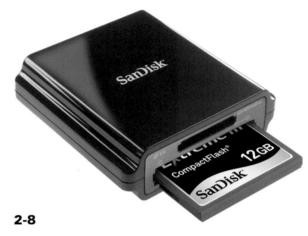

ABOUT THIS FIGURE Media card readers allow you to quickly and easily transfer your images to your computer. Photo courtesy of SanDisk.

TRIPODS

If you are shooting in low light or at night, your exposure requires a slow shutter speed, and you need a tripod. Using a slow shutter speed makes your camera sensitive to the slightest camera movement caused by wind, unsteady hands, or even depressing the shutter button — which often results in out-of-focus images. If you aren't concerned about traveling light, and you have a few extra minutes to set up your shot, using a tripod is a good way to improve the sharpness of your images. Trying to handhold a camera using a shutter speed below 1/30 second is risky, and using a long focal length lens further increases your chances for image blur.

You also need a tripod for environmental portraits in which the foreground requires sharp focus through the background. Deep depth of field requires a small aperture, and a small aperture, in turn, requires a slower shutter speed to maintain the correct exposure in your scene.

Tripods come in all shapes and sizes, and it's important to choose one that stabilizes your

CHAPTER 2

camera and is easy to use. A dSLR camera and a long lens can be heavy, so a heavier tripod is necessary to balance the weight and ensure a stable platform. A lighter tripod may work well for smaller, lightweight camera and lens combinations. You can stabilize compact cameras with very small, lightweight tripods.

TRIPOD FEATURES

A tripod consists of two major parts: three legs that you can collapse and extend as necessary, and a center shaft that you use to raise or lower the camera. This center shaft ends at a flat platform through which projects a threaded screw. It's on this platform that you mount a tripod head.

- **Tripod heads.** Tripods are available with different types and qualities of heads. These heads are the part of the tripod that supports the camera and allows you to pivot it into position for your shot (see 2-9). Some tripods are controlled by a series of knobs; some have a ballhead. Tripod heads with a series of knobs require independent adjustments for directional camera movement; tripods with ballheads enable you to smoothly adjust your camera in multiple directions with one knob. Both types allow you to move the camera into different positions and keep it stabilized while you compose and capture your image. Whichever tripod you choose, make sure that after you connect your camera to it, your camera's memory card slot is accessible.
- Quick releases. A must-have for photographing with a tripod, a quick release allows you to quickly release the camera from the tripod. It consists of two parts: a plate that mounts on the bottom of the camera and a clamp on top of the tripod head that enables you to quickly attach and detach the camera to the tripod plate. Without a quick release, you are left to unscrew your camera from the tripod head, which can become cumbersome and impractical. If your

tripod does not include a quick release, there are quick release adapters available.

p tip

When using your tripod, position the third leg away from you and not

between your legs. This way, you won't trip and accidentally knock over the tripod and your camera.

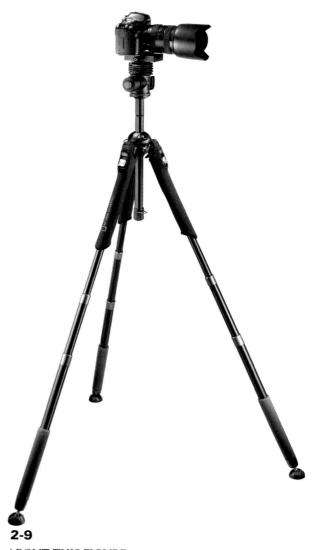

ABOUT THIS FIGURE This is an example of how a tripod head attaches between the camera and the tripod, helping to support and pivot the camera. Photo courtesy of Bogen.

MINI-TRIPODS

Mini-tripods are smaller, lighter versions of a standard sized tripod. Often used for stabilizing small, compact cameras on various surfaces, minitripods are easy to carry and less obtrusive than their larger counterparts. The Gorillapod is a unique solution, as shown in 2-10.

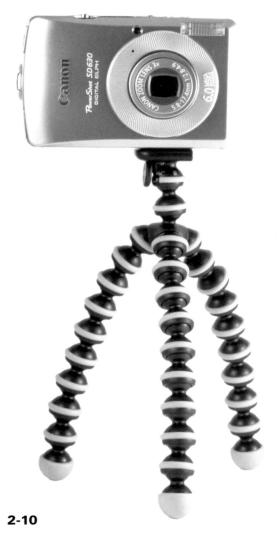

ABOUT THIS FIGURE A lightweight Gorillapod is a handy way to stabilize your compact camera and set up self-portraits or timed group shots. You can easily fold it up and place it inside a purse or backpack. Photo courtesy of Joby.

MONOPODS

A monopod, shown in 2-11, consists of only one leg and requires you to hold it upright. Monopods are generally used by sports photographers who

ABOUT THIS FIGURE A monopod helps you stabilize your camera when a tripod isn't convenient. Photo courtesy of Bogen.

ABOUT THIS FIGURE

An extender called the Quikpod attaches to the bottom of your compact digital camera and extends the space between your camera and face when you're taking self-portraits without the timer. Photo courtesy of Quik Pod.

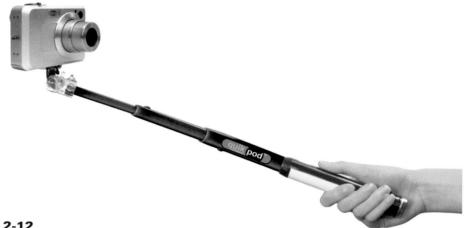

2-12

need to move around on the fly but don't want the burden of holding their cameras all day long. However, a monopod isn't just for professional photographers. You can use monopods in any low-light situation, such as a kid's basketball game or other sporting events where a steady hand and mobility are needed. You can also use a monopod to elevate the camera above a crowd.

An extender attachment can connect to the bottom of your compact digital camera and allow you to extend the distance from your camera to your face when you take self-portraits (see 2-12). An extender is also very handy when you're photographing hard-to-reach places.

Tripods are constructed with different materials. at different weights, for a range of prices. Visit your local camera store and do some hands-on research to see which tripod feels right for you.

REFLECTORS AND DIFFUSERS

One of the secrets to taking flattering portraits is learning how to see and manipulate the light falling upon your subject. Outdoor locations provide plenty of natural light, but if you don't have the tools to enhance or subdue the available light, your photographs may not turn out as well as you had hoped. Using reflectors and diffusers is fundamental to controlling and manipulating this light.

A reflector can be anything that reflects light into your scene. A mirror, a white tablecloth, a cookie sheet covered in tinfoil, or even a car dashboard reflector can do the trick. Professional reflectors come in various shapes and sizes and are essential for bouncing light back into areas of shadow to reduce contrast. They're available in white, silver, and gold (see 2-13).

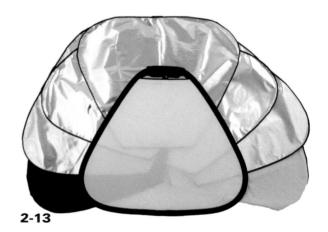

ABOUT THIS FIGURE Reflectors come in many different sizes and are often gold, silver, or white. Photo courtesy of Bogen.

I like to use a collapsible, soft, gold reflector that when positioned cor-

rectly, fills in shadows, brightens faces, and puts a twinkle in the eye of everyone I photograph.

A common mistake when you begin to photograph people outdoors is placing them in harsh, direct sunlight. Harsh light can be very unflattering, cast harsh shadows under your subjects' eyes, and result in squinting faces. The quality of light changes throughout the day: In the morning, the light is soft; by midday, it's directly overhead and very harsh; and then in the late afternoon or early evening, the sunlight softens as the sun sets below the horizon. Be aware of this difference in light quality and plan your photo shoot during the early morning or late afternoon. If shooting midday is necessary, you can soften the harsh light by positioning your subject in a shaded area, or can use a diffuser to soften the light falling upon your subject.

A *diffuser* is translucent material that when placed between the harsh light and your subject, softens and diffuses the light falling upon your subject. Even everyday household objects such as a white umbrella or silky white material can help diffuse harsh light and make your subjects look far more appealing.

After you learn the principal of reflecting and diffusing light, you have much more control over the scene and can take advantage of the light instead of avoiding it when composing your photograph.

LIGHTS AND FLASH

You create a compelling image by seeing, controlling, and capturing the light that falls upon your subject in the scene. Sometimes natural light is not enough, and you need to light up the scene with artificial light. Most digital cameras have a built-in flash to cover the basic lighting needs, but the light they emit can result in images that look flat and lack subtle gradations of tone. Use your on-camera flash as a last resort to fill in shadows in bright light or to capture images at parties or events where bringing an external flash isn't convenient. If you are determined to take better pictures using artificial light sources, prepare to make some extra room in your camera bag.

Lights for photography can be classified into two categories: strobes or flashes and continuous lights. *Strobes* and *flashes* emit a burst of light for a fraction of a second. *Continuous lights* are a consistent light source that you can easily adjust and manipulate because you can see how the light affects your subject in the scene and then compose your image.

EXTERNAL FLASH

You attach an external flash to your camera by connecting it on the camera's *hot-shoe* — a mounting bracket located on the top of your camera (see 2-14). The main benefit to using an external flash is that it's elevated well above the camera's lens. This extended elevation solves the red-eye problem that occurs due to the close proximity of the on-camera flash to the camera lens.

ABOUT THIS FIGURE An external flash has many merits, among them is helping to reduce red-eye. Photo courtesy of Canon.

If the flash is designed to work with your camera, you can use the TTL (through the lens) metering features on your camera to create well-lit scenes. You can also swivel the flash head so the light can be reflected off of other surfaces, softening the light and extending the coverage over a greater area.

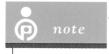

Red-eye occurs in low-light situations when an on-camera flash reflects the back of the retina into the camera.

You can purchase *flash diffusers* at a camera store, and they generally consist of a white, translucent plastic or fabric cover that slips over the head of your flash unit. A popular version is made of molded white plastic, giving a directional but more attractive light. The flashed light passes through the translucent cover and is diffused and softened by the time it reaches your subject.

Another type of diffuser is a *bounce card* that attaches to the head of your flash. You can also use a white business card attached with a rubber band. Some new flash units have a white bounce card that pulls out of a slot next to the flash head, creating a nice white bounce of light on your subject.

FLASH SLAVES AND TRANSMITTERS

Slaves are small sensors that trigger a flash unit to fire when another flash unit goes off. You can position them at varying distances, and you use them in situations in which you have a main flash at camera position and need another light source to fill in the shadows and even out the light in your scene.

A transmitter, shown in 2-15, attaches to your camera's hot-shoe and sends an infrared trigger (no wires needed) that causes other dedicated Speedlite flash units in the near vicinity to flash. For example, you use the Canon ST-E2 Speedlite transmitter to trigger external Canon Speedlites positioned on top of stands that are pointed toward the interior of a reflector umbrella. This bounced light creates a broader light source in the scene and provides more control over the quality of light falling upon your subject.

note

Each light source emits its own color temperature, which equates

to a potential color cast in your images. You can solve this color cast problem by adjusting your camera's white balance (WB) function for the light source in your scene.

ABOUT THIS FIGURE A transmitter triggers other external flash units to light your scene. Photos courtesy of Canon.

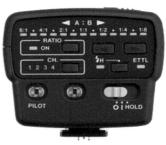

CONTINUOUS LIGHTS

Each light source has advantages and disadvantages. A continuous light source is on all the time; this makes it easy to see the light falling upon your subject. The disadvantage is that some continuous light sources can generate a lot of heat and can possibly make your subjects hot and uncomfortable. Different types of continuous light sources are available.

■ Photo floods. You can find photo floods at your local hardware store, and they are very inexpensive. They are similar to household lights in that they emit a golden color cast, and they are often used as construction or utility work lights. They produce a generous amount of light, but the bulbs have a fairly short life span and put out a lot of heat. Photo floods are not considered a professional studio light source, but I have used them for lighting up backyard party shoots and I have seen them used on many video productions.

When working with hot lights, it's necessary to exercise caution. Read the fine print, determine the allowable bulb wattage, and never clip something over a hot light that could burn. Instead bounce the light onto a white wall, or large whiteboard, and let it cast a softer light upon your subject. Experiment with the white balance settings on your camera for different bulb temperatures.

■ Household lights. Yes, those household lights you purchased at your local hardware store can help you illuminate your subject. You can use 200-watt bulbs with inexpensive metal clampons inside Chinese lanterns. A Chinese lantern produces a soft, even light similar to a softbox in a professional photo studio. This is a rather weak light source, so don't expect to light up an entire room, but when it's used creatively, it can be very effective.

- Tungsten lights. Tungsten lights are the affordable, professional studio light. They provide a broader range of light and cast a semigolden glow upon your subjects.
- Fluorescent lights. Fluorescent lights are common in offices and public buildings because they are efficient and inexpensive light sources. Unfortunately, most of them emit a sickening, flickering green color cast. Now professional fluorescent photo lights are very popular because they operate at cooler temperatures and are energy efficient and easy to use, but they can be expensive. You also can purchase inexpensive fluorescent light setups at the hardware store with bulbs that are color-corrected for daylight. Daylight bulbs don't have a golden or green color cast and can be a very inexpensive and creative light source for your portrait sessions.

Another factor that affects your image is the shape of the light you are using. The shape of the light source creates a reflection, or catch-light, in your subject's eyes. Fluorescent bulbs are long and thin, creating a unique light reflection. These lights have been used in many music videos and fashion photographs. The next time you flip through a magazine or watch a music video, look for the light reflections in the model or actor's eyes and see whether you can detect the shape of the light source.

BACKDROPS

You should always consider the background in your portrait photo. Sometimes the backdrop is the great outdoors or the interior of a home; this is considered an environmental portrait. A classic backdrop is seamless paper or muslin cloth draped behind subjects in a photo studio.

2

Seamless paper backdrops are sold in large rolls and are available in a variety of colors. You can purchase a professional backdrop setup with two stands and a pole that holds the role of paper, or you can fashion your own homemade backdrop by hanging a pipe or wooden pole from the ceiling. Fabric backdrops are also available from a photo supply store, and you can drape them almost anywhere that accepts clamps. Inside or outside, a solid colored backdrop can provide a clutter-free background so your subject is the focus.

idea •

Be creative with your backdrop choices — a textured wood fence, a

brightly colored wall, and a colorful fabric create different effects in your images. Visit a fabric store and purchase large remnants of fabric to experiment with. Leopard spots, velvet, fur, flowers — get creative!

CAMERA BAGS

After you start acquiring accessory equipment, you need a place to safely store and transport your camera and accessories. Camera bags come in all shapes, colors, and sizes, so look for one that handles your gear and fits your lifestyle (see 2-16 for an example). Make sure you have enough room for your necessary items: camera, lenses, filters, batteries, media cards, flash, and flash accessories, with some spare room for future purchases. When you visit your local camera store, bring your camera and a few lenses and try out the camera bags. Check to see whether the bag is comfortable on your shoulder and your equipment is easily accessible. When traveling, do not check your camera bag at the airport; keep it with you at all times.

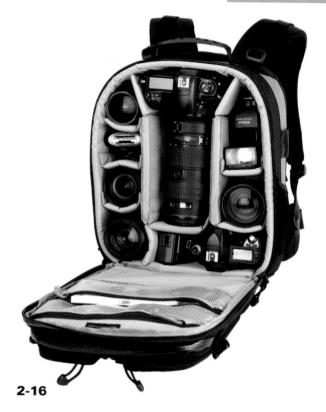

ABOUT THIS FIGURE A sturdy, comfortable camera bag is an essential for storing and transporting your camera and accessories. Photo courtesy of Lowepro.

MEDIA STORAGE AND VIEWING

There are a multitude of brands, sizes, and types of storage media in all price ranges and levels of convenience. What you choose should be the best for your needs, and those vary from photographer to photographer. The best way to know what to choose is to be informed. The following sections offer you a brief outline that should be helpful as your skills and needs change and grow.

MEMORY CARDS

Memory cards are considered camera media, which explains why some people call them memory cards and others call them media cards. Either way, these cards are where your images are stored when you use a digital camera (see 2-17). Various types of memory cards are available, and some are proprietary to certain digital cameras. Whatever type of card your camera uses, it's always a good idea to purchase a memory card with enough capacity to hold the number of photos you plan to take on your vacation, or at an event. Memory cards are available in megabyte (MB) and gigabyte (GB) capacities. A 2GB memory card can hold hundreds of images depending on the resolution setting on your camera. Memory cards are available today in capacities up to 16GB — that's a lot of images.

2-17

ABOUT THIS FIGURE An 8GB memory card. Photo courtesy of SanDisk.

Memory cards are small and very sensitive electronic devices that you should handle with care. Do not place them near strong magnetic sources, drop them, or mangle them — you could lose all of your images. Make sure you label your card with your name and contact information just in case you misplace it.

Memory cards all have a speed rating. Your digital camera processes your images and writes them onto your memory card at a certain speed. Your memory card should be able to keep up with your camera's processor. Manufacturers rate their cards at specific speeds, but also define the card's capability in general terms, making it easier to match your camera's speed with the memory card speed.

Before you begin taking pictures, it's a good idea to format your memory card. This action prepares and optimizes the card for use with your specific camera. Formatting is also the best way to clear the images off of your card after you transfer them to a hard drive or portable storage device, or burn them onto a CD/DVD. Formatting your memory card after you safely save your images elsewhere ensures that your card is clean, restructured, and ready to go. Check your camera's manual to find where the format option is located in your menu system.

PHOTO-VIEWERS

You've taken some wonderful images, a lot of images, and you're on vacation or on the road and don't have anywhere to transfer and unload them, view them, and back them up for safekeeping. You also want to clear out your memory card and capture more images. You could purchase another memory card, but perhaps you can't find a camera supply store. What do you do? Bring a photo-viewer that has 100GB of storage space with a viewing screen.

A photo-viewer allows you to download your images from most memory card types and back them up for safekeeping (see 2-18). After you've transferred your images to this traveling hard drive with a screen, you can easily share them with others on an LCD screen that is considerably larger than your camera's LCD viewfinder. You can also format your memory card, clearing it out to ensure a clean slate for capturing more photographs.

2

ABOUT THIS FIGURE Epson photo view with a 4" display screen. Photo viewer image courtesy of Epson.

ODDS 'N ENDS

Many accessories are designed to enhance your photographic adventure, giving you endless options for a safer, easier, more prepared, and more creative experience. Rest assured, you may never have another boring day in your life after you discover how many photo accessories exist to assist you in this venture.

DIOPTRIC ADJUSTMENT LENSES

To ensure that images and focusing points in your viewfinder are adjusted for your vision, you can adjust the diopter setting. The little diopter dial is typically located just to the right of the optical viewfinder on a dSLR. The built-in diopter setting handles minimal vision correction and is very handy for photographers who are burdened by eyeglasses. If you require stronger correction, an additional dioptric adjustment lens is available, and it fits right over the camera's existing optical viewfinder (see 2-19).

2-19

ABOUT THIS FIGURE A dioptric adjustment lens provides enhanced vision correction, increasing your ability to see through the optical viewfinder. Photo courtesy of Canon.

PHOTOGRAPHY VEST

These handy vests have a multitude of pockets, enabling you to become a walking camera bag. Sometimes shooting on location or on the go precludes you from setting down your camera bag every ten feet to retrieve a different lens, a battery, or a filter. When you wear one of these vests, your accessories are at your fingertips. Typically made of heavy khaki- or olive-colored cotton, they aren't the most fashionable addition to your wardrobe, but they're very practical (see 2-20).

If you have trouble finding a vest made specifically for photography, you could wear a fishing vest instead.

2-20

ABOUT THIS FIGURE A photography vest holds many photo accessories so they're ready at your fingertips. Photo courtesy of Tamrac.

UNDERWATER CAMERA HOUSING

If you've used the disposable underwater cameras and want more professional-looking images, try using an airtight camera housing made specifically for underwater photography (see 2-21). Housing accessories exist for most camera models, and depending on the model, they allow you to submerge underwater from 15 to 300 feet. They're great for vacation photos where you plan on spending a lot of time in, and under, the water.

ABOUT THIS FIGURE An airtight camera housing gives you underwater mobility. Photo courtesy of Canon.

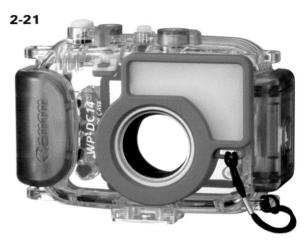

LCD VIEWFINDER CAPS

With digital photography, the ability to view images on the LCD viewfinder immediately after capturing them is a wonderful feature; however, problems can arise when bright, outdoor light makes it difficult to see your images on the LCD screen. LCD viewfinder caps come in various sizes for most camera models (see 2-22). They adhere or attach to the area around your LCD viewfinder to help shield the glare on your LCD screen, allowing you to see what you're capturing.

REMOTE SHUTTER RELEASE

When you photograph large groups, using a tripod and a *remote shutter release* in unison enables you to interact with the group and easily provide direction. This remote release connects to the camera and replicates the functions of the camera's shutter release (see 2-23).

ABOUT THIS FIGURE An LCD viewfinder cap shields the sun, allowing you to see

the screen in bright sunlight. Photo courtesy of Hoodman.

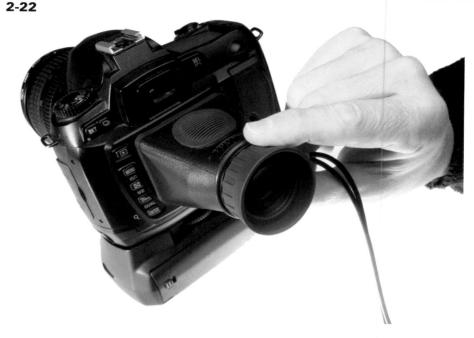

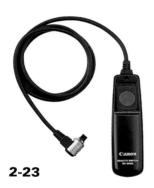

ABOUT THIS FIGURE A shutter release is handy for taking pictures of subjects that are difficult to approach or for minimizing vibration for close-ups and time exposure. Photo courtesy of Canon.

LENS CLOTHS, PENS, AND TISSUES

A microfiber lens cloth, lens pen, or lens tissue is an essential item in every photographer's bag. By always keeping your lens clean, you can save yourself hours in the post-production phase of image editing, and it helps preserve the life of your gear.

MULTI-TOOL KNIFE

Also known as a Swiss Army knife, this is your versatile tool kit for any emergency. The world of photography is full of surprises, and you never know which tool you might need for the unexpected. When traveling, don't pack it in your carry-on luggage, or it's going to be confiscated by airport security. Pack your multi-tool knife in your checked luggage.

POWDER

Most people have a slightly oily nose and forehead, and the flash of a photographic light can exaggerate this shine. You've probably looked through photo albums and noticed the sheen on people's foreheads; it's rarely attractive and can distract your eye when you view an image. That is why you should keep a bag with colorless, loose face powder and multiple powder brushes on hand when photographing people. Lightly powdering your shiny subjects before a photo shoot pays off. You may hear a few objections from Uncle Gus when he claims that he's never worn makeup before, but if you apply it lightly, the powder reduces the shine, and your pictures look fabulous. On the next family photo shoot, Uncle Gus may holler out "makeup!" and insist on powder for his close-up.

Assignment

Experiment with Backdrops

Use a fabric backdrop as a design element in your portrait. Choose a favorite patterned shirt or dress, bring it to the fabric store and find a fabric that echoes or contrasts the pattern in your out-fit. One or two yards of fabric should be enough for a portrait background. Don't be afraid to try something unusual, go with what feels right to you and experiment.

To complete this assignment I used one of my favorite black and white psychedelic-patterned shirts on my subject, Gianina, to complement the black and white polka dotted fabric I found at the fabric store. We played around with props and a fan to enhance the look. Taken at ISO 400, f/5.6, 1/100 sec. with a Canon EF 24-105mm f/4L IS lens.

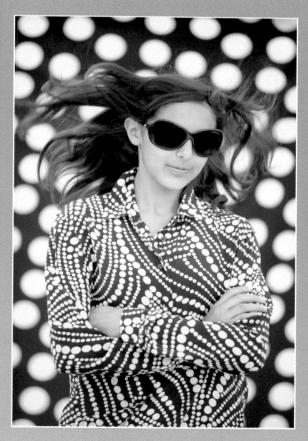

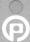

Remember to visit www.pwsbooks.com after you complete this assignment and share your favorite photo! It's a community of enthusiastic photographers and a great place to view what other readers have created. You can also post comments, read encouraging suggestions, and get feedback.

RECOGNIZE THE CHARACTERISTICS OF LIGHT CONTROL THE LIGHT METER FOR EXPOSURE

When I initially learned to recognize the different qualities of light, it was equivalent to learning a new language. This new spark of understanding inspired me to develop my creative eye and explore the world of photography in a more confident manner. My goal is to assist you in identifying the characteristics of light so you understand this language and can use it to improve your photographs. Light can speak to you and influence every image you create, if you know how to identify the basics.

RECOGNIZETHE CHARACTERISTICS OF LIGHT

Great images are a synthesis of content, composition, technical ability, and timing, but these components are secondary to the presence of light. The quality, direction, intensity, and color of light all have an effect on your image.

QUALITY

Millions of years of evolution have conditioned the human eye to judge all light in terms of natural sunlight. The sun's position in the sky and various atmospheric conditions alter the quality of light visible in our natural world. To develop your awareness of light, look at the world around you at different times of the day and observe how the light falls upon a tree in your backyard, or a building in your neighborhood. Think of the soft, warm light of sunrise; the harsh overhead light of midday; or the warm, golden light of late afternoon and sunset, as shown in figure 3-1.

Learn to read where the light is coming from by looking at shadows. Longer shadows occur when the sun is lower in the sky, during sunrise and sunset; short shadows occur when the sun is high in the sky. Notice if the shadows are hard-edged or soft-edged. A general rule for beautiful images is to plan your photo shoot for early morning or late afternoon light because softer shadows equate to less contrast in your scene and more flattering light for your subject.

ABOUT THIS PHOTO Late afternoon light on a winter day in California creates a magical glow in the sky and a reflection on the sand that captures my surfer subject in silhouette. Taken at ISO 200, f/5.6, 1/200 sec. with a Canon EF 17-35mm f/2.8 lens.

3

DIRECTION

The angle of light falling upon your subject is an important concern in portrait photography. Whether natural or artificially created in a studio, the direction of light dictates the outcome of your image. The four angles of light discussed in the following paragraphs — sidelight, front light, backlight, and top light — are the basic light directions that you need to understand.

■ **Sidelight.** Accentuates facial features and emphasizes texture, creating dimension to the face.

In 3-2, an early morning scene outdoors shows long shadows accentuating my subject's facial characteristics and adding dimension to the rock formations in the background.

In 3-3, I used a backdrop and homemade studio lights to create an example of sidelight, illustrating the way early morning or late afternoon sunlight might fall upon your subject's face. Figure 3-4 illustrates how I achieved this result by positioning a lantern next to my subject to create the sidelight.

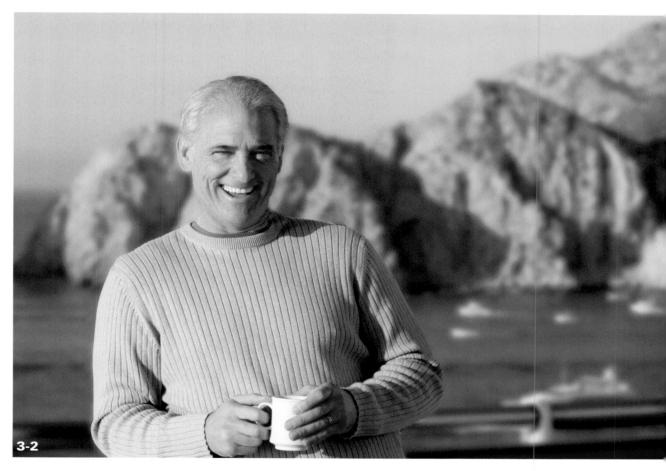

ABOUT THIS PHOTO The texture of Bryan's face and sweater are enhanced by directional, early morning light. Taken at ISO 100, f/6.7, 1/1350 sec. with a Canon EF 17-35mm f/2.8 lens.

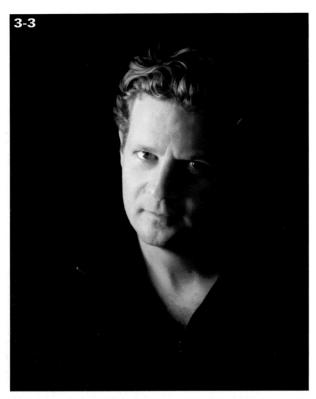

ABOUT THIS PHOTO Using a Chinese lantern and a 200-watt household bulb, I placed Michael in front of a black backdrop and positioned the lantern off-camera and to the side of his face. Taken at ISO 800, f/4.0, 1/100 sec. with a Canon EF 24-105mm f/4L IS lens.

ABOUT THIS PHOTO This is the simple setup I used to illuminate the side of Michael's face. Taken at ISO 800, f/4.0, 1/100 sec. with a Canon EF 24-105mm f/4L IS lens.

Review Chapter 2 for more information about the lighting accessories used in this chapter.

■ Front light. Illuminates the entire face and occurs when your subject is facing the light. The hard light of a camera flash creates an image lacking in the gradual tones that help add dimension. In 3-5, the soft front light of my Chinese lantern illuminates all of Michael's face, yet allows for some tonal subtleties as the light falls away.

Another example of front light is soft, early morning or early evening light when the sun is very low in the sky. Soft light enables your subjects to face the light without squinting, and allows for some gradation in tone, as shown in 3-6.

■ Backlight. Happens when your subject faces away from the light. This can be the trickiest lighting to expose for, but depending on the desired effect, you can master it by metering correctly or by reflecting light into the shadows. In 3-7 and 3-8, you see extreme examples of backlit subjects, with very little front light, creating silhouettes.

When using backlight without a flash or a reflector, make sure your camera is metering the exposure from the subject's face and not from the light source.

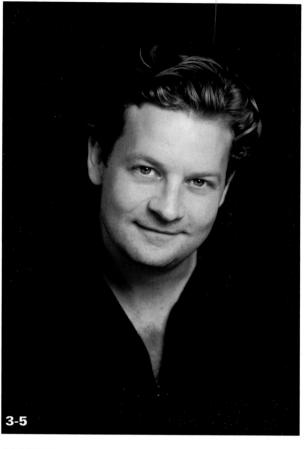

ABOUT THIS PHOTO A soft, front light allows for a subtle dimensional quality to Michael's face. Taken at ISO 800, f/4.0, 1/100 sec. with a Canon EF 24-105mm f/4L IS lens.

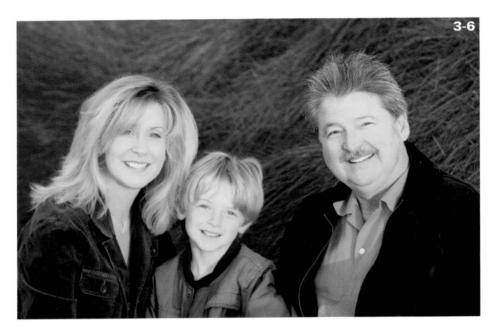

ABOUT THIS PHOTO Captured in a casual pose as they faced the light, my subjects were enveloped in the golden glow from the soft rays of the setting sun. The most attractive natural front light occurs at sunrise and sunset. Taken at ISO 400, f/2.8, 1/180 sec. with a Canon EF 70-200mm f/2.8 lens.

ABOUT THIS PHOTO Exposing for the last glimpse of Tahitian sun behind the clouds in the background enabled me to render my two subjects as silhouettes in the foreground. Taken at ISO 400, f/4, 1/160 sec. with a Canon PowerShot SD 300.

3

ABOUT THIS PHOTO Metering for the backlight created a silhouette against the setting sun. Taken at ISO 400, f/9.0, 1/200 sec. with a Canon EF 24-105mm f/4L IS lens.

In 3-9, I used a flash to illuminate my subject yet still captured the sunset in the background, as shown in figure 3-8.

In 3-10, I incorporated a glowing yellow background with a well-exposed face and body in the foreground by using the camera's *spot metering* feature.

ABOUT THIS PHOTO Michael's jump is captured and illuminated in midair with an on-camera flash. The backlit scene still registers in the background. Taken at ISO 400, f/8.0,1/200 sec. with a Canon EF 24-105mm f/4L IS lens and Canon 580EX Speedlite flash.

■ Top light. Harsh overhead sunlight or studio light creates deep shadows under eyes and chins. Unless you fill in the shadows with a flash or a reflector, this is a very unattractive lighting scenario, as shown in 3-11.

There are 360 degrees of possibilities. If the light isn't working for you, change your position, your subject's position, or, if possible, the light source.

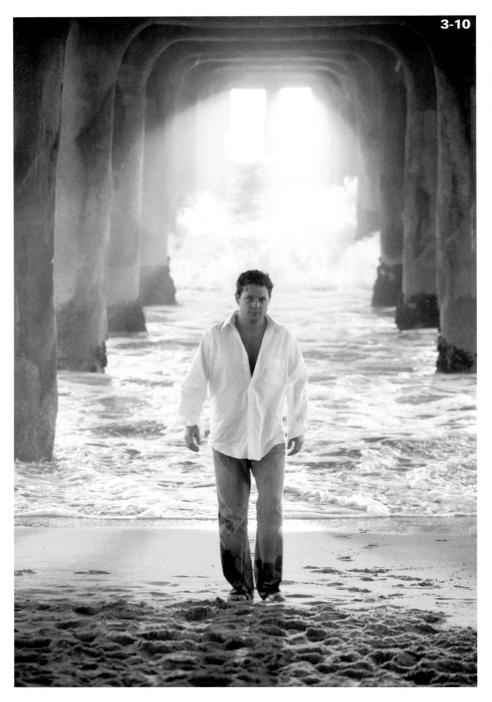

ABOUT THIS PHOTO Backlight gives Michael a golden rim light to his hair and creates a dynamic image. I exposed for his face and let the background highlights over expose. Taken at ISO 400, f/4.0, 1/160 sec. with a Canon EF 70-200mm f/2.8 lens.

Substea S

ABOUT THIS PHOTO Direct overhead lighting is similar to sunlight at high noon — usually not attractive! Taken at ISO 800, f/4.0, 1/100 sec. with a Canon EF 24-105mm f/4L IS lens.

INTENSITY

A light's intensity, or brightness, determines your camera's ability to interpret the light and make an exposure. This intensity affects your camera's capacity to capture action and depth of field (DOF). Less intense light may create motion blur and a shallow DOF. More intense light helps you capture action and a deeper DOF. The size of your light source and your subject's distance from the light also affects the intensity of the light. For example, if your subject is positioned very close to a bright light, your camera settings would be different from a scene where your subject is positioned far away from the light source. The correct exposure depends on your lighting conditions,

your artistic interpretation of the scene, and the camera settings you use to achieve your desired results.

COLOR

If your home has incandescent/tungsten lights, the photos you take inside your home have a golden cast; the images taken at an office using fluorescent lighting have a greenish cast; and the pictures taken outside in the shade look a bit blue. There are many different types of light, and each light source has its own color temperature. This translates to a colorcast in your final image. Your eyes automatically adjust to various light sources and compensate for the colorcast; this allows you to see white as white in most situations. Unfortunately, camera sensors are not as advanced as the human visual system.

On digital cameras, color temperature is measured in kelvin, which is translated to white balance in your camera settings. The automatic white balance (AWB) function performs the color compensation, but this default setting doesn't always make the best guess regarding your particular conditions. You need to take control. Digital camera settings vary from manufacturer to manufacturer, so consult the user's manual and find your camera's white balance setting. Scroll to the white balance options — daylight, cloudy, incandescent/tungsten, and so on — and pick the one that matches your specific light condition.

Color temperature is measured in kelvin. The Kelvin scale describes

the intensity of lower temperature light as warmer or redder in appearance, midrange temperatures as neutral, and the higher readings as cooler or bluer. Temperatures range from 1,000K to 10,000K.

CONTROLTHE LIGHT

A light source can initiate from many sources and directions with varying degrees of intensity. The possibilities continue because you're able to control the light by reflecting and diffusing natural and artificial light.

REFLECTING LIGHT

Any type of light can be reflected to produce more light. Light is being reflected around us every day. Mirrors, glass, white walls, and even white tablecloths reflect light. You can buy professional reflectors of gold, silver, and white from camera stores, but you can also use common household items to reflect light back onto your subject. A white foam-core board from an art store and a car dashboard reflector are both handy, ready-made reflectors.

To reflect light, find your light source and bounce the light from your main light source with a reflector back onto your subject; this fills in shadows and livens up the catch-light in their eyes. In 3-12, I am using a handheld reflector to bounce additional light into my subject's face.

Figure 3-13 is an example of what the shadows can look like on your subject's face when you do not use a reflector.

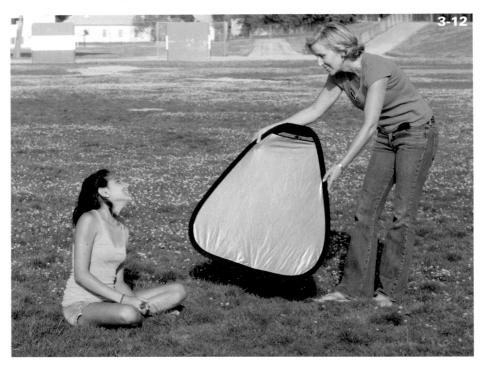

ABOUT THIS PHOTO Reflecting the sunlight back into Gianina's face with a gold reflector fills in the shadows. Taken at ISO 250, f/5.6,1/1000 sec. with a Canon EF 24-105mm

f/4L IS lens.

ABOUT THIS PHOTO The shadows on Gianina's face are hard and need to be filled in. Taken at ISO 250, f/5.0,1/640 sec. with a Canon EF 70-200mm f/2.8 lens.

Figure 3-14 shows the result of using a gold reflector to bounce light into the shadows on Gianina's face.

ABOUT THIS PHOTO Golden light reflected into the dark shadows creates a beautiful, even light across Gianina's face. Taken at ISO 250, f/5.0,1/640 sec. with a Canon EF 70-200mm f/2.8 lens.

DIFFUSING LIGHT

You can soften harsh light by placing sheer white fabric, paper, or a professional diffuser between your subject and the harsh light source. In 3-15, my subject holds a white, translucent umbrella between himself and the sun to soften the bright afternoon light.

ABOUT THIS PHOTO A translucent white umbrella, placed between the light source (the sun) and Michael, softens the directional afternoon light and evens out his skin tone. Taken at ISO 200, f/4.0, 1/200 sec. with a Canon EF 24-105mm f/4L IS lens.

In 3-16, my assistant is holding a sheer, white diffuser between the sunlight and my subject, Matthew, to soften the harsh afternoon light.

Figure 3-17 illustrates what harsh light looks like on Matthew's face without a diffuser to soften the light.

Figure 3-18 shows the result of using a diffuser to soften the harsh light falling upon my subject's face.

ABOUT THIS PHOTO A diffusion disk placed between the light source and Matthew softens the directional afternoon light and evens out his skin tone. Taken at ISO 250, f/4.0, 1/320 sec. with a Canon EF 24-105mm f/4L IS lens.

USING A FLASH

The on-camera flash can be an instant source of light in a pinch, filling in shadows on bright days and illuminating low-light scenes at evening events and occasions. Learn how to cycle through all the flash options on your camera, and take advantage of these creative benefits; force your flash to fire in bright light to fill in shadows; use red-eye reduction to reduce the amount of red-eye in your low-light pictures; and use the night-flash setting for low-light situations where

3

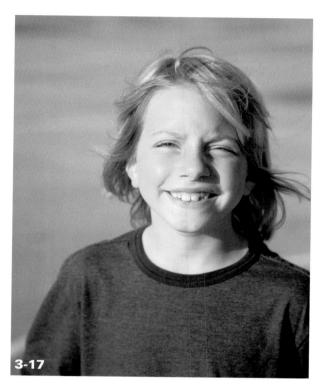

ABOUT THIS PHOTO Harsh afternoon sunlight creates shadows across Matthew's face. Taken at ISO 250, f/4.0, 1/800 sec. with a Canon EF 24-105mm f/4L IS lens.

ambient light is present. Night flash automatically sets your camera to use a slower shutter speed to record ambient light, while still illuminating your subject with a flash. Be sure to hold your camera steady or use a tripod with this setting as the slower shutter speed may record your camera shake as motion blur.

An accessory flash enables you to point the flash head in a variety of directions. Directing the flash head towards a neutral or white ceiling bounces the flash and produces a large, diffused light source upon your subjects.

ABOUT THIS PHOTO Using a diffuser to soften the light results in a beautiful, even lighting across Matthew's face. Taken at ISO 250, f/4.0, 1/320 sec. with a Canon EF 24-105mm f/4L IS lens.

METER FOR EXPOSURE

Our eyes can see a greater dynamic range of light than our cameras are capable of recording. If your scene is high contrast, with dark shadows and bright highlights, your camera has difficulty capturing all the detail. You have probably experienced the result of this camera limitation if you've taken a photograph of someone positioned in front of a bright background. Although your eyes can see the detail in your subject's face, in the image, your subject is in the dark.

In addition, by positioning your subject in front of a bright background, the sharp contrast between the lights and darks in your image can confuse a camera's internal reflective light meter. When you press the shutter button, the reflective light meter analyzes the light in your scene, selects an aperture and shutter speed combination, and produces an exposure. Understanding how your camera's metering system works is necessary to control the light entering your camera. You do have options. Take out your camera manual and find the section on metering. Locate your metering mode button and learn about these three ways to control your image:

- Evaluative metering. Depending on your camera, this mode may be called Pattern or Matrix. This is a good default mode because it divides the image into sections, analyzes the light, and calculates for the optimal exposure. The downside is this setting can be fooled by heavily backlit scenes.
- Center-weighted metering. This is the original metering mode used in cameras for years. It meters (reads) the light in the entire frame but gives greater emphasis to the center area of the frame. A work-around for quickly reading the light in a specific area in your scene is to center the frame over the area in the scene you want the meter to read (ensure sharp focus by metering on a focal plane near your subject), press the shutter button halfway down, then recompose your shot.

■ Spot, or partial, metering. The spot meter measures the light in a very small area of the scene. The spot is centered in the frame and the size varies, but it's typically about 2 to 10 percent of the entire image. A situation where it's good to use a spot meter is when your subject is backlit. Read the light from your subject's face by pressing the shutter halfway down, then recompose your shot and fully depress the shutter button.

On a digital camera, the internal reflective light meter measures the luminance of your scene. The reflected light is averaged into medium-tone 18 percent gray. This is great for rendering good exposures of medium-toned scenes, but may cause problems when you're photographing white or black surfaces. Using exposure compensation is recommended in those instances.

Exposure compensation is a feature that enables you to quickly let more or less light into the camera without manually adjusting your shutter speed and aperture. You can access it by pressing a button located on the back or top of your camera. Consult your camera user guide to locate the exposure compensation button on your camera. Photographers often use it to override the camera's reflective light meter when shooting a bright, white scene or black surfaces.

Learning how to recognize the different types of light is an integral part of creating beautiful images. By studying these basics and applying the principles individually or simultaneously in your shots, you can develop your own unique photographic sensibility.

Assignment

Use Backlight in a Portrait

Use backlight to create an interesting effect upon your subject. Experiment with your camera's light meter to capture the most attractive exposure. Post your favorite image on pwsbooks.com and explain why this image appeals to you.

The backlight in this image creates a beautiful rim light around the outline of my subject, separating him from the background. The late afternoon light is still bright but not harsh. I like the moment this image captured — it's a timeless stance and his expression is accentuated by the light.

This photo was taken at ISO 100, f/3.5, 1/250 sec. with a Canon EF 70-200mm f/2.8 lens.

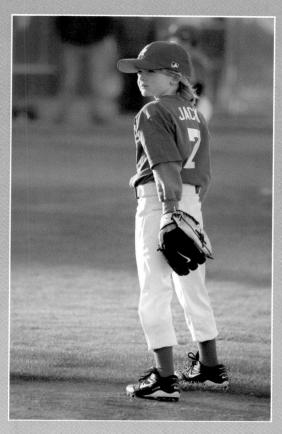

LEARN THE BASICS OF COMPOSITION
CHANGE YOUR PERSPECTIVE
SHIFT YOUR POINT OF VIEW
USE SELECTIVE FOCUS

Have you ever wondered why some pictures are more interesting or "better" than others? What is the mysterious formula? Must you attend art school to understand? Although there is no guaranteed formula, you can shoot better pictures by understanding some basic principles, whether or not you have an intuitive eye for design. Let me explain my understanding of intuition. To some extent your ability to intuit and perceive are governed by sensory and intellectual wiring; however, as you develop your understanding and learn about photography, what you learn over time becomes a part of you and your intuitive response. Once you learn to see the design elements all around you, your ability to read an image and create your own compelling photograph greatly improves.

LEARNTHE BASICS OF COMPOSITION

The rules of composition are proven design principles you can use to create compelling images. After you learn these guidelines, your world opens up, giving you infinite creative opportunities because you know the basics. Having honed your intuitive eye, you can then take risks, break the rules, and create your own unique style. Your sense of design principles also assists you in critiquing your images, allowing you to evolve and become a better photographer.

SIMPLICITY

"Simplicity is the ultimate sophistication." Leonardo DaVinci was right. Less is more. In other words, edit everything out of your image that does not contribute to the story you want to convey. Pay attention to your background when

you compose your shot. Is there a plant coming out of anyone's head? Are toys scattered about? Is there an unknown or unwanted lurker in the scene? An image with elements and objects that compete with your subject is one that is busy and confusing. Your viewer's eyes may dart around the photograph and never rest, and possibly may not even focus on the subject at all.

DaVinci created his works of art with a blank canvas and painted only what he wanted us to see. You, as the photographer, have to create your image amidst the clutter of reality and selectively omit anything that is not important. However, you do have control over the composition of the shot and how you choose to portray your subject: By using creative framing, you can exclude elements you don't want in the picture. Don't dilute the focus of your image with a busy background. Take the time to move unwanted objects, reposition the camera and stand back from your subject, or use your camera's lens to zoom in and exclude any distracting elements.

In figure 4-1, I positioned my subject on an uncluttered, evenly lit stairway to give her the attention she deserved in the photograph. The stairway provided a repetitive pattern with a receding diagonal line that draws your eye through the image. The overhead skylight provided soft, even lighting and the white walls reflected the soft light onto my subject. I used a gold reflector positioned near my subject's feet, and just out of frame, to fill in any shadows on her face.

RULE OF THIRDS

Placing your subject right in the middle of an image is great for the perfunctory passport and driver's license photo, but unless other interesting compositional elements are present, it's not an

ABOUT THIS PHOTO The light was perfect in this stairwell. Taken at ISO 200, f/11.0, 1/125 sec. with a Canon EF 70-200mm f/2.8 lens.

ABOUT THIS PHOTO Maria is interesting and full of spirit, but this picture is boring and has no visual message or impact. Taken at ISO 400, f/4.0, 1/100 sec. with a Canon EF 24-105mm f/4L IS lens.

exciting image. When composing your image, use the Rule of Thirds and think of the scene in your viewfinder or on your LCD display as a tic-tac-toe board and mentally divide the image into thirds. Try not to place people or things right in the middle of the frame, but instead place something of interest at one or more of the tic-tac-toe intersections. In figure 4-2, I positioned my friend, Maria, slightly off-center and shot the image in the vertical format from a distance. It's not a very interesting image because it doesn't convey any particular message. Her casual pants and shoes don't work in

combination with the sophisticated scarf, and there is no reason for the shelf on the wall near her knees. I decided to simplify the image by changing my camera position to horizontal, zooming in to exclude the distracting elements, and directing her to lift her arm across the frame. The result in figure 4-3 is a more compelling image. Her eyes are located near one intersection in the frame, and her hand is near another intersection. This placement of important elements in the scene, her eyes and her hand, creates an asymmetrical balance in the image.

One of the reasons many people place their subjects in the middle of the image is because the focusing point on many cameras is located right in the middle of the frame, but a well-composed image may require that you place your subject offcenter. How are you going to produce a sharp, focused image of your subject if she is off-center? Newer digital cameras now have multi-focusing points that give you more control over how you focus the image, so you don't have to center your subject in order to focus your shot. And whether your camera is capable of multi-focusing or not,

you can compose your subject off-center by prefocusing with your shutter button. Here is how it works: Focus on your subject, press the shutter button halfway down to set the exposure and focus, keep holding the shutter button halfway down, and recompose your shot.

With a few adjustments to composition and orientation, figure 4-3 has more impact and conveys a feeling of simplicity and sophistication. You would never know that she is wearing tennis shoes and casual pants.

ABOUT THIS PHOTO This image was shot in midday sun in the open shade of a building and didn't use reflectors or lights. Taken at ISO 400, f/4.0, 1/100 sec. with a Canon EF 24-105mm f/4L IS lens.

СНАРТЕВ

LINE

Lines are in everything we see. The straight vertical line of a building, the curved line of a winding road, the horizontal line of the horizon, the diagonal line of a runner leaning forward, these are all examples of physical lines. There are also implied lines that you create in your mind's eye, similar to connecting the dots in a children's coloring book. Used in the composition of an image, these lines instill a sense of unity and guide the viewer's eye through the photograph. You can control the composition and the resulting level of

interest in your photographs by understanding how to work with these lines.

Horizontal lines imply rest and peacefulness; vertical lines give a sense of stability and strength; and diagonal lines are dynamic, implying movement and action. A *leading line* draws your eye into and through an image. This line can begin on any edge of an image, but in Western culture, it typically begins on the lower left and ends somewhere near the right edge or top of the frame.

In figure 4-4, the diagonal line created by the baseball player in action conveys a dynamic feel.

ABOUT THIS PHOTO I used the Rule of Thirds in composing the shot and left space for Shota to run within the frame. Taken at ISO 400, f/6.3, 1/1000 sec. with a Canon EF 70-200mm f/2.8 lens.

Note the different shapes present in the image: the squares, rectangles, and circles. When photographing a subject in action, it helps to leave space ahead of the subject to visually allow for the anticipated movement.

There are many lines in figure 4-5, but the dominant one is the diagonal line of the batter's shadow leading your eye through the frame.

Converging lines, often created by diagonal lines receding into the background in an image,

capture the viewer's attention. Together, receding and converging lines create depth and a three-dimensional illusion to a two-dimensional space. In 4-6, I positioned the band members at various distances from the camera inside an elevator and used a wide-angle lens to accentuate the distance between them. I used the leading lines of the elevator interior to create a leading line that draws your eye through to the back of the image.

4

ABOUT THIS PHOTO A musician and his new band needed publicity photos. This was shot in late afternoon light using a reflector to brighten their faces inside the elevator. Taken at ISO 400, f/5.6, 1/125 sec. with a Canon EF 17-35mm f/2.8 lens.

FRAMING

A framing element in your scene draws attention to your main subject. A well-known framing element is a picture frame, like the one my friend, Maria, is playing with in figure 4-7. Although it's a literal way to illustrate the point, it does help you remember that a frame focuses attention to your subject by showing your eye where to look. After you become aware of their benefit, whether they are organic or constructed, you can find framing elements everywhere — doorways, archways, windows, overhanging tree branches. You can use any open shape that surrounds your subject on two sides or more in the foreground of your scene. Choose an interesting frame, such as an arched trellis covered in flowers or a unique

doorway, that adds to the story conveyed in your image. If your subject and frame lack visual interest due to a similarity in brightness, try using a frame darker than your main subject. Position your subject in a brighter light than your framing element, and be sure to meter your exposure for the bright light. This enables you to darken the frame around your subject and creates greater visual impact.

note

Your camera's reflective light meter analyzes the light in the scene and

determines the proper exposure prior to taking the picture. You can accomplish metering for exposure by pressing your shutter button halfway down to read the light from the desired area in the scene.

ABOUT THESE PHOTOS A solid black picture frame helps illustrate my point about framing elements, and these photographs turned out to be fun. Taken at ISO 400, f/6.3,1/250 sec. with a Canon EF 24-105mm f/4L IS lens.

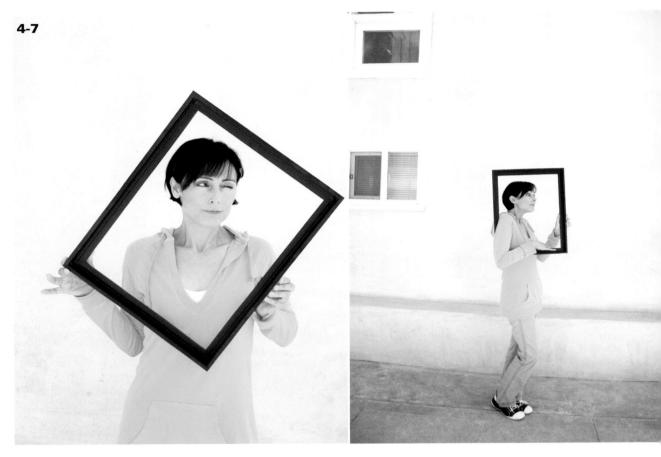

As Maria and I walked around my neighborhood looking for framing elements, I came across a tree with overhanging branches. The first shot, shown in 4-8, has a framing element, but there is too much going on in the background with the houses behind her and the garage creeping into the frame on the right. As a result, your eye cannot rest on Maria. I moved to my left and

shot the picture from a different angle (see 4-9). This viewpoint allows the tree to frame her and I have eliminated the busy background. Remember this solution when you include a framing element in your scene. Use your sense of simplicity and don't let other objects in your scene overwhelm your subject.

In addition to including the trellis in the scene to frame my mom, 4-10 also created an unusual perspective by tilting the scene at an angle and introducing an unexpected color tone with the camera's white balance setting.

In 4-11 I composed the scene from an interesting angle, used bold primary colors, and included the jungle gym bars in the scene to frame Dylan's face.

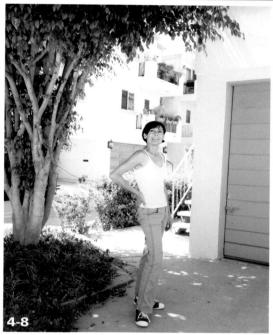

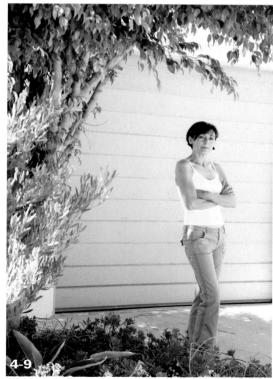

ABOUT THIS PHOTO My mom is resting against a large, angular trellis that forms a nice frame around her. Taken at ISO 200, f/8.0,1/200 sec. with a Canon EF 70-200mm

f/2.8 lens.

ABOUT THIS PHOTO This playground structure is a practical element that I used to frame my subject in the image. Taken at ISO 200, f/11, 1/180 sec. with a Canon EF 17-35mm f/2.8 lens.

COMPLEMENTARY COLOR

Artists and designers use color wheels to study the relationships between colors and how they might affect a painting or the interior colors in a room (see 4-12). The rest of the population makes color decisions every day, from choosing cell phones to automobiles, and carpeting to wardrobes and home appliances. Many of these decisions are based on a favorite color or an intuitive sense of what looks best. However, the study of color is a science and can be very involved and complex. For these purposes, I depart from the

complexities of color theory, and I explain how color can impact a photograph, as well as what you should be aware of when you choose colors for your portrait images.

Color appeals to the emotions and creates feeling and response. Warm colors evoke warmth and happiness, while cooler blues and greens are associated with peaceful retreat. Certain color combinations can create punch and impact in your images or evoke a soft, quiet sensibility. Knowing the effect of these color relationships helps you plan the desired result in your images.

ABOUT THIS PHOTO A color wheel is a chart that illustrates color relationships. Harmonious colors are located near each other on the wheel; complementary colors are located opposite each other.

Complementary colors lie opposite each other on a color wheel. These opposite colors are complementary because when they appear together, their intensity increases. For example, red and green, blue and orange, and violet and yellow complement each other. Use these colors in combination when you want to create images with strong visual impact.

Harmonizing colors are next to each other on the color wheel. For example, green and blue, yellow and orange, and red and violet harmonize nicely. Use these colors to convey a sense of peace and balance.

Because color is a product of light, the quality of light in your scene is going to affect the intensity of every color. A green tree looks very different in bright midday sun than it does in the late afternoon or on a foggy day. Consider how the atmospheric conditions are going to affect your color choices if you are shooting images outside.

To emphasize your subject's eyes in an image, try experimenting with clothing and backgrounds that match or complement the subject's eye color. In figure 4-13 I placed Maria in front of a gray wall, draped in a gray scarf. This *monochromatic* combination of her wardrobe and the background complemented her peach skin tone, brown hair, and brown eyes. The result is an image with subtle color impact that focuses your attention on her eyes.

Use a color wheel and play with the basic color combinations, then experiment: Shake it up and try something new. Sometimes a happy accident turns out to be a winning image.

PATTERN AND REPETITION

Small or large, patterns exist wherever lines, shapes, colors, or textures repeat themselves. The simple repeating pattern of stair steps, scalloped house shingles, or multiple trees aligned in a row are all repeating patterns, and when they're used in an image, they can convey rhythm and texture. In portrait photography, pattern is often used as a background element to enhance the

4

ABOUT THIS PHOTO The gray wall and scarf complement Maria's peach-colored skin and brown hair and eyes. Taken at ISO 400, f/6.3, 1/320 sec. with a Canon EF 24-105mm f/4L IS lens.

scene. You can find interesting patterns everywhere you look. In our continued walk around the neighborhood, Maria and I discovered a patterned backdrop in an unlikely place (see 4-14). It wasn't the most elegant location, but looking at 4-15, you would never guess that the background was the door to a trash bin. You can find beauty in unusual places.

Depth of field (DOF) refers to the zone of sharpness in your image.

Your DOF is deep if most of your scene is in focus; it is shallow if a small area is in focus. Chapter 1 explains DOF in greater detail.

ABOUT THIS PHOTO Who expected that a back-alley trash bin would be the perfect location for a patterned background? Taken at ISO 400, f/6.3, 1250 sec. with a Canon EF 24-105mm f/4L IS lens.

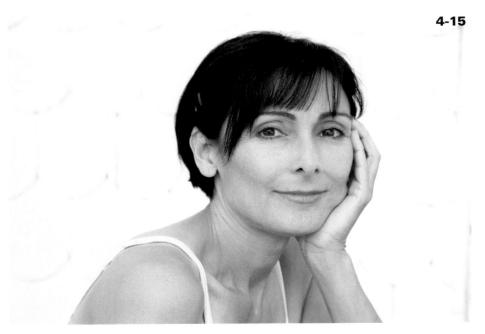

ABOUT THIS PHOTO Using the Rule of Thirds, I placed Maria slightly off-center in front of a patterned backdrop. Shot in midday open shade, the reflection of indirect light from the surrounding buildings created a nice catch-light in her eyes. Taken at ISO 400, f/6.3, 1250 sec. with a Canon EF 24-105mm f/4L IS lens.

СНАРТЕВ

CHANGEYOUR PERSPECTIVE

You can control the perspective in your scene by changing your position to the subject and changing your lens focal length. The lenses listed provide various perspectives:

- A wide-angle lens perspective (17-28mm) enables you to get very close to your subject and include more in the photograph at the expense of distorting your subject and rendering a deeper DOF. This perspective is great for environmental portraits such as a mother reading to a child under a large tree, but unless you intend to capture the big-nose effect, it's not a flattering choice for up-close portraits.
- A telephoto lens perspective (60-1000mm) magnifies your image and narrows your field of view. Images taken with a telephoto lens have a flattened perspective and a shallow DOF. This focal length is ideal for portraits because you can isolate your subject from the background, and the flattened perspective is very flattering. A disadvantage to using a

telephoto lens is the distance required between the photographer and subject when taking the photo. Depending on your focal length, this distance could make it difficult to interact with your subject.

- A standard 50mm lens approximates what your eyes see and does not create the exaggerated effects obtained with wide-angle or telephoto lenses.
- A standard zoom lens of 28-70mm allows you to capture a wide-angle perspective and zoom out to the longer 70mm focal length.

I used a zoom lens with a focal length of 24-105mm in figures 4-16 and 4-17. In figure 4-16, I moved in close and captured Victoria with a wide-angle perspective of 24mm. Victoria is beautiful, but this wide-angle lens perspective distorts her face and is not the most flattering image. Compare her face to figure 4-17, where I zoomed out and used the telephoto perspective on the same lens at 105mm, which created a more flattering image.

ABOUT THESE PHOTOS In 4-16 the wide-angle lens also captures a deeper DOF and does not isolate Victoria from the background. In 4-17, I stepped back and zoomed in with a longer lens perspective, Victoria's face is back to normal and she looks like her beautiful self. The background is blurred, which helps isolate her from the distractions. Both taken at ISO 400, f/6.3, 1250 sec. with a Canon EF 24-105mm f/4L IS lens.

Now that you know how to change your perspective, experiment with different focal lengths and lenses to create your own masterpiece.

SHIFTYOUR POINT OF VIEW

Are most of your images taken from the same distance and same angle? If so, this may explain why some people are falling asleep during your slide shows. While lenses create different perspectives, for example, a wide-angle perspective or a telephoto perspective, photographers need to understand the importance of their own points of view. Shifting your point of view includes moving closer or farther away and changing your angle in relation to your subject. The human eye needs variety to maintain an interest in an image or collection of images.

Think about how movies and television shows are edited together to tell a story and create visual interest. There is a full shot of an area, then a mid-range shot of the scene, and then a detailed close-up, all taken from different angles and varying distances. This dynamic creates visual interest and sends the message, "This is a story, pay attention."

Consider this array of possible viewpoints when you photograph your next subject. Elevate yourself on a ladder or stair and shoot down on your subject. In 4-18, I captured my subject rolling around in the grass on a spring day. In 4-19, I captured my cousin in her prom dress from a flattering and interesting angle.

Vary the distance. Get up close and capture details about your subject. Perhaps your subject has weathered hands or shocking green eyes, and this feature adds to a story about the person. Shoot from down below to make your subject seem taller and more important. I do this in the

ABOUT THIS PHOTO The line created by my subject rolling around in the grass is an S-shape and helps draw your eye through the image. The angle captures a natural gesture and expression. Taken at ISO 200, f/5.6, 1/200 sec. with a Canon EF 24-105mm f/4L IS lens.

4

ABOUT THIS PHOTO By elevating myself above my cousin, I was able to capture her in a flattering and unique, spontaneous pose. Taken at ISO 200, f/8, 1/180 sec. with a Canon EF 17-35mm f/2.8 lens.

image in 4-20, and my subject exudes a feeling of importance. To capture a person looking out the window into the unknown, shoot from behind or from the side of your subject. Take pictures in vertical and horizontal formats to further vary your viewpoint.

Even professional photographers can fall into a visual rut and automatically compose their images a certain way. If your first reaction is to take a picture with a specific composition, go ahead. Next, try to find at least two other compositions for the scene.

ABOUT THIS PHOTO I positioned my camera on the floor and took the picture looking up at my subject. I was careful to meter for my subject and not the bright light behind her. Taken at ISO 200, f/11, 1/180 sec. with a Canon EF 17-35mm f/2.8 lens.

USE SELECTIVE FOCUS

One way to direct your viewer's eye in a photograph is to use shallow depth of field and selectively focus on the important part of your scene. Our eyes are drawn to the sharpest contrast and focus in an image. Rendering my subject out of focus with shallow DOF enables me to direct your eye to the orange he is holding close to camera in figure 4-21. This is a contemporary way to break the rules and experiment with your images. Depending on your creative intentions, your subject does not have to

be in focus. Out-of-focus images convey a sense of memory, dreams, and emotion.

With the immediate feedback on your digital camera's LCD viewfinder and the low-cost nature of digital exposure, you now have the convenience and safety to experiment with new ideas. Study the Rule of Thirds, concentrate on framing your subjects, vary your lens perspective, explore multiple points of view, and consider using complementary colors. Don't be afraid to shake it up and try new things, and to take a lot of pictures! And remember the words of Leonardo DaVinci: "Simplicity is the ultimate sophistication."

ABOUT THIS PHOTO In addition to using shallow depth of field to focus on the orange, I used complementary colors, blue and orange, to make the orange pop out in contrast to the blue. Taken at ISO 200, f/4.0, 1/100 sec. with a Canon EF 24-105mm f/4L IS lens.

Assignment

Using the Rules

Take a series of portrait photographs incorporating one or more rules of composition in your images. Choose the most eye-catching image, post it online at www.pwsbooks.com, and tell me what interests you most about the photograph.

The photo I took to complete this assignment is a good example of breaking some rules and following a few others. My subject is not facing me, and having him right in the middle of frame is breaking the Rule of Thirds. Using leading lines, shapes, and symmetry to draw the viewer's eye through the image is following the rules. I positioned my camera in back of my subject and under the middle of the pier to capture the symmetry and repetition of the pier pylons. This angle creates depth, and the contrast of a rounded shape within the square shape of the pier adds interest to the composition. I like the bold and abstract elements in this image. Taken at ISO 100, f/9.0, 1/125 sec. with a Nikon E950.

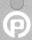

Remember to visit www.pwsbooks.com after you complete this assignment and share your favorite photo! It's a community of enthusiastic photographers and a great place to view what other readers have created. You can also post comments and read encouraging suggestions and feedback.

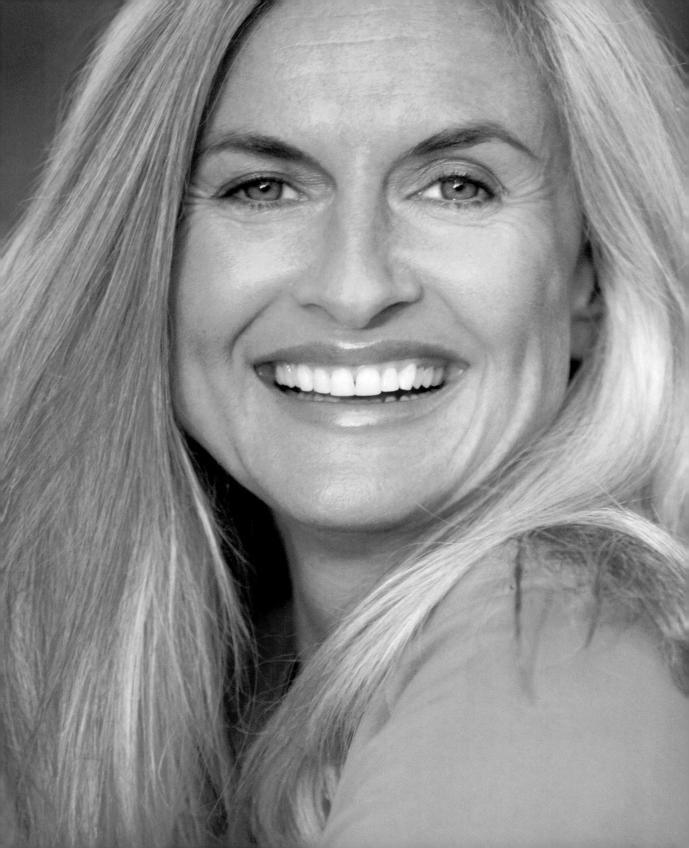

I like to visit art museums and observe how artists have painted, sculpted, or photographed their portrait subjects over time. It's interesting to note that the political, economic, social, and technical context of any era does affect the style of a portrait, but the inspiration to capture a person's essence and record something important is timeless. Prior to the emergence of photography, a portrait session was reserved only for the wealthy; now with digital photography, everyone can take portraits in a creative, efficient, and cost-effective way.

In addition to the technical and creative execution of your image, a successful photographic portrait captures something significant and identifiable about a person's character and personality. Whether you are familiar with your subject or not, you need to build a rapport and engage him in conversation; observe his expressions, reactions, and body language; and judge how to best capture him in your image. This requires an interest in your subject and sensitivity to human nature. For example, the series of images in figure 5-1 shows my subject carefully considering a question I asked him, and then giving his response.

In this chapter, you discover ways to work with your subject, find and create a flattering environment, and capture a compelling portrait.

The eyes are the windows to the soul — focus on them! Even if everything else is out of focus, the eyes must be in focus.

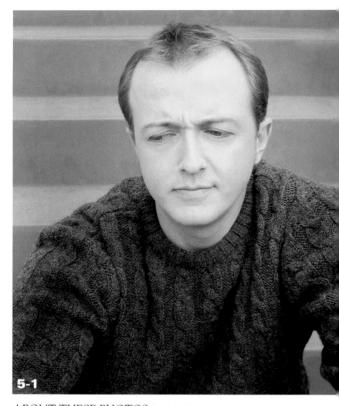

ABOUT THESE PHOTOS Per is a filmmaker and more accustomed to being behind the camera than in front of the lens. I captured his thoughts while we talked. Taken at ISO 100, f/5.0, 1/125 sec. with a Nikon E950.

CREATE THE LOOK

Being resourceful and creative on the fly can be difficult, especially while you are also thinking about the technical requirements of your photo shoot and conversing with your subject. For these reasons, planning a photo shoot beforehand is essential for a successful outcome.

DO YOUR HOMEWORK

Before you begin your shoot, you need to know what your subject expects and/or how the image is going to be used. Is it for a business brochure or

5

a dating Web site? A holiday card or an actor's headshot? A formal sitting or a casual candid portrait? What message should be conveyed in the photograph? You can adjust your plans according to the requirements.

Starting with a visual reference is also helpful. A good example is what professionals use when they come up with ideas and need to express them to others on their creative team. Sometimes referred to as "tear sheets," "scrap," or "comps," these visual references can be a page from a magazine or newspaper, or anything that inspires you and helps communicate your idea.

I am constantly on the lookout for visual inspiration, whether it's a photograph in a magazine, a painting, a combination of colors, fabric textures, or elements in nature. I save these visual references in a notebook and refer to them when I begin germinating ideas for photo shoots. I can also use these visuals to convey my intentions and help others articulate their ideas. This enables me to plan a style for my portrait session, and because I have the tear sheet with me, the subject can see the result I am trying to achieve.

CHOOSE A BACKGROUND

Your subject should be emphasized, and the environment must enhance, not detract, from the overall portrait. Therefore, you need to pay attention to the background. A plant growing out of your subject's ear, or a busy background, can ruin an otherwise good photograph, so look for the simplest background possible. In this section, I cover a few basic background considerations and effective techniques for optimizing your locations.

You are at a family gathering and want to capture memorable portraits of your loved ones, but too many distracting elements are behind your subject. Other than clearing out the room, changing your angle, or moving your subject to another location, a good way to eliminate distractions in the background is to stand back and zoom in closer to your subject with your compact camera lens, or to use a longer focal length lens on your digital single lens reflex (dSLR) camera. For example, my mom was visiting for Easter brunch and we thought it was a great opportunity to take some pictures. I had her sit on the living room sofa facing indirect window light and used a long focal length lens to zoom in close and eliminate the surrounding background distractions, as shown in 5-2.

ABOUT THIS PHOTO To eliminate background distractions, I zoomed in close and changed my angle. This close-up shot places the emphasis on my mom's face, and the camera angle helps avoid the cluttered background. Taken at ISO 400, f/4.0, 1/100 sec. with a Canon EF 24-105mm f/4L IS lens.

CHAPTER 5

Using a longer focal length has many benefits. It enables you to get closer to your subject and crop out unsightly clutter, and it compresses space, providing a more flattering perspective on your subject. You can also use a longer focal length to create shallow depth of field (DOF). Doing this blurs the background and isolates your subject from the surrounding distractions. To achieve this effect, you must move your subject more than a few feet away from the background.

note

If you are using a long focal length and shooting in low light, you may

need to raise your ISO and/or use a tripod to eliminate camera shake.

Another way to simplify the background is to introduce a backdrop. Professional photographers often use colored background paper or special fabric backdrops purchased from a camera store, but there are other creative alternatives. When you zoom in close to your subject, a smaller backdrop is sufficient and you can use everyday household items in place of professional ones. I keep swatches of fabric handy for interesting backdrops, but a blanket, large pillow, or even a scarf works well too. In figures 5-3 and 5-4 we had fun experimenting with different swatches of fabric as a backdrop and wrapped my mom in colored scarves that complemented her skin tone and enhanced her eye color.

ABOUT THIS PHOTO In this photo I used a backdrop for the solution to the background problem. Taken at ISO 250, f/2.8, 1/320 sec. with a Canon EF 70-200mm f/2.8 lens.

ABOUT THIS PHOTO This is an example of how a very small backdrop can cover up a distracting background.

If you want to use a larger backdrop, seamless paper rolls and fabric backdrops are available in many colors and are sold in various sizes. You can find inexpensive decorator's dropcloths at building supply stores, or you can create backdrops from sheets or heavy muslin fabric. I have draped backdrops over doors, tables, cars, and beds, but sometimes a designated support system is in order. You can

create your own freestanding supports from wood or plastic pipe, or purchase the ready-made version at your local photography retail store or online.

SELECT A LOCATION

When choosing a location for an environmental portrait, try to incorporate the background and location in a way that reveals something about the subject and helps convey a message. For example, a location for a corporate executive's portrait might be inside the office, outside the building, or with the product or service she provides. Place a teacher in the classroom, a rock-climber near the mountains, or a take a gardener's portrait in the garden. There are so many possibilities.

Finding a location for an environmental portrait is only limited to your imagination, the light, and the time allotted for the shoot. Knowing your location's potential enables you to pre-plan for lighting, props, and wardrobe, as in 5-5. For example, if you need to take advantage of natural light, you can rearrange the furniture in the room, or you may discover you need to control the light by reflecting or diffusing it. Remaining flexible invites creativity and new ideas to develop while you shoot.

ADJUST WARDROBE, HAIR, AND MAKEUP

Different types of portraits may require different types of clothing, but a proven clothing choice for the portrait photo is a solid color that complements the subject's hair, skin tone, and eyes. Ask

CHAPTER CHAPTER

ABOUT THIS PHOTO Carm is a design professor and avid baseball fan. We chose a local park as the location to shoot in and brought along some props that convey his interest in baseball, thus combining his love of beauty and baseball. Taken at ISO 200, f/4.0, 1/250 sec. with a Canon EF 70-200mm f/2.8 lens.

your subjects to bring a few different shirts in colors they feel they look good in. For example, a sweater that accentuates a person's eyecolor. Avoid busy patterns, logos, or bright colors that overpower your subject.

Typically, jewelry and watches are not recommended for portrait photography unless they have a special significance in the photograph or are understated and don't command attention.

Makeup can help enhance a person's best features, even out skin tone, and control the oily shine that causes reflections. If a professional makeup artist is not in the budget, keep the makeup tones neutral, with a soft and pretty finish. Teresa, shown in 5-6, is a natural, fair-skinned beauty and typically wears no makeup at all. I suggested some powder, light eye make-up, and a natural colored lip gloss to add some polish.

p tip

Powder is a necessity for almost everyone. I keep a few neutral tones

of loose powder and a brush in my camera accessories bag; it comes in handy when someone needs a touch up.

ADD PROPS

Props are great for adding an element of interest and purpose in your portrait images. They also help keep your subjects relaxed by giving them something to do with their hands. If you need to use a prop, make sure it's relevant to the message you want to convey. In portrait imagery, fewer distractions result in a more compelling image.

The image in 5-7 was designed to reflect Carm's interest in reading and referencing information in his books. We used a magnifying glass to emphasize his interest in examining things while also magnifying the intent look on his face.

ABOUT THIS PHOTO Note the solid purple shirt that complements her skin tone and contrasts nicely with the background. Taken at ISO 400, f/5.0, 1/320 sec. with a Canon EF 70-200mm f/2.8 lens.

ABOUT THIS PHOTO Positioning Carm in front of his library with a magnifying glass was a fun way to show his interest in reading and examining things. Taken at ISO 200, f/4.0, 1/100 sec. with a Canon EF 70-200mm f/2.8 lens.

In 5-8, we set up the background and props to reflect Carm's interest in the visual arts, and I used his many paintings not only as a prop but to create a visual collage in the photograph itself. His wardrobe is simple and does not detract from his face or the paintings.

ABOUT THIS PHOTO Carm's many paintings made an interesting environmental backdrop and prop. Taken at ISO 200, f/4.0, 1/125 sec. with a Canon EF 17-35mm f/2.8 lens.

Jeffrey's love of surfing and the ocean location suggested the surfboard prop in 5-9. I could have taken a picture of him surfing, but instead chose to have him stand with his surfboard looking out towards the ocean, which gives the photograph a meditative quality — and we didn't have to wait for the big wave.

ABOUT THIS PHOTO Jeffrey lives near the ocean and loves to surf. It was easy to think of this prop and location, and shooting during sunset at the beach is the magical time for light. Taken at ISO 200, f/5.6, 1/250 sec. with a Canon EF 17-35mm f/2.8 lens.

EXPLORETHE LIGHT

I prefer to shoot portraits using natural light because it enhances the contours and shading that reveal a person's expressions and facial nuances. Because the direction and quality of sunlight vary significantly throughout the course of the day, it's important to know how to plan for, find, and create beautiful light. After you learn these techniques, your portraits are going to be stunning.

PLANNING FOR THE LIGHT

To be fully prepared, you must check your location prior to your photo session to study the light. First determine where your main source of light is coming from, and then account for the quality of that light and plan your positioning options. A good rule of thumb is to avoid direct overhead light at all times because it creates deep shadows under the eyes and causes your subject to squint — not a very attractive look.

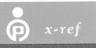

For more on different lighting scenarios and how to work with them, see Chapter 3.

Sunlight is softer and more flattering when the sun is lower in the sky. Early morning and late afternoon are the optimum times for beautiful, natural light. If these times are not feasible, opt for taking pictures in open shade where the light is soft and even. An overcast day can be a little dull, but the diffuse light works well for portraits.

FINDING THE LIGHT

Shooting pictures outdoors requires being able to identify good light and knowing how to manipulate it to achieve the look you desire. Tree-filled parks on a sunny afternoon offer open shade for soft, even lighting. When the sun is lower in the sky, you can opt for backlighting your subjects. Open doorways, north-facing windows, or in the shade of a large building or porch are all "good light" possibilities.

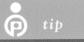

If your subject's eyes appear dark, use a reflector to bounce soft light

into the face and create a catch-light (that little twinkle or reflection) in the eyes.

CHAPTER 5

MANIPULATING THE LIGHT

With a few accessories, you can learn to manipulate natural light to your advantage. Your mission is to reflect light into the dark areas and diffuse any harsh light falling upon your subject. For example, I like the "hair light" effect created by backlighting my subjects in late afternoon light. Because my subject's back is towards the sun, his face is in the shade. By reflecting light back into his face, I also create a catch-light in his eyes. A soft gold reflector, a piece of white foam core, or even a car dashboard reflector can be used to

reflect the light. When exposing for a backlit portrait, make sure your camera is reading its exposure from the subject and not from the light source. In 5-10, the backlight creates a rim around Pavel's hairline. I bounced some light back into his face with a gold reflector and was careful to avoid pointing my lens into the sun to avoid lens flare.

Unless it's the early morning light or the golden hour of sunset, direct sunlight can be harsh and unflattering on your subject. You can diffuse and soften this direct light by placing anything

ABOUT THIS PHOTO Pavel is an actor in Los Angeles and needed a new headshot. I experimented with different

experimented with different lighting techniques at a local park. In this image, Pavel stands with his back towards late afternoon sunlight. Taken at ISO 200, f/3.5, 1/1320 sec. with a Canon EF 70-200mm f/2.8 lens.

translucent or sheer between the light source and your subject. I like to use a silk diffusion panel or a collapsible circular diffusion disk. You can find these items at most professional photography stores. If you prefer to create a homemade diffuser, it's also possible to use a sheer fabric or paper to diffuse the light — white nylon from your local fabric store or tracing paper from the art supply store works well as diffusion material. Experiment taking pictures with these variations of translucency.

It was still bright outside, yet too dark for a good exposure beneath the tree's shade when trying to get the shot in 5-11. I positioned Pavel facing the

sun and had my assistant hold a circular silk diffuser about two feet in front of Pavel's face to soften the light.

Forcing your flash to fire in bright light fills in harsh shadows and comes in handy if your scene is too dark, but use it sparingly. Flash flattens out features and overpowers the subtle nuances of expression. However, there are situations where fill flash is necessary to get a good shot. In 5-12 you can see that the boy's face is too dark. Using fill flash, shown in 5-13, eliminated the shadows created by the hat without overpowering the rest of the color.

ABOUT THIS PHOTO Using a diffuser created an even distribution of light on Pavel's face. It also prevented him from squinting and allowed a catch-light in his eyes. Taken at ISO 200, f/2.8, 1/250 sec. with a Canon EF 70-200mm f/2.8 lens.

ABOUT THESE PHOTOS Using a flash in harsh overhead light helps fill in shadows on your subject's face. Taken at ISO 200, f/5.6, 1/1000 sec. with a Canon EF 17-35mm f/2.8 lens.

WORK WITH YOUR SUBJECT

A great portrait is created when a person's true character and essence are captured in an image. Most people don't feel comfortable opening up for strangers, and that is why connecting with your subject is important to the success of your photo session. It's just you, your subject, and your camera — you need to embrace the relationship. Begin by conversing and finding some common ground. Listen and observe your subject's mannerisms, and, above all, provide an atmosphere of mutual respect.

If you are shooting outside, find a quiet location, especially if you are taking images of someone who is inexperienced in front of the camera. Bystanders can get in the way and distract your subject.

GAIN YOUR SUBJECT'S TRUST

Having a picture taken can be an intimidating and uncomfortable experience for many people. As the photographer, you need to direct and care for your subject. Talk with him about his concerns and alleviate issues he may have about the

portrait session process and the outcome. It doesn't have to be an elaborate ordeal, just an acknowledgment and a caring response to any questions. When I take portraits of people I've never met before, it may take a little longer to get started, but the investment of time up front always pays off in the final image.

As you take images, be sure to give your subject positive feedback and suggest ways to move or reposition for the camera. "Beautiful! Great! Nice! Wow! Love it! Try turning this way. That's perfect." Provide any comment that gives the subject direction and communicates something positive about what he is doing. Carry on your conversation while you are taking pictures. It's easy to capture candid shots when your subject is talking, laughing, and responding to you. If you don't like his position or expression, don't say "No," "I don't like that," or "That's terrible." This only succeeds in deflating your subject's confidence and does not strengthen your connection. Instead, use "Let's try it another way," or "I liked it when you did this." Be sure to communicate clearly so your subject can hear you.

Another way to instill trust in your subject is to get him involved in the process by reviewing some of the photos on your LCD viewfinder. After he sees how good he looks in the images, his worries dissipate and he can relax and enjoy the photo session.

It's necessary to be respectful, encouraging, and flexible, but it's equally important for you to be regarded as competent, knowledgeable, and in charge. Make sure you are comfortable with your camera, and avoid fumbling with your equipment or spending too much time making adjustments for the light. If you aren't prepared to run the show efficiently, your subject loses patience and confidence in you, and may never truly relax in front of the camera.

SHARE ON-CAMERA TECHNIQUES

Your portrait session is off to a good start and you are already taking pictures, but your subject looks a little stiff, and her smile seems forced. Don't panic or get discouraged, it's a typical beginning to many photo shoots. Sometimes it takes a while to warm up. To help move the session along, I encourage people to try the following exercises to loosen up in front of the camera:

- When your subject tries to smile continuously, her face stiffens and her smile does not look natural. That's when I suggest using the "puffer-fish" technique (shown in 5-14), and I do it with my subjects. Tell them: Take a deep breath, blow up your cheeks like a puffer fish, hold it for a few seconds, and then blow the air out. The result is a relaxed face.
- Sitting in one place can be boring and put some people to sleep. To energize your subject, suggest some techniques to put some life into her on-camera presence. Whether your subject is sitting or standing, she can turn away from the camera and then turn back towards the lens. Add a "Hey" or "Yo" or whatever she wants to say and watch the energy level rise. If she feels silly, you can capture the laughter in a candid image.
- Standing in one place can be uncomfortable for many people because they don't know what to do with their hands or body.

 Movement helps loosen them up, but how do they move while in the contained shooting area? Planting their feet a shoulder's length apart and rocking back and forth from one foot to the other foot creates movement and limits any traveling out of frame. It also helps if you demonstrate this technique first.

ABOUT THIS PHOTO This is a good example of the puffer-fish technique. Taken at ISO 200, f/6.7, 1/125 sec. with a Canon 90mm f/2.875 lens.

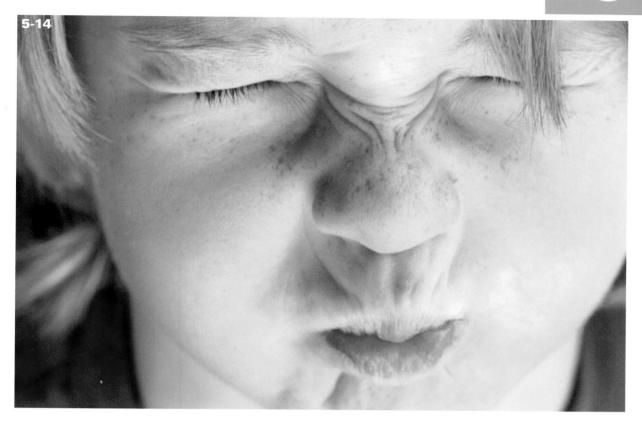

■ Even if your subject is positioned in the shade, bright outdoor light can cause a furrow in the brow and squinting. When you see this occur, encourage your subject to take a moment, close her eyes, relax her face, softly rub her brow, and open her eyes again when she is ready.

TRY DIFFERENT POSITIONING

Formal and informal posing is an art, especially when the intent is to create a natural-looking portrait. Depending on the subject's comfort level and image requests, I try to include a variety of poses and spontaneous candid shots in each

portrait session, along with any last-minute, location-inspired ideas.

There are two basic portrait setups, the headand-shoulder (headshot) and the three-quarter or full-length. After you study your subject's features, it's time to position him in front of the camera and decide on a flattering way to portray him in the photo. Some people know how to naturally pose in front of a camera, but most feel like a deer in the headlights during a portrait session. Keep a few standard pose ideas in mind and be prepared to suggest some additional ones to compensate for and flatter your subject's body and features. Adam needed headshots, and we decided that a mix of headshots and three-quarter-length portraits would give him a range of looks to help promote his entertainment career. Figure 5-15 is a three-quarter-length portrait that gives the viewer more information about Adam than a standard headshot.

The solid backdrop in 5-16 matches Adam's sweater, creating a monochromatic context that

ABOUT THIS PHOTO Casual posing against a solid colored backdrop creates a simple, yet effective portrait. Taken at ISO 400, f/8.0, 1/250 sec. with a Canon EF 24-105mm f/4L IS lens.

enhances his eyes and emphasizes his face. I directed him to lean towards me as if he were talking to me across the table, which resulted in the natural pose and engaging smile you see in the image.

Many people don't like the way they look in photographs, but with a few proven posing techniques, you can minimize flaws and enhance their best features. Following are suggestions about where to start, what to avoid, and general rules for correcting any problems:

- If your subject is standing, have him place his weight on the back foot and stand at a three-quarter angle to the camera. Have him also cross his arms or put one hand in a pocket. If there is a wall in the scene, try different leaning poses. Above all, make the pose look and feel natural.
- If your subject is sitting, use a stool that does not show in the photograph or a chair that complements and does not detract from the look of your image. Remind your subject not to slump. Experiment facing your subject's body three quarters toward the camera and positioned over the chair back. Try not to shoot your subject facing straight on, unless your intention is a passport photo or driver's license.
- Mix things up. Try slanting your subject's shoulders at an angle toward the camera. Have your subject bend slightly at the waist and lean in towards the camera for a more engaging photograph.
- Don't have your subject lean away from the camera with his chin tilted up high; it appears snooty.
- Have your subject tilt his chin down slightly to open up his eyes, but not so low that a multiple chin problem develops.

GHAPTER 5

ABOUT THIS PHOTO Adam wanted a very simple, clean portrait where he is the main focal point. Taken at ISO 400, f/8.0, 1/250 sec. with a Canon EF 24-105mm f/4L IS lens.

- Shoot overweight people from the side. Shoot underweight people from the front.
- Shoot from a low angle to make people appear taller. Shooting from a high angle makes people appear smaller.
- **Experiment.** It isn't always necessary for your subject to look straight into the camera. Try a variety of head and eye positions. Have your subject turn his head and look off to the side for some shots.
- For men, a solid pose is to position the head directly at the camera. Women can look directly into the camera or slightly tilt their heads, but avoid any exaggerated coy poses.

- Your subjects shouldn't hold their breath for a shot. Have them take deep breaths and relax their shoulders. Shake it out. Tell women to think "long neck," but don't exaggerate this position or the neck looks like a turtle.
- Adjust your camera level and experiment with different chin positions to find the most pleasing angle. Most portrait images are taken a few degrees above the subject's eye line. This is only a guideline; try other viewpoints and see if they work with your subject.
- Opposite sides of a person's face photograph differently. Change angles and find the side that works the best.

- If your subject has prominent ears, hide one ear behind the head by turning the face three-quarters of the way toward the camera.
- Watch your subject's hands; this is where tension typically appears in a photograph. Suggest they rest their hands in their lap, on the back of a chair, or that their chins rest very lightly on one of the hands. If you see their hands clamped around each other, or gripping the side of the chair, suggest they shake out their hands and let them fall naturally.
- Encourage multiple expressions for the shots.
- Avoid having your subject's arms hanging flat against the sides of their bodies. Bend the arms slightly, and try other poses that involve alternate placement of the arms.

Figure 5-17 is a good example of natural positioning. I asked Olivia to use her hands in the photograph and she decided on the most comfortable pose.

ABOUT THIS PHOTO Olivia's hands become part of the portrait with thoughtful posing. Notice how lightly her hand rests on the side of her face. Taken at ISO 400, f/2.8, 1/1250 sec. with a Canon EF 70-200mm f/2.8 lens.

Guarter 5

WHAT EXACTLY IS A HEADSHOT? A headshot is a term for a type of portrait used for marketing purposes in various industries. For example, real estate agents often use headshots on promotional material, and actors and models need headshots to market themselves in the entertainment industry. This style of portrait typically emphasizes the head and shoulders, but this rule may be broken in favor of a three-quarter or full body shot.

For the shot in 5-18, I positioned Olivia beneath the shade of a tree and created a hairlight by placing her back towards the late afternoon sun. I filled in the shadows on her face with a gold reflector.

CAPTURE CANDID MOMENTS

Posing your subjects works well for formal and casual portraits and is a good place to begin when you're taking pictures of people, but capturing candid moments is another art form. Successful candid images capture a piece of time that is not rehearsed, posed, or planned. It is a life moment that occurs when people are not aware of the camera or when all conscious thought has momentarily disappeared. This is the authentic human essence that is so sought after in an image, yet so difficult to cajole. It just happens, and you must be observant and ready to capture it. In figure 5-19, I shot Teresa in front of her favorite painting using a selective focus lens. We were having a conversation about her collection of artwork, and this is the candid moment I captured.

ABOUT THIS PHOTO Olivia is a professional model and has multiple, natural-looking poses for every situation. She makes it easy to take a good photograph. Taken at ISO 200, f/2.8, 1/250 sec. with a Canon EF 70-200mm f/2.8 lens.

ABOUT THIS PHOTO With this dreamy selective focus effect, Teresa's colorful shirt and natural expression become part of the artwork. Taken at ISO 400, f/4.0, 1/60 sec. with a Lensbaby selective focus lens.

EXPERIMENT

A simple portrait can intrigue even the most discerning viewer if it's unique, artful, and emotionally engaging. After you understand the basic photographic guidelines, you can break the rules and get creative. Experiment with your ideas and your equipment. If you make a lot of mistakes, that is perfectly okay. When you're shooting with a digital camera, you just erase what doesn't work — but wait until you view your images on a computer screen before you send anything to the trash. Some of the most interesting photographs are happy accidents. You can accentuate an interesting characteristic about your subject, as I did with Cortnee in 5-20. He has amazing hair, so I had him swing it around for emphasis.

CHANGE YOUR POINT OF VIEW

Think about different angles and perspectives when experimenting with your portrait images. Based on the effect you intend to achieve, it isn't always necessary for a face to be present in a portrait, or for the image to be in sharp focus. Explore your creative side and let loose.

Sonya is a ballet dancer and her feet are very important to her profession. A typical image would render her feet in focus with a deep DOF. In figure 5-21, I chose to experiment with a shallow DOF and a different point of view.

ABOUT THIS PHOTO This hair-in-movement effect creates a unique portrait. Taken at ISO 400, f/4.0, 1/100 sec. with a Canon EF 24-105mm f/4L IS lens.

ABOUT THIS PHOTO Sonya's feet are out of focus, yet still a prominent part of the image. Taken at ISO 200, f/2.8 1/100 sec. with a Canon EF 17-35mm f/2.8 lens.

TAKE A SELF-PORTRAIT

Now that you understand the basics about taking portraits of other people, try them on yourself by taking a self-portrait. The first step is learning to use your camera's self-timer. By using the self-timer to capture your own portrait, you have control over how you look, how the photograph is taken, and what happens to it afterwards.

Press the self-timer icon and cycle through your options. Self-timers on digital cameras vary. Some let you select the time it takes for the self-timer to release the shutter, usually between two and ten seconds. Others have a custom self-timer that allows you to set the countdown time and the number of shots to be taken. The ten-second

option gives you enough time to position yourself in front of the camera. Follow these steps to take your picture:

- 1. Place your camera on a tripod or stable surface.
- 2. Get rid of any background clutter.
- 3. Select a chair to sit on and place it in your location.
- 4. Compose your shot by using an object to focus on. A large pillow or stuffed animal propped up in the chair does the trick. You can also create a group "self" portrait, setting your focus on another person or other people and then moving into the frame, as in 5-22.

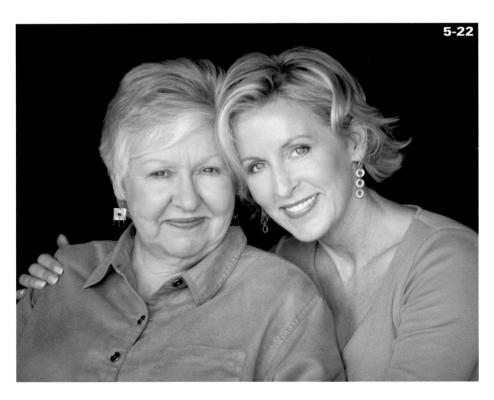

ABOUT THIS PHOTO This self-portrait of my mom and me was achieved by using my camera's self-timer and a tripod. Taken at ISO 200, f/2.8, 1/320 sec. with a Canon EF 70-200mm f/2.8 lens.

CHAPTER CHAPTER

- 5. Press the shutter button halfway down to lock in the focus and exposure; then, fully depress the shutter-release button to trigger the timer. The red warning light on the front of the camera will blink steadily during countdown, and just before taking the picture it will start to blink faster.
- 6. Move into place, get comfortable, laugh, look into the lens, and give the camera a real smile.

As you take more shots, position your body at an angle to the camera and experiment with various expressions. Keep in mind that smiling and leaning towards the camera convey a friendly, approachable personality.

One way to instantly see how you look is to place a mirror right behind your camera. You can check your expression and see how you look before the picture is taken.

Assignment

Create an Image Using a Visual Reference

Start your own collection of visual references. Use one, or a combination of these references, to plan and execute a portrait shoot. Experiment with posing your subject and inspiring candid moments. Choose your favorite image, post it online at www.pwsbooks.com, and explain how the image relates to your visual references.

The visual reference for this portrait of my dad who is an artist, was inspired by some images I had of 16th-century Renaissance painters. My intention was to capture my dad in his "art mode." Taken at ISO 200, f/4.0, 1/160 sec. with a Canon EF 24-105mm f/4L IS lens.

© Erin Manning/Workbook Stock

Remember to visit www.pwsbooks.com after you complete this assignment and share your favorite photo! It's a community of enthusiastic photographers and a great place to view what other readers have created. You can also post comments and read encouraging suggestions and feedback.

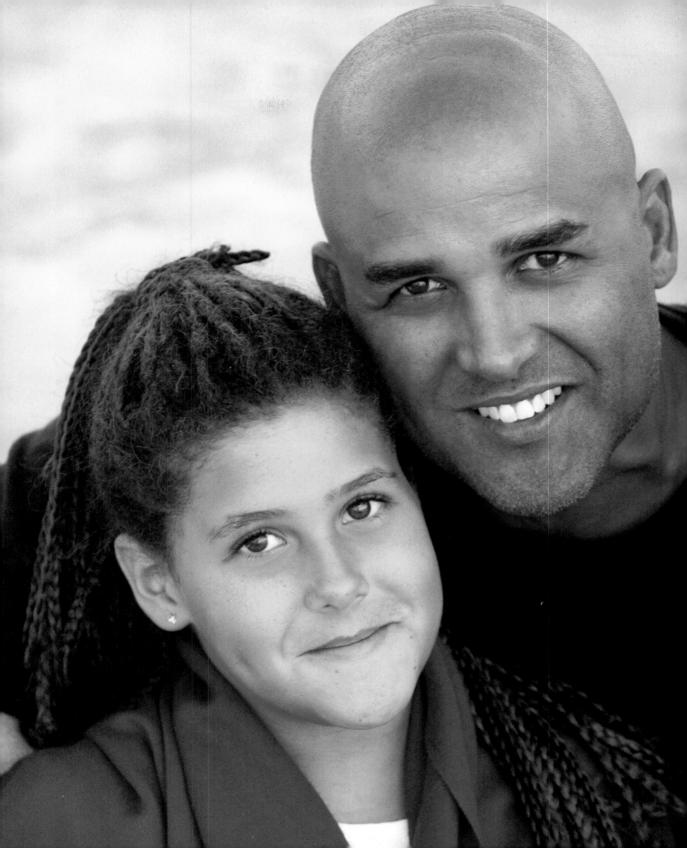

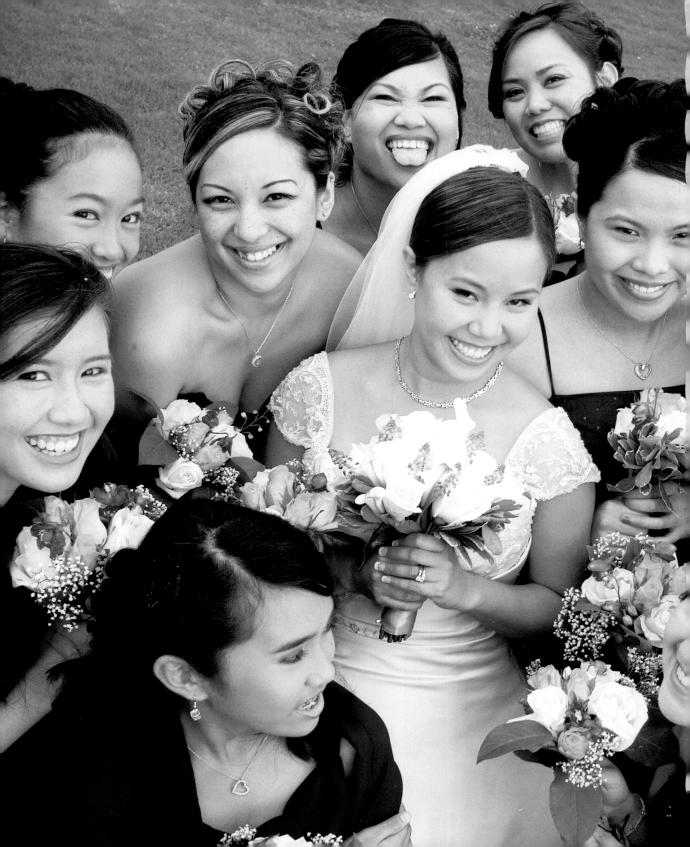

Prepare Yourself
Direct and Position the Group
Candids
Get Creative
Optimize Your Equipment for Group Settings

© Robert Holley

Whether you're celebrating a birthday, gathering for a family reunion, or documenting a child's sports team, photographing groups requires specific preparation and a particular approach to create a successful image.

A different dynamic is present when more than one person is in front of the lens. A good photo captures the relationship between people in the image. Your preparation, communication, composition, and attention to light are important and include some of the same considerations as a single portrait; however, and there are additional things to think about too.

PREPARE YOURSELF

Having the luxury of planning a formal group photo session before it happens gives you more control over the outcome than taking photographs as a camera-toting party guest; however, they both require preparation prior to snapping the shutter button.

For large occasions, people may hire professional photographers and ask you to come in and shoot the candid shots; at smaller functions, you may wind up doing a bit of both. If there is a professional photographer at the event, you should be aware of photographer etiquette.

Do not follow the professional photographer to his formal portrait setting and start taking pictures over his shoulder. It can distract the group from fully engaging with the professional photographer and is considered stealing the shot. As a camera-toting party guest, wait until these formal shots are over and use your existing relationships and communication skills to connect with people at the event and capture casual, candid shots.

LEARN ABOUT YOUR SUBJECTS

Having knowledge about your subjects prior to taking a photograph helps you think about various locations, positions, and directions to use for the photo session, whether you are taking more formal groups shots or candid shots. You need to find out the number of people involved, the approximate age range, height, genders, and relationships between your subjects. The size of the group dictates the location. Is it a 50-person reunion or a family of four? Is there a wide age range? Think about how you would arrange a group of 80-year-olds versus a sports team of 7year-olds. Would some people be more comfortable sitting than standing? What is the relationship between the subjects — is it personal or professional? Your posing suggestions should not make anyone feel inappropriate or uncomfortable. Is there a guest of honor? All of this information assists you in making a thoughtful plan and provides multiple ideas for creating an image everyone loves. When you are confident about your photo session it shows, and your subjects mirror your relaxed attitude right back into the camera.

KNOW THE DESIRED RESULT

Some group photographs are meant for a specific purpose: Know what the purpose is and make sure you plan your location, lighting, and positioning accordingly. A casual group photo might incorporate an unusual background and more spontaneous moments, but a formal group portrait might include a simple background and a traditional pose. If your subjects request a certain style — formal or casual — you need to know how to produce the desired result. For example, in figure 6-1, this family wanted a contemporary, casual portrait

ABOUT THIS PHOTO Barbara and her sons express their relationships and personalities in an engaging moment. Taken at ISO 400, f/4.0, 1/200 sec. with a Canon EF 70-200mm f/2.8 lens.

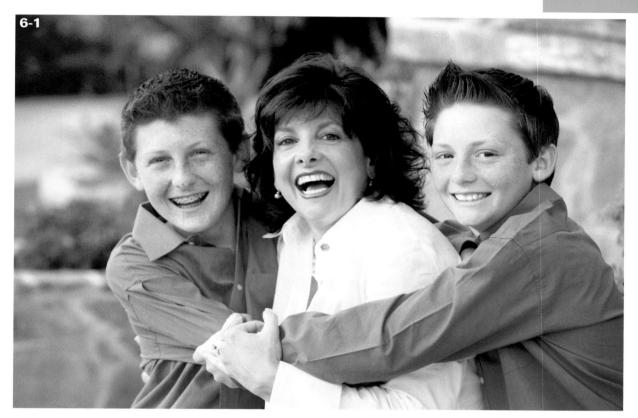

that expressed relationships within the family. In this photo I asked the boys how they felt about their mom, and the result was a spontaneous, loving moment.

CHOOSE A LOCATION

Scout out various locations for your shoot if you are planning it in advance. Look for simple backgrounds and evaluate the available light around the same time of day you plan on shooting. During the day, indirect, even lighting, found just inside an open garage door or under a shady tree in midday sun, is ideal for photographing couples and small groups. Early morning and late afternoon afford the most flattering light for your

subjects. If you are photographing a large group, position your subjects with their backs to the sun and fill in the shadows on faces with a reflector or fill flash. You don't want your subjects squinting into the camera.

If you are a party guest and just wandering into the location for the first time, look around and locate simple backdrops and places to sit or stand that afford even lighting. If you're shooting inside in low-light, consider turning off your flash to capture the ambient light in the room. If your exposure is too dark, raise your ISO setting. This allows more light to pass through the lens and enables you to expose for the low-light scene without using a flash.

The downside of a using a high ISO speed is a possibility of digital noise and artifacts in your final image. Experiment with different ISO settings until you find one that captures the mood of the ambient light in the scene. When shooting in low-light without a flash, you may need to stabilize your camera on a table or tripod to eliminate blur caused by camera shake resulting from a slower shutter speed.

Noise is the digital version of film grain. It creates discolored pixels, also knows as *artifacts*, throughout your image.

Some parties and events occur in very low-light situations and require a flash in order to see people's faces. Now is the time to use the night flash or slow-synch setting on your camera. This setting uses a slower shutter speed with the built-in flash and picks up the beautiful ambient light in the room while it lights up your subject's face. Keep your camera very still in this mode or use a tripod to eliminate camera shake and blurred images.

CONSIDER THE LIGHT

Our eyes are capable of seeing a greater dynamic range of light than our cameras can, so you must be aware of harsh contrasting light in your scene and try to avoid it when positioning your subjects.

Natural light creates some of the most beautiful images; however, contrasting lights and darks throughout your scene makes it difficult for your camera to correctly expose the shot — and harsh shadows across faces are not attractive. Neither are squinting eyes due to facing bright sunlight. If you are shooting outdoors, make sure that you place your subjects in an evenly shaded area or face their backs towards the sun. If the scene is too dark, fill in shadows with a fill flash or bounce soft light into your subject's faces with a reflector.

The early morning light or very late afternoon light is the most flattering. During these times it's easier to position your subjects anywhere, even facing the sun, because the light is softer and makes people look beautiful. Figure 6-2 illustrates how the last few minutes of golden light prior to sunset are soft enough to evenly illuminate faces without harsh shadows or squinting.

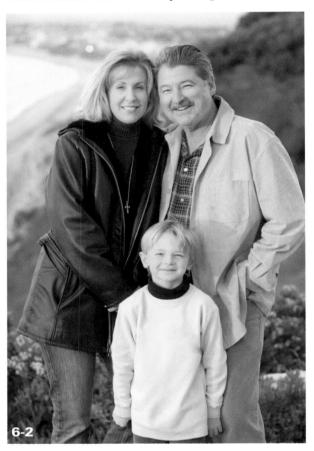

ABOUT THIS PHOTO The last rays of sunlight enveloped the Kuller family in a golden glow. Taken at ISO 200, f/4.0, 1/100 sec. with a Canon EF 24-105mm f/4L IS lens.

Eyes look bright and alive when a *catch-light* is present. A catch-light is the reflection of light you see in a person's iris. Look in your subject's eyes and make sure you see some sparkle. If you don't, create a catch-light by reflecting soft light into your subject's face.

Снартев

If you are inside, pay attention to the type of light in your scene. Is it

harsh or soft? Natural or artificial? Take some test shots to see how your camera is recording the light in the environment, and adjust your camera settings to fit your intentions. If it's too dark, use your flash options to control the light in your scene.

ANTICIPATE SURPRISES

Regardless of whether you are asked to take a portrait spontaneously or you are at a scheduled shoot, to make sure you always get the shot, you need to be prepared for the unexpected.

Imagine you have planned a photo session in advance, you have the perfect location, the light is just right, and everyone is there, feeling happy and ready to go. You have positioned the entire crowd and they are patiently awaiting the sound of your camera shutter firing and beginning the shoot, but something goes wrong. It could be myriad things: your camera is malfunctioning, the media card is damaged, you drop the lens, the battery dies and it's your last one, and the list goes on and on. There is nothing more embarrassing than having something go wrong right in the middle of a shoot, in front of many people.

Professional photographers always have a backup plan. They bring an extra camera, extra batteries, extra media cards, extra lenses, and additional lights, and they have them ready and available. There are always things that are unexpected and beyond your control. If you're a beginning photographer, you may not own any additional cameras or have extra accessories with you, but you can bring extra batteries and do some thinking in advance about the situations you might encounter and the techniques you will be using. For example, consider the time of day you plan on shooting and think about possible areas within your location to position your subjects.

The success of any photo session depends on how you handle these unexpected situations.

tip

On every shoot, hope for the best and plan for the absolute worst.

Planning a photo shoot in advance helps you alleviate the possible problems before they begin.

DIRECT AND POSITION THE GROUP

When an organized group of people is waiting for you to entertain, direct, and impress them with your creative and technical skills, their patience is fleeting. Your job as the photographer is to be prepared and keep everyone happy, together, and interested by taking control of the situation in a firm, friendly manner.

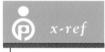

I discuss motivation techniques in Chapter 1.

No matter what location or formation your group is in, the most notable action that ensures a successful image is taking as many shots as possible when photographing a group of people. The odds are against you when you're trying to photograph a large group because people blink, talk, and glance away from the camera. Taking many pictures increases the odds of capturing everyone looking good at the same time. Communicate to the group that you are going to take quite a few photographs after everyone is in position to prevent your subjects from dispersing after the first few shots are taken.

Let your group talk and interact until you are ready to take the shot. Use the time between shooting intervals to praise them, get them closer

together, or adjust their positions slightly. And remember that it doesn't have to be a stiff, formal arrangement. For example, 6-3 is an example of a casual group portrait. I achieved this spontaneous positioning by asking them to give a group hug. I instructed them to keep looking in the lens and took about 20 shots to ensure that everyone's eyes were open.

) tip

When photographing with a flash indoors, move your subjects away

from the wall. Doing this prevents harsh shadows on the wall behind them.

EXPLORE POSING TECHNIQUES

A formal group portrait has been a tradition for centuries. Depending on the artist and the era, historical paintings depict glorious portrayals of families and groups, often dressed in formal clothing and in reserved poses. When photography hit the scene in the late 19th century, families and other groups dressed in their best clothes and had a formal portrait taken at a photography studio. Due to the limitations of their equipment, photographers required their subjects to sit still for

ABOUT THIS PHOTO This family is a fun-loving group and the pose depicts their close relationships. Taken at ISO 400, f/5.6, 1/320 sec. with a Canon EF 24-105mm f/4L IS lens.

very long periods of time in order to execute a proper exposure. Hence, the very still and solemn expressions in many old photographs. Once cameras became more available to the masses, lots of family gathering occasions were captured more informally.

The old family photograph of my relatives in figure 6-4 appears as though it was taken during or after a celebration or family event. It's not the most interesting composition, but this photo is a rare and priceless recording of my heritage. I'm very thankful that someone brought a camera to the party!

A formal group portrait is usually requested to achieve a conservative and traditional portrayal of the subjects to commemorate milestones such as graduations, weddings, birthdays, or anniversaries. A sense of refinement in the demeanor of the subject and simple positioning is a good place to begin. If you are posing a large group, your choices are limited to lining people up in rows on a flat surface and shooting the picture from a slightly elevated position, as in 6-5, or staggering your subjects on ascending steps in order to capture everyone in the scene. Remember those old school photos taken on the bleachers?

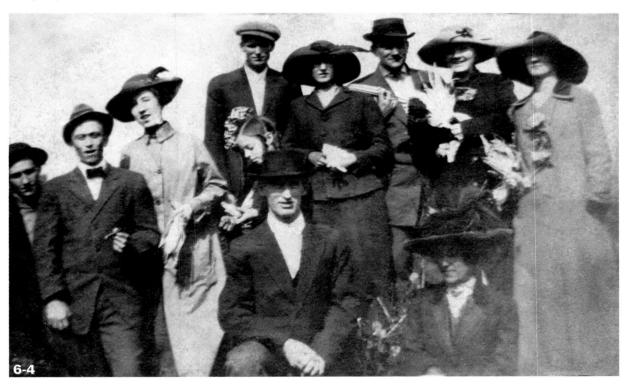

ABOUT THIS PHOTO This informal group portrait of my relatives dates back to the early 1900s.

ABOUT THIS PHOTO The photographer fulfills a formal group portrait request by positioning his subjects in the classic wedding-party pose. © Robert Holley, Taken at ISO 400, f/11.0, 1/160 sec. with a Canon EF 17-35mm f/2.8 lens.

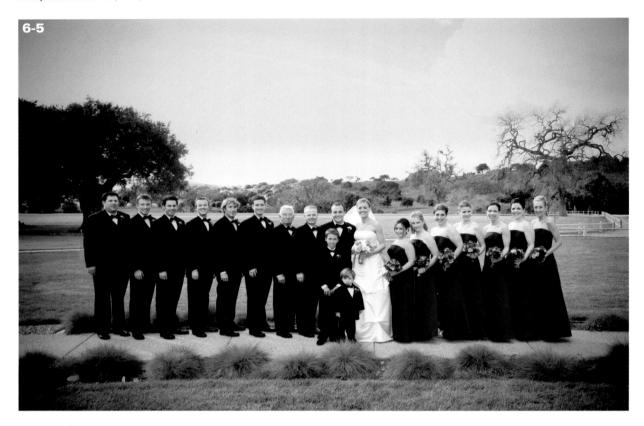

The formal wedding portrait in 6-5 was taken by Robert Holley, a professional wedding photographer. Robert positioned the wedding party around the bride and groom in a linear fashion according to height. Everyone is visible and on the same focusing plane. If you are ever called upon to photograph a friend's wedding, this is one traditional group portrait posing option you can use.

If you are posing a smaller group of people, the previous choices apply, but you have other options, too. Rather than lining everyone up, try positioning your subjects in a casual group to allow for a more intimate feel. In 6-6 I positioned the group in two rows, but it's a small group and the gestures imply emotional closeness.

Regardless of the size of the group, when your subjects within the scene are positioned at different distances from the camera, they are on different focusing planes. This means that some people may be out of focus in the image unless you use a deep enough depth of field. To counter this problem, use the aperture priority AV (Aperture Value) setting on your camera to select an aperture of f/8 or higher to ensure everyone is in focus. Use your DOF preview button on your digital single lens reflex camera to check the focus in your scene before taking the shot. If you are using a compact camera, use your infinity or landscape mode to ensure a deep DOF and render everyone in focus in your image.

ABOUT THIS PHOTO Here is a formal pose with a contemporary feel. This family wanted a simple, classic group photograph. Their expressions and relationships are the focal point in the image. Taken at ISO 400, f/4.0, 1/250 sec. with a Canon EF 70-200mm f/2.8 lens.

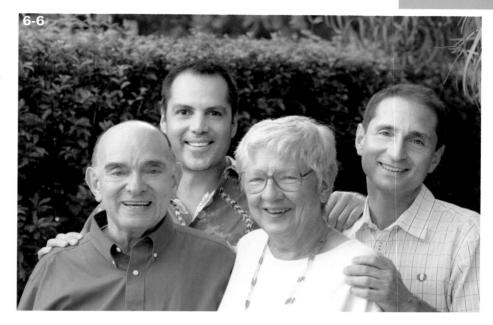

PLAN A CASUAL SHOOT

Casual group portraits are considered more contemporary and have grown in popularity over the years. The location, clothing, and physical formation of your group can be varied and unique. From classic poses in casual clothing to creatively wacky arrangements of people in the scene, a casual group portrait can be a lot of fun. One of my favorite families to photograph is my friends and neighbors, the Tainters. Over the years, I've worked with the mom, Suzie, in developing unique ways to document her family in a group photograph. The locations, lighting, and clothing are varied, but the central theme is that they are a close, active family with a lot of energy.

The Tainters like to take time to think through possible scenarios for their family photographs, and we work together as a team to create the images they want. Rather than providing instructions, I am there to capture those moments that are part of their natural interaction with each other. While some feedback may be helpful when shooting informal groups, it's important not to force anyone to do something they are uncomfortable doing. To avoid the artificial, staged shot, let the action unfold naturally before your lens and be ready to capture the spontaneous moments. To prompt ideas regarding activities or locations for photo shoots, I often show people shots I've done for other families or groups to inspire their creativity.

Because we had planned this pajama party setup prior to the shoot, the Tainters were already enthusiastic about having a pillow fight as the family portrait was taken. For simplicity, the adults wore classic pajamas in solid colors with small, simple stripes. The kids had on their favorite "jammies," as you can see in 6-7.

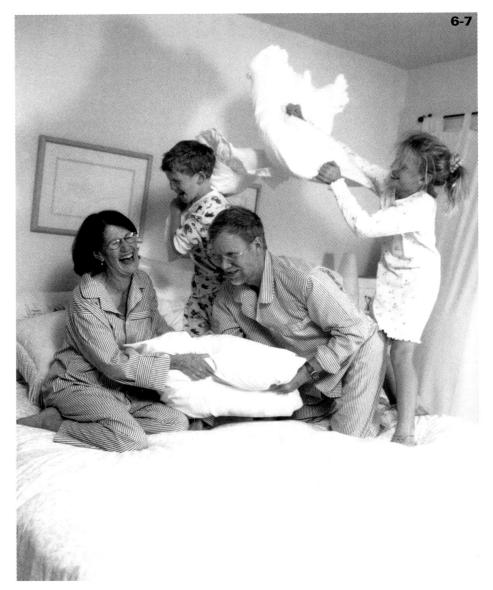

ABOUT THIS PHOTO An organized yet chaotic activity, a pillow fight, was a fun idea for this family portrait. Taken at ISO 200, f/8.0, 1/250 sec. with a Canon EF 17-35mm lens and a Canon Speedlight external flash.

I positioned them on a solid colored bedspread and yelled out "let the pillow fights begin!" I encouraged the pillow fighting and joined in the laughter. To illuminate the scene, I used an external flash on my camera that I alternated pointing at the white ceiling or the walls for bounced light on my subjects. Capturing the action was easy; I just set my camera in Continuous mode and took continuous sets of pictures for about five minutes. There were a lot of good shots to choose from!

The Tainters play a lot of volleyball and wanted to depict this activity in their family portrait the following year. We discussed wardrobe and decided on the natural, "less is more" approach; solid colors only, no logos or busy patterned shirts to detract from the group image in 6-8. Again, this is a casual approach with a straightforward arrangement.

If you run out of ideas for casual portrait shots, think about forming your group into an overall shape. For example, if you were shooting an image of ten people from above, it might look interesting to direct them into a rounded group, in the shape of a circle, as illustrated in the bride and bridesmaids image on the opening page of this chapter. Experiment and have a few ideas up your sleeve if things become boring. Triangles, as shown in 6-9, are a classic shape and draw the viewer's eye into the photograph. I positioned my subjects in mid-afternoon open shade, but I was able to enhance their faces by bouncing light on their faces and filling in shadows with a gold reflector.

ABOUT THIS PHOTO The positioning and wardrobe convey the casual attitude in the image. Taken at ISO 100, f/5.6, 1/200 sec. with a Canon EF 17-35mm f/2.8 lens.

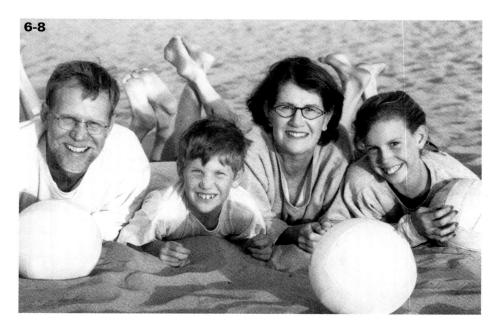

ABOUT THIS PHOTO A casual family portrait with a classic triangle pose creates a visually interesting close-up. Taken at ISO 200, 1/4.0, 1/250 sec. with a Canon EF 70-200mm f/2.8 lens.

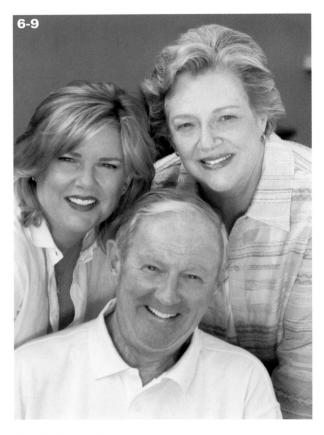

CANDIDS

Not every photo you take will be posed or planned. Both formal and casual portraits offer opportunities for candid images. It could be the emotion shared between people before or after a formal pose is struck, or the natural reaction to something funny that occurred during the casual pose. Whatever happens, you need to be fully present in the moment, keenly aware of what is happening with your subjects, and capable of anticipating and recognizing an important moment.

For example, in 6-10 you see a spontaneous moment between a mother and her son after another beach shot. The slight blur around the edges is from shooting with a slower shutter speed while using flash. It was an overcast evening and the sun had just set below the horizon. I used a medium to slow shutter speed with an external flash. While this captures the moment effectively, the slight blur appears. This effect is called *shutter drag*, *slow-synch*, or *dragging the shutter*.

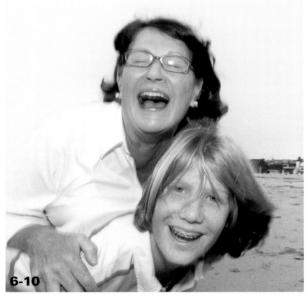

ABOUT THIS PHOTO I captured fun, spontaneous moments with a ready eye and an external Speedlight to light up the scene after the sun set. Taken at ISO 800, f/11, 1/60 sec. with a Canon EF 17-35mm f/2.8 lens.

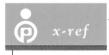

To read more about using a slow shutter with a flash, refer to Chapter 9 where I discuss this effect in more detail.

СНАРТЕВ

Many staged group portrait shots may begin with more formal poses, but if you pay attention to the reactions that occur between the posed shots, you can capture authentic candid shots showing personality and a group dynamic, as illustrated in 6-11.

Candid, less posed shots, can be captured even when you have given some general direction — your group may naturally produce an imaginative arrangement, as shown in 6-12. You have to be prepared to capture such moments though!

Always continue to observe the way the light in your scene falls on each person. If you are taking a portrait of a large

each person. If you are taking a portrait of a large group, make sure everyone is positioned in similar light; otherwise, part of your image may be under- or overexposed.

To set the scene for candid, spontaneous images, capture people in action or give them something to do. When you place your subjects within the context of objects or activities, your image tells a

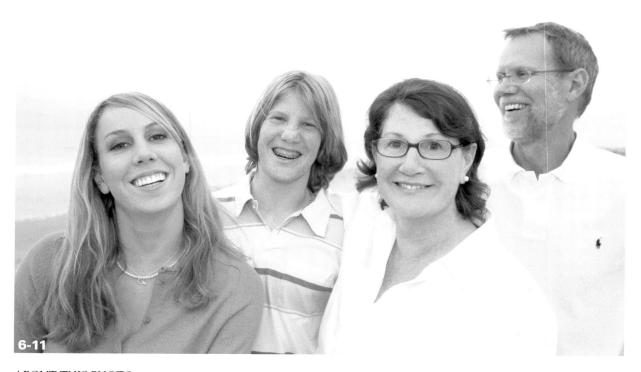

ABOUT THIS PHOTO An intimate and casual portrait can include a candid moment. Taken at ISO 200, f/5.6,1/100 sec. with a Canon EF 70-200mm f/2.8 lens.

ABOUT THIS PHOTO Families in motion have something to do and can produce spontaneous, unique poses. The beautiful sunset light created a magical feel to the image. Taken at ISO 400, f/4.0, 1/200 sec. with a Canon EF 70-200mm f/2.8 lens.

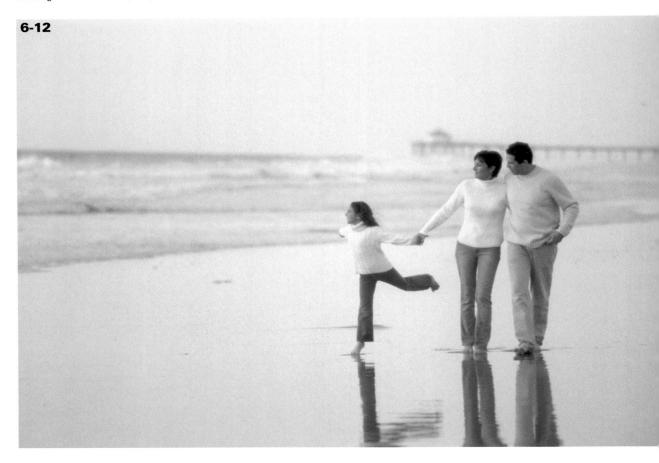

story and becomes more interesting. Figure 6-13 captures a moment and tells a story about the groom surrounded by bridesmaids. All the people in this image are looking towards another camera, which gives this image a natural, candid feel.

When an emotion or reaction occurs, capture every second by using the Continuous mode setting on your camera. Hold your finger down on the shutter button to capture multiple frames in quick succession.

ABOUT THIS PHOTO A candid image taken from another angle captures a natural moment with the formally posed group. © Robert Holley. Taken at ISO 200, f/4.0,1/250 sec. with a Canon EF 70-200mm f/2.8 lens.

GET CREATIVE

Couples, small family groups, and large groups all have one thing in common — a relationship with each other. It's your job as the photographer to capture this relationship in the image. Use your imagination, look around for ideas, and try some of them out with willing subjects in your photo sessions. Not all people have an adventurous streak, so use common sense when suggesting anything unusual with people you don't know. Practice on your friends and family first; experiment and see what happens. You might create a

masterpiece. With the immediacy of digital photography, you can check out your images as you shoot and take as many pictures as your media card can hold.

Not all portraits need to be faces. Consider how other details about a family depict their relationships. In 6-14, a family's feet are shown with their toes in the grass. The mother and father's feet surround their daughter's feet, conveying a message of parental support and protection. Relationships can be revealed in a group portrait by noticing the details.

ABOUT THIS PHOTO A family's feet in the grass conveys a sense of relationship between the parents and their child. Taken at ISO 400, f/8, 1/200 sec. with a Canon EF 17-35mm f/2.8 lens.

ABOUT THIS PHOTO
The groom is the person of
honor and the focal point in this
contemporary group portrait.
© Robert Holley. Taken at
ISO 200, f/20.0, 1/125 sec. with a
Canon EF 24-105mm f/4L IS lens.

СНАРТЕВ

By placing the groom in the foreground of 6-15 and the groomsmen and mountain range in the background, a sense of three-dimensional space is created in the image. The photographer used a deep depth of field to ensure that everyone was in focus.

To capture more candid shots, give your subjects something to do so they are more comfortable. The image in 6-16 shows how suggesting activities your subjects are interested in can help you take natural, candid shots. Cortnee and Tabitha are good friends and had a lot of fun taking self-portraits with Cortnee's new camera.

The image in 6-17 is a creative way to compose a group portrait. The composition roughly follows the Rule of Thirds. The distance between the camera and the subjects allows the photographer to place the group low on the horizon and emphasize the difference in human scale and the larger environment. Although the subjects are in the distance and silhouetted, you can see this image captures the feeling of a moment shared by this group.

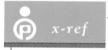

To read more about composition and the Rule of Thirds, see Chapter 4.

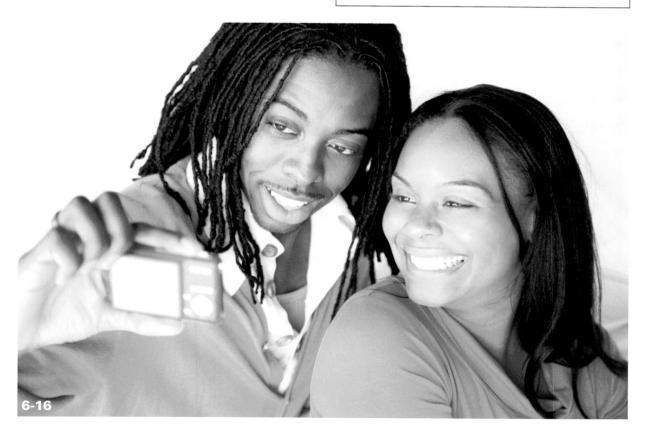

ABOUT THIS PHOTO Using a simple prop and indirect window light, I took a picture of a fun couple taking a picture. Taken at ISO 400, f/4.0, 1/125 sec. with a Canon EF 24-105mm f/4L IS lens.

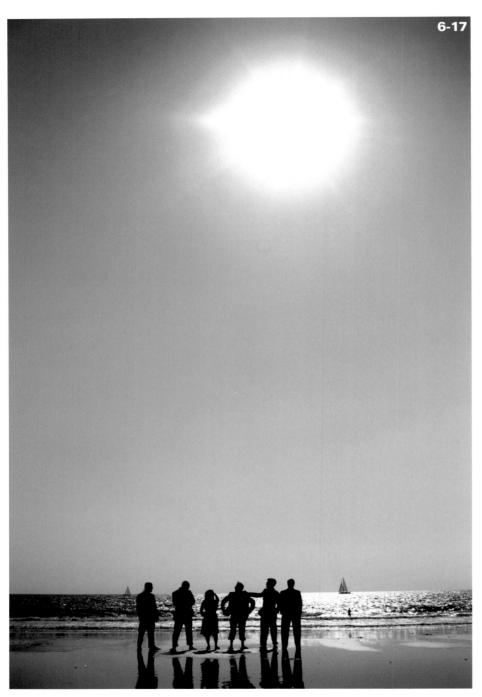

ABOUT THIS PHOTO

By exposing for the bright light in the scene, the photographer captured a silhouette of the group. The contemporary composition is achieved with the use of negative space in the image. © Robert Holley. Taken at ISO 100, f/5.6, 1/100 sec. with a Canon EF 17-35mm f/2.8 lens.

CHAPTER CHAPTER

The image in 6-18 was one of many fun shots taken in honor of Mary and Bob's 50th wedding anniversary. They were both very good sports as I suggested various ideas and activities to give their portraits a dynamic feel. Twirling each other, hugging, standing cheek to check, and dancing were just a few poses I photographed. As marriage is a sort of dance through life together, I thought this image of Mary and Bob depicted their closeness and zest for life.

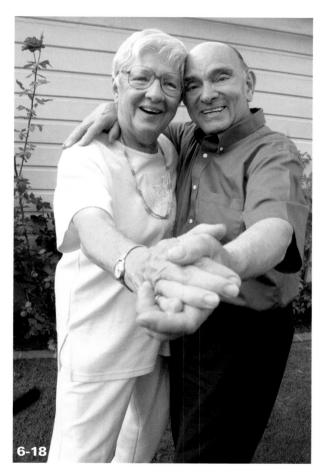

ABOUT THIS PHOTO I experimented with a wide-angle lens and directed Mary and Bob to move in close together and close to the camera to create an unusual viewpoint. Taken at ISO 400, f/5.6, 1/180 sec. with a Canon EF 17-35mm f/2.8 lens.

OPTIMIZE YOUR EQUIPMENT FOR GROUP SETTINGS

Your camera is a wonderful tool, but it's up to you to know how to use the camera to its fullest potential so that you can exercise your creative expression and technically capture the image when dealing with groups. Use these special settings to gain more control over your camera:

- Continuous mode. This setting enables your camera shutter to fire multiple times and capture images in quick succession so you never miss that special expression or great candid moment.
- **Self-timer.** Use this setting when you decide to join the group and get in the shot.
- Aperture priority. This gives you control over the DOF in your image by allowing you to choose the aperture setting; the camera then adjusts the shutter speed for the correct exposure. This setting is useful when you have larger groups and want to keep everyone from front to back in focus.
- Shutter priority. This setting gives you control over the motion and ambient light in your image by allowing you to choose the shutter speed setting; the camera then adjusts the aperture for the correct exposure. Try this setting when the light is less than perfect or the light isn't as strong.
- Landscape mode. The camera chooses a small aperture to ensure both foreground and background elements are in focus, and ensure the fastest shutter speed depending on the light in the scene.

- Portrait mode. The camera chooses a wide aperture that isolates your subject from a softly blurred background.
- Flash-off mode. The camera's flash does not fire regardless of how little light exists in the scene. The mode is great for museums, plays, or capturing the subtle nuance of expression in natural light.
- ISO. This setting is similar to film speed but instead it measures your digital camera sensor's sensitivity to light. Raising your ISO allows more light into your exposure and enables you to use a faster shutter speed for motion or a smaller aperture for greater DOF.

Remember that at higher ISOs, you may end up with noise in your image (grainy appearance).

White balance. This setting compensates for different light temperatures and can be used to adjust how your camera interprets the color cast of any type of light. For example, if you are shooting on an overcast day, there is likely a WB setting on your camera that counteracts the blue tone of the overcast day, with a warmer tone, neutralizing the colorcast in your image.

Assignment

Organize a Group Shot

The next time you are with a group of people, take that courageous leap and organize your group shot, whether it's your cousin's wedding reception or a child's soccer team. Check your location, consider your light source, get out your camera, use your directing skills, and give it a whirl!

To complete this assignment, I organized a group shot at Annie's high school graduation celebration. The party was held outside, so I found the best light in open shade and positioned her and her friends in a circle. This group portrait was taken from an elevated angle, and I positioned the girls' faces close together. Taken at ISO 200, f/4.0, 1/250 sec. with a Canon EF 24-105mm f/4L IS lens.

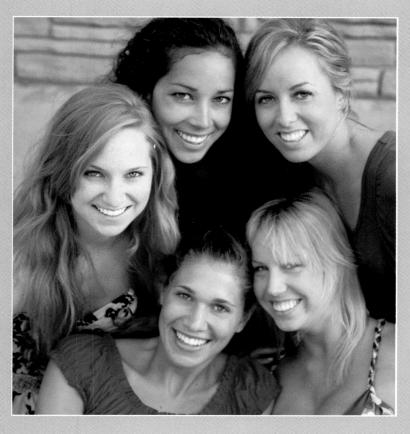

Remember to visit www.pwsbooks.com after you complete this assignment and share your favorite photo! It's a community of enthusiastic photographers and a great place to view what other readers have created. You can also post comments and read other encouraging suggestions and feedback.

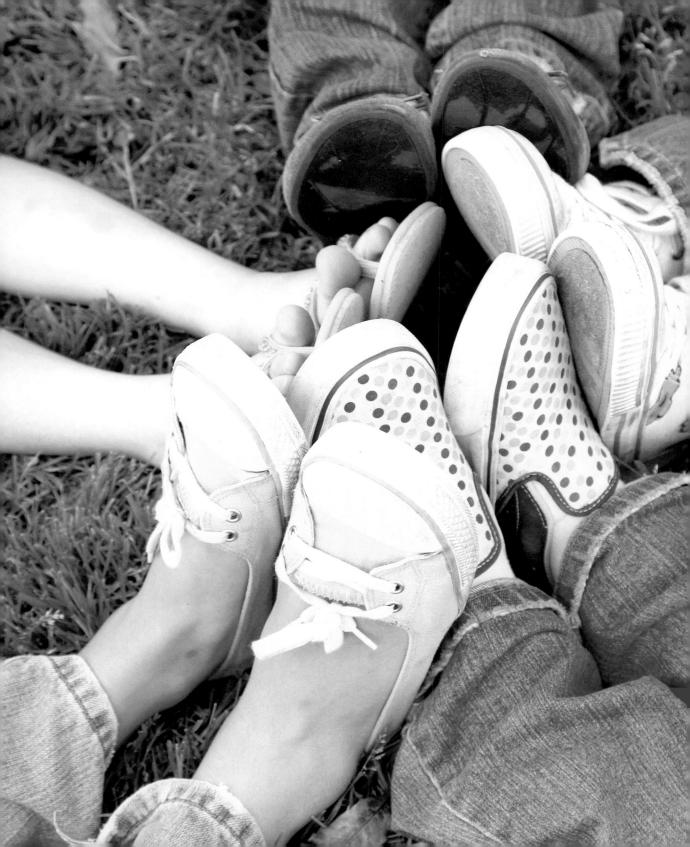

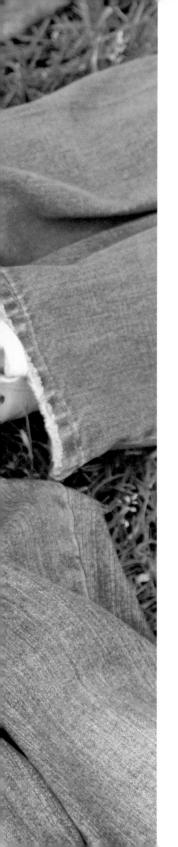

DIRECT THE KIDS KEEP IT REAL Frame the Shot Kids are a lot of fun to photograph, because they have myriad expressions, emotions, and energy. On the flip side, sometimes they have short attention spans and can be uncooperative and cranky, so it's important to understand how to prepare for taking a great picture. Kids also grow up quickly, but with the following tips, you can make the most of recording those unexpected, fleeting moments and capture priceless memories for the future.

Family portraits of children at different ages offer opportunities and challenges. You can capitalize on the natural dynamic between them, but you really need to be watchful for the special moments that occur. Siblings can interact positively or negatively, revealing a lot about their

relationship. In this chapter, not only do you learn some great ways to work with kids, you learn to recognize these kinds of moments and capture them yourself.

DIRECTTHE KIDS

When you are directing kids in a photo shoot, it's important to have an understanding of their particular needs, given their ages and individual temperaments. Find ways to help them relax in front of the camera — perhaps making jokes about their interactions with and reactions to each other or other members of the family. These siblings in figure 7-1 had fun rolling around in the sand and laughing at their mom. She was

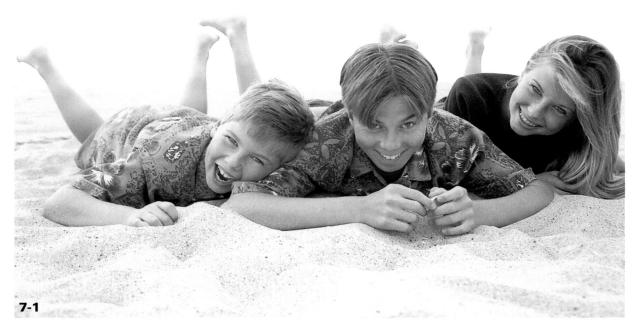

ABOUT THIS PHOTO An afternoon at the beach is always full of photo possibilities. Taken at ISO 200, f/8.0, 1/200 sec. with a Canon EF 70-200mm f/2.8L lens.

СНАРТЕЯ

right behind me making funny faces as I composed the shot. You want to capture their spontaneous behavior rather than have them pose before the camera. Try to engage children in the photography process. This helps them become involved and cooperative. There is nothing more difficult than dealing with a subject who is bored. Standing behind your camera and occasionally saying a few words to your subjects is not going to capture their attention or give you the expressions you were hoping for.

DIFFERENT AGES, DIFFERENT STAGES

An awareness of a child's general developmental stages will help you take better photographs. From the terrible twos through the teenage years, children react differently to the camera depending on their ages, personalities, and comfort level. Small children have short attention spans and become bored with a formal photo session in minutes, so be prepared with your setup and equipment before bringing the child into the picture-taking area. If an informal portrait or candid shot is what you're after, take time to observe the child; this way you can anticipate the special moment or unexpected expression. Play with toys, make funny noises, and be quick with your shutter button. Children ages four through ten are often experienced in front of the lens, which can be a problem. They may have learned to force a smile in order to please picture-takers. Avoid poses; instead, distract them from the camera and get them involved in a fun project. Making cookies, petting the dog, swinging on the swing, or blowing bubbles is much more fun than posing awkwardly and saying "Cheese"; and these

activities create opportunities to capture children's natural, spontaneous expressions. Preteens through 18 years are often more self-conscious in front of the camera and are very aware of your presence. Encouragement and acceptance go a long way in gaining their trust for a photograph. Concentrate on who the preteen or teen is in that moment and your image will express a thousand words, even if she is silent. Allowing her to do what she feels, as in 7-2 and 7-3, might result in getting the shot you want. It's reverse Psychology 101 — try it!

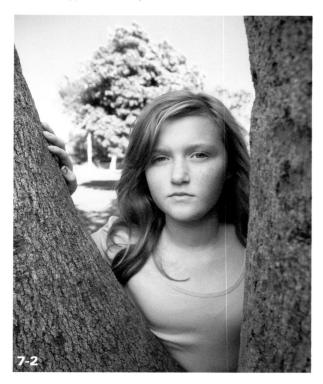

ABOUT THIS PHOTO Smiling isn't everything it's cracked up to be. This teenager was having a moment and I decided to capture it. Taken at ISO 200, f/6.0, 1/250 sec. with a Canon EF 24-105mm f/4L IS lens.

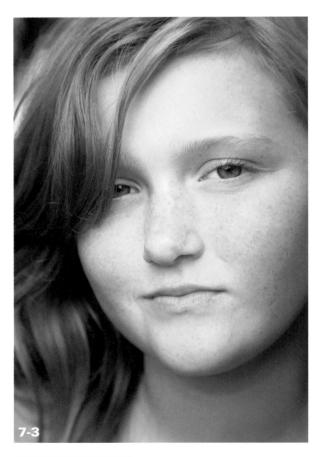

ABOUT THIS PHOTO After she was convinced I was not going to force her to do anything, a small smile developed, and I filled the frame with Bella's beautiful face. Taken at ISO 200, f/6.0, 1/250 sec. with a Canon EF 24–105mm f/4L IS lens.

GETTHEM INVOLVED

Kids grow more interested in participating in your photo shoot if you take the time to include them in the process. One of the benefits of shooting digital images lies in the ability to see what you've shot as you progress. As you're reviewing images on the LCD screen, share what you've captured with the kids, as shown in 7-4. If you show them what's happening behind the lens, they feel more important and invested in your photo project. Let them take self-portraits and have fun controlling the outcome (as in 7-5).

Another way to include the kids in your photo quest is to have them choose their favorite place as a location for your photo shoot. Knowing they helped plan your production builds their enthusiasm about having their picture taken.

I recently went on a trip to one of Jack's favorite places, the golf course. He had a photo project for school about "his favorite place," and instead of planning the shoot, I tagged along in hopes of taking great candid pictures of his adventures. It worked. He was so engrossed in his project that I was able to follow him around unnoticed and, by anticipating his expressions and gestures, record the moments of the day, as shown in 7-6, 7-7, and 7-8.

ABOUT THIS PHOTO

Older kids love to take self-portraits. Get them involved in the photo-taking process too. Taken at ISO 200, f/5.6, 1/250 sec. with a Canon EF 24-105mm f/4L IS lens.

ABOUT THIS PHOTO

Younger kids like to do anything the older kids are doing — don't leave them out. Taken at ISO 200, f/5.6, 1/250 sec. with a Canon EF 24-105mm f/4L IS lens.

ABOUT THESE PHOTOS Documenting life moments doesn't always include a gaze towards the camera. I had fun watching the activity and shot lots of pictures this day. The resulting images in 7-6, 7-7, and 7-8 are candid moments. Taken at ISO 100, f/5.6, 1/400 sec. with a Canon EF 70-200mm f/2.8L lens.

CHAPTER

KEEP IT REAL

A compelling photograph captures an authentic moment, look, or gesture that elicits a feeling from the viewer. Instead of forcing a child to strike a pose or force a smile, choose a location for your shoot, then encourage play, action, and activity.

ENCOURAGE REAL MOMENTS

Anticipating a moment means being observant of the people you are photographing and technically ready to control your camera in order to get the shot. Whether you are planning on shooting a formal portrait or following the action in a stealth-like manner, you need to be aware of kids' reactions and relationships in order to successfully capture them in an image.

If you already have a relationship with the kids, then you are probably aware of their personalities. If not, you need to create opportunities that allow the child's personality to emerge. A lot of adults feel that the camera is something they

have to tolerate and perform for, and kids are no exception. If children are forced to do anything, that reluctant expression is going to show up in the photograph. You have a better chance of capturing a natural expression and a real moment when children are allowed to be themselves.

Most people are happier when they are doing things they like to do or spending time with people they care about. When photographing children, include their friends, family, pets, or toys in your photo shoot and watch the fun begin. When I began, the three sisters in 7-9 were sitting nicely posed, waiting for my direction. I could have let them sit there sweetly with forced smiles, looking into the camera, but instead I asked them "who is the most ticklish?" and the result was a real, candid moment that revealed personality and a sense of relationship in the image. For some of the shots, the dog wandered in. You can see in 7-10 that Alexis and the beloved family pet both seem to be comfortable in their relationship and don't mind sharing it with the camera.

ABOUT THIS PHOTO All you have to say is "tickle" and kids know exactly what to do. Taken at ISO 200, f/5.6, 1/125 sec. with a Canon EF 24-105mm f/4L IS lens.

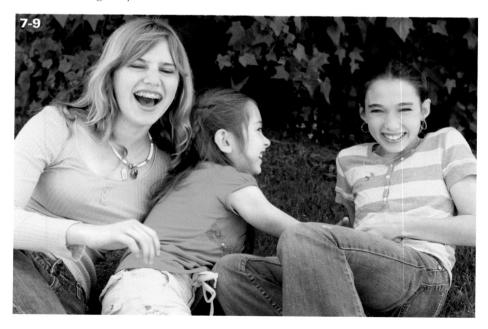

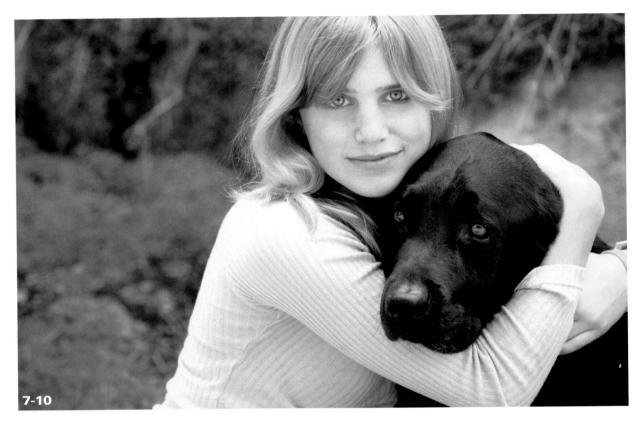

ABOUT THIS PHOTO A portrait with the family pet gives the photo another meaning. Taken at ISO 200, f/5.6, 1/125 sec. with a Canon EF 24-105mm f/4L IS lens.

OBSERVE AND CAPTURE REAL MOMENTS

Once children feel comfortable in your presence and forget about the intrusion of the camera into their world, you have the opportunity to observe their play and interactions. Your mission is to be on the alert for moments that are most revealing of the child's personality and responses to the environment. To be successful in your mission, you must be prepared.

To get your camera ready, look through your viewfinder, find your subject, then hold the shutter button halfway down to lock the exposure and prefocus. Keep holding the shutter button halfway down until the special moment occurs, then depress the shutter button the rest of the way. Doing this eliminates the usual shutter lag and allows you to quickly take the picture. Setting your camera to continuous mode is also an easy way to shoot a sequence of shots as the

СНАРТЕЯ

action is occurring. The amount of pictures you take is only limited by the capacity of your media card. Take a lot of pictures, even when you think the moment has passed, because that is often when real-life moments begin to happen. Don't wait for someone to look perfect or try to contrive an emotion; capture life as it is — perfectly imperfect. Authenticity in a photograph is something everyone can connect with.

In 7-11 you can see Jacob was tired after a festive birthday dinner for his grandmother. I was

watching him and noticed he had rested his head on the dining table chair, so I followed him with my camera and captured this quiet moment.

Use the scene settings on your camera's mode dial and experi-

ment. Use portrait mode for headshots; landscape mode for keeping people in focus in the foreground and background; night flash or slow synch mode to flash your subject's face yet capture ambient light in the background; and sports mode to freeze the action and reduce blur.

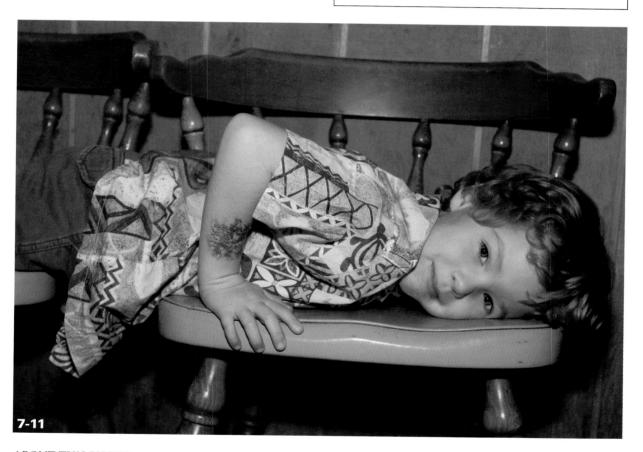

ABOUT THIS PHOTO I followed Jacob to his resting place on the chair and captured his natural expression from an unusual angle. Taken at ISO 400, f/4.0, 1/60 sec. with a Canon EF 24-105mm f/4L IS lens.

FRAMETHE SHOT

Images of children require some special considerations. Kids are smaller, have more energy and less patience, and their latest pictures are usually in demand by family and friends. Make your images something everyone enjoys seeing by following these rules of thumb.

EXPERIMENT WITH ANGLES

Nothing is more boring than watching someone's slideshow with images that are all taken from the same distance and perspective, but you can create a compelling story with your images by

experimenting with various angles. Take pictures from different distances and perspectives. An image shot from below your subject will look very different from one taken from above. Think about all the angles you can try, and don't forget to turn your camera from horizontal to vertical to capture elements above or below your subject. Figure 7-12 shows the viewpoint from behind the action on home plate.

Try to think of every possible angle you can shoot your subject from and incorporate at least two of these experimental angles into your next photo session. For the image in 7-13, I had Nyle sit on the ground and look up at me.

ABOUT THIS PHOTO A viewpoint from behind a few subjects allows me to focus on the pitcher. Taken at ISO 400, f/13, 1/200 sec. with a Canon EF 24-105mm f/4L IS lens.

CHARTER

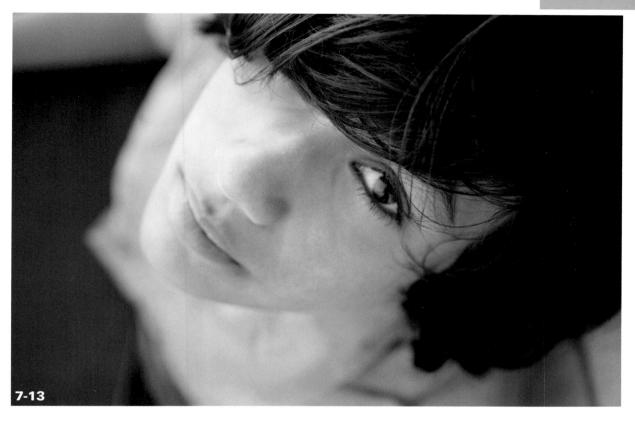

ABOUT THIS PHOTO Taken from above Nyle's head for an exaggerated effect, this angle gives the image a dynamic feel. Taken at ISO 250, f/4.0, 1/250 sec. with a Canon macro EF 50mm f/2.5 lens.

Mix up your angles for a unique and interesting image. Shot from down below, 7-14 depicts Nyle as being larger than life.

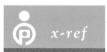

Refer to Chapter 4 for more information on composing your shot.

GET DOWN ON THEIR LEVEL

By positioning your camera at a child's eye level, you can create images that are more intimate and compelling. Kids relate to you, and you can capture more of their personalities and less of the tops of their heads. Be flexible: Kneel or sit down next to them, have a conversation, and take a lot of pictures.

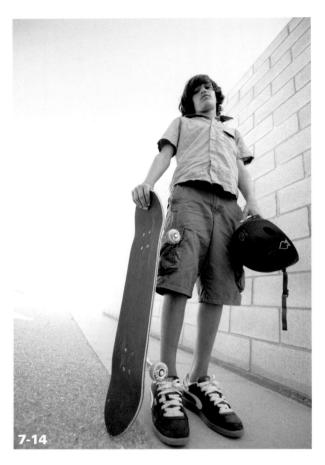

ABOUT THIS PHOTO This unusual point of view makes your subject appear larger than life. Taken at ISO 250, f/4.0, 1/320 sec. with a Canon EF 17-35mm f/2.8 lens.

GET CLOSE

Fill the frame with your subject to create greater visual impact, as shown in 7-15. Use your camera's zoom or long focal length lens to get closer and fill the frame, as shown in 7-16. By zooming in and emphasizing what's important, you also

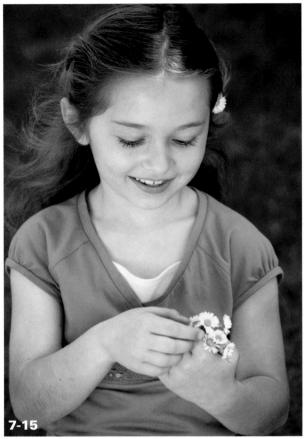

ABOUT THIS PHOTO Zooming in close allowed me to eliminate all the background clutter, and this girl's candid "flower" moment is very sweet. Taken at ISO 200, f/5.6, 1/250 sec. with a Canon EF 70-200mm f/2.8L lens.

exclude any distracting background clutter surrounding your subject. Unless you are intending to create a wide-angle effect, be careful not to get too close to your subject using the wide aspect of your camera's lens because your subject will appear distorted.

CHAPTER

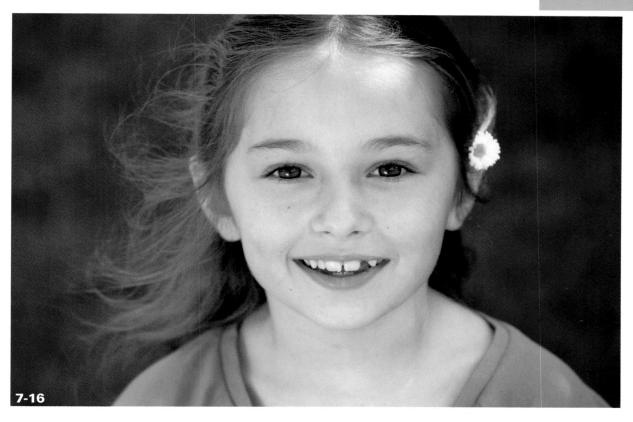

ABOUT THIS PHOTO Zooming in even closer creates a connection with the subject. Taken at ISO 200, f/5.6, 1/250 sec. with a Canon EF 70-200mm f/2.8L lens.

The best advice I can give you is to have fun, have patience, and keep things stress-free. Enjoy spending time with kids and sharing their adventures and games. Childhood lasts for but a moment; be sure you capture it well.

Assignment

Capture a Real Moment

For this assignment, bring your camera and take one or two kids to a park, or even the backyard. Have some fun — laugh, run, spin the kids around, and roll in the grass. Or bring a toy or game that helps them forget about the camera. It might help to have a friend assist you. Follow the kids' actions and capture candid shots from different angles. Choose your most compelling image, post it online at pwsbooks.com, and tell me why you like it.

To complete this assignment, I diverted Alvin's attention by playing with soap bubbles in the backyard. He was mesmerized with catching the bubbles, which made it easy to capture an authentic expression in this image. Taken at ISO 800, f/3.5, 1/250 sec. with a Canon macro EF 50mm f/2.5 lens.

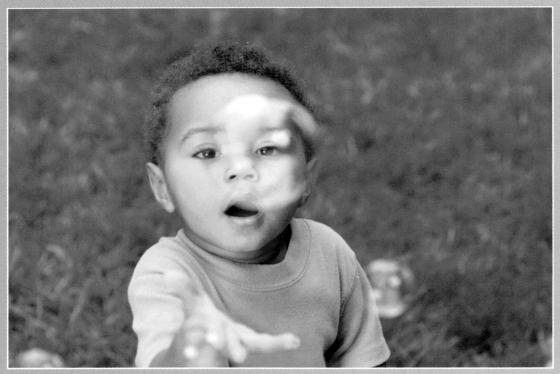

© Workbook Stock / Erin Manning

Remember to visit www.pwsbooks.com after you complete this assignment and share your favorite photo! It's a community of enthusiastic photographers and a great place to view what other readers have created. You can also post comments and read other encouraging suggestions and feedback.

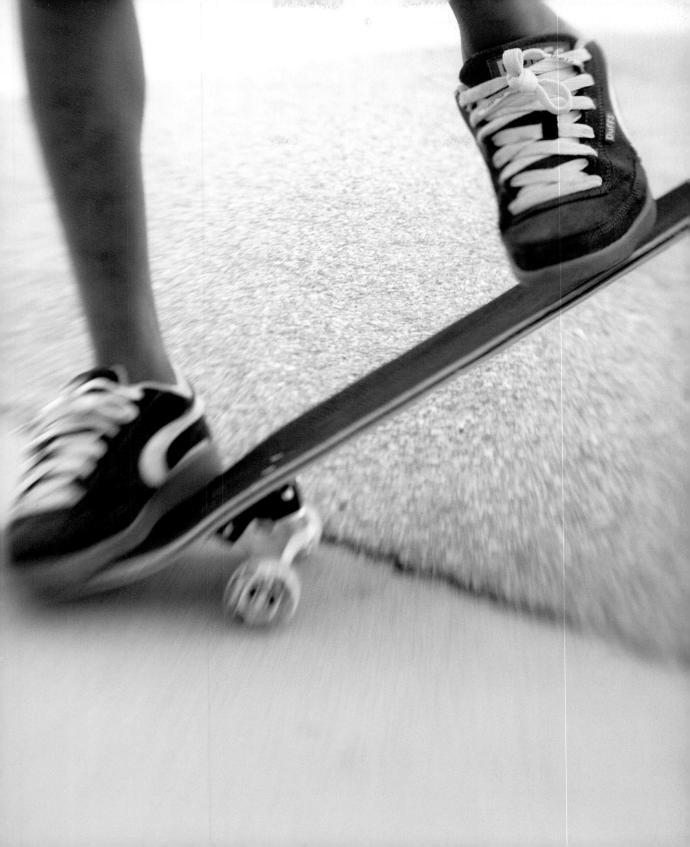

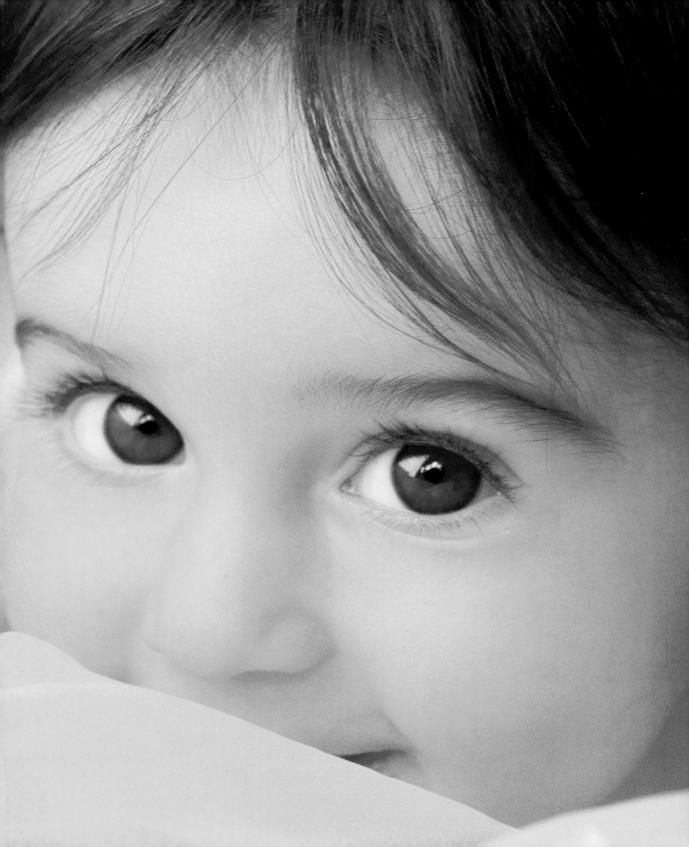

GET COMFORTABLE WITH THE BABY KEEP IT SIMPLE USE SOFT LIGHT SEIZE THE MOMENT

There is one subject in the world you can never have too many pictures of — a baby! Film and developing costs can be quite expensive, especially when taking a great number of images. Luckily, shooting images with a digital camera is cost effective — you can take as many as you'd like.

Other than just being really cute subjects, there are a lot of "firsts" in a baby's life so it's important to take pictures often, capturing each phase of a baby's development before he or she grows up. Perhaps more memorable in the long run are the things a baby does all the time while growing up: eating their oatmeal, playing with a puppy, standing up in their crib, crying, laughing, or any daily activity that depicts the reality of life.

Whether you're a parent, an aspiring baby photographer, or have a lot of friends and family with babies, follow these rules for photographing the little darlings and you're on your way to capturing magical moments and creating fantastic images that are treasured forever.

GET COMFORTABLE WITH THE BABY

The term "comfort" is subjective for many adults, but for babies there is a special formula to ensure their comfort. If you intend to shoot for more than 30 seconds and capture happy, spontaneous expressions, it's best to abide by these guidelines.

note

The approximate age of a baby is 0 to 18 months old, and a toddler can

be defined as 12 months to 2 years old. There is crossover-some babies develop faster than others.

PLAN YOUR TIMING

One way to photograph babies is to make sure they are already rested, fed, and changed before your photo shoot; then position them in the area vou've prepared for the photo session. Another way is to follow the action in a photojournalistic manner and record moments during a baby's daily rituals. Either way, you need to adjust your photo shoot around the baby's schedule. Every infant has a ritual of eating, sleeping, bathing, and changing with some crying, bonding, and play intertwined. If you're the parent, by now you know your child's optimum times for interacting. If you're photographing someone else's baby and don't have all day to follow the action, be sure to communicate with the parents about the baby's schedule. Ask them when the child seems most engaged — some babies are more alert in the morning, while others seem more animated in the afternoon. Noa, perched on her mother's shoulder, had just finished a nap and was giggling at my assistant's imitation of a duck when I snapped the shot in 8-1.

Happy and animated after her midday nap, Noa, who is ten months old, really warmed up and enjoyed having her picture taken, as you can see in the series shown in 8-2, 8-3, and 8-4. I took advantage of the indirect window light and filled in the shadows with a continuous light source.

CREATE THE RIGHT ENVIRONMENT

If you show up with a camera and abruptly start shooting pictures, you run the risk of upsetting the baby and missing out on those special moments you intended to photograph. If you aren't familiar with the baby, take the time to slowly introduce yourself with smiles and coos, get down on the baby's level, and say hello. If you plan on getting in close for upcoming baby shots, it's a good idea to introduce your camera, too.

8

ABOUT THIS PHOTO

Noa was facing towards indirect window light as she peeked at me over her mother's shoulder. Taken at ISO 200; f/5.0; 1/100 sec. with a Canon macro EF 50mm f/2.5 lens.

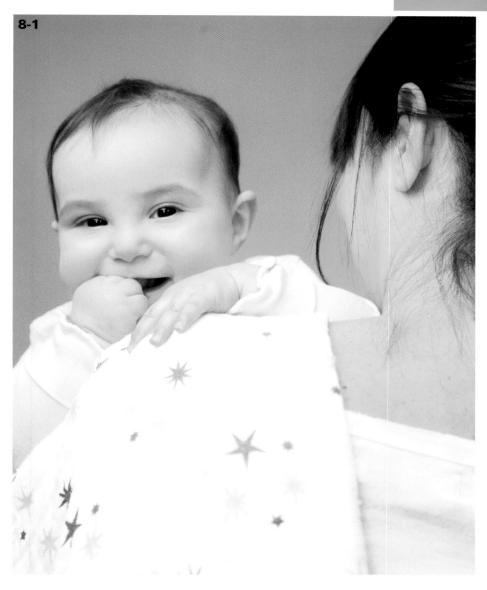

When babies feel comfortable with your presence and your camera, they soon forget the camera and this can lead to capturing many memorable pictures.

Just like Baby Bear's porridge, the temperature must be "just right" for the baby, which means it errs on the warm side. If you are inside, make sure the shooting environment is cozy and quiet. Music can also influence the ambiance. Newborn babies are soothed by soft music and are startled and frightened by loud, unexpected noises. For a more active photography session, older babies through toddlers can be energized by rhythmic dance music.

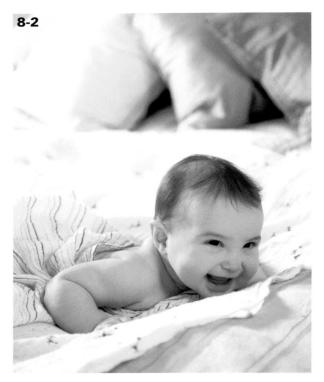

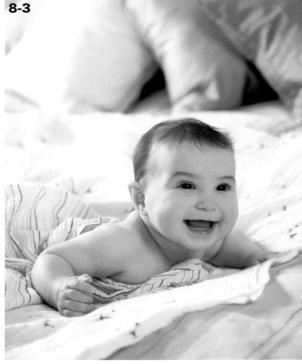

You might be short on time or frustrated with your equipment, the light, or other people in the room, but do not allow this stress to enter into the shoot. Babies and toddlers are human sponges, picking up all the emotions and tension in the room. Take a deep breath, be patient, and don't let any negativity ruin your baby photo session. These moments are important and priceless.

ACCOMMODATE FOR THE AGE

Depending on the age of the baby you are photographing, certain challenges can be expected. For example, newborn infants are like rag dolls and must be held for any pose, while 18-month-old babies will be walking, exploring, and playing, and unless they are sleeping, in constant movement. The following list explains how babies generally behave and respond according to their age, as well as offers ideas for forming your approach:

Zero to three months. Babies in this age range have no mobility or strength. Unless they're sleeping or in horizontal poses, they must be held for a photograph. They sleep a lot. Take some shots of the baby sleeping and being held by friends or family members, and don't forget those close-up pictures of fingers and toes. Anya is only six weeks old and needs to be held in order to take the photo, as shown in 8-5. Outside, in soft, open shade, I positioned her in the doorway and zoomed in close to capture her expressions and isolate her from the background, as shown in 8-6 and 8-7. This helped eliminate any surrounding distractions and you'd never know that she was being held.

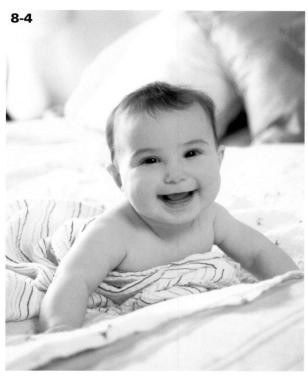

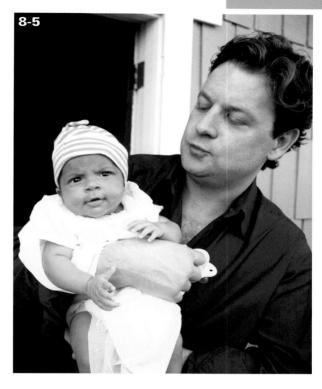

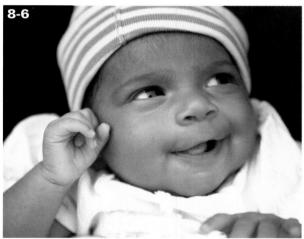

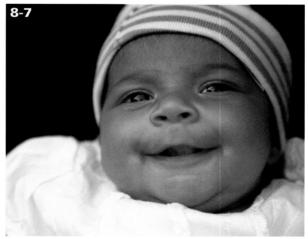

ABOUT THESE PHOTOS Even while tiny babies are held as in 8-5, you can still get great close-up portraits capturing nuances in their expressions and eliminating distractions as in 8-6 and 8-7. Taken at ISO 200, f/4.0, 1/320 sec. with a Canon EF 24-105mm f/4L IS lens.

Three to six months. They can raise their heads and chests when they are put down on their tummies. Take shots of the baby lying on the floor, in a crib, or with a parent, or position the baby over a blanket mound or sofa cushion. Little three-month old Poppy is positioned on a furry blanket in a classic baby portrait pose in figure 8-8.

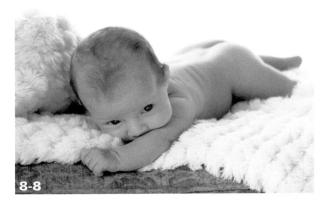

ABOUT THIS PHOTO Three-month-old Poppy was comfortable and happy when I positioned her on a warm blanket. Taken at ISO 400, f/4.0, 1/1000 sec. with a Canon EF 70-200mm f/2.8 lens.

- Six to nine months. Most babies are beginning to sit up on their own and can feed themselves with finger foods. You can creatively pose them, but prepare for movement at any time. Think about taking candid action shots when they are eating or playing. Six-month-old Amelia was sitting at a table, happily playing with her toys when I captured the candid moment shown in 8-9.
- Nine to twelve months. Now they are reaching for toys, can pull themselves up, and may be beginning to walk. Capture a moment with a baby and his blanket or favorite stuffed animal. Figure 8-10 captures a playful moment between eleven-month-old Mia and her dad.

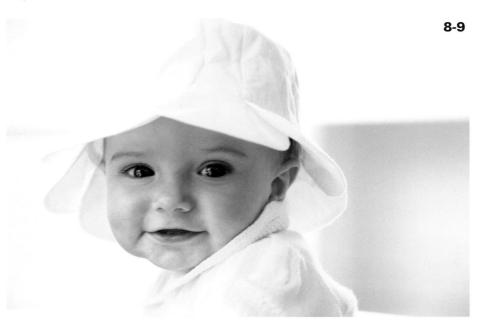

ABOUT THIS PHOTO By positioning myself at Amelia's level and remaining ready with the shutter button, I was able to capture a natural expression in this photograph. Taken at ISO 200, f/5.0, 1/100

sec. with a Canon EF 24-105mm f/4L IS lens.

ABOUT THIS PHOTO I placed Mia on her dad's lap and took a lot of photographs when they began to play. Taken at ISO 400, f/11.0, 1/125 sec. with a Canon EF 17-35mm f/2.8 lens.

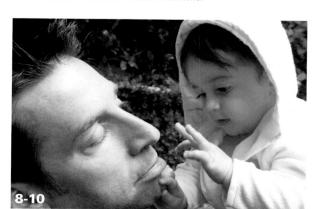

■ Eighteen months. The baby is walking — get ready to follow the action! The world is a new and exciting place for babies and toddlers. Try to capture their interactions and fascination with the experience. Eighteen-month-old Natalie is full of wonderful expressions as she reacts to her mother's storytelling in figure 8-11.

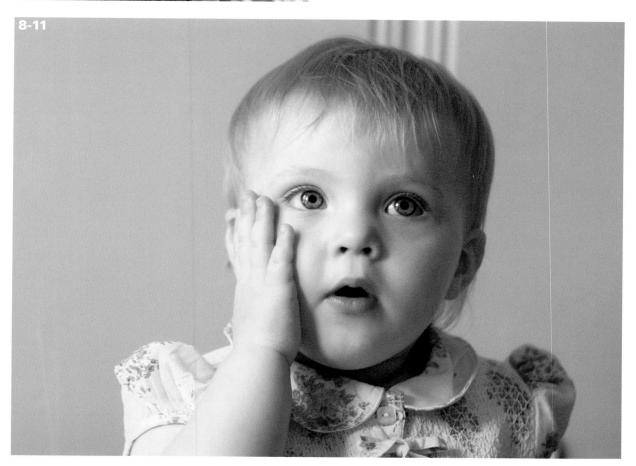

ABOUT THIS PHOTO Natalie was running around the house but stopped to listen to her mother's stories. Taken at ISO 400, f/4.0, 1/1000 sec. with a Canon EF 70-200mm f/2.8 lens.

KEEP IT SIMPLE

Less is more when taking beautiful baby portraits. Think Zen. Clean, calm environments with few people, minimal noise, and unobstructed backgrounds allow you to focus completely on the baby and produce quality images that everyone wants to see.

PREPARE THE BACKGROUND

If you are taking pictures inside the home, check your surroundings and remove any background clutter before taking the shot. Clear out items that get in the way and compete for attention in the photograph — keys, toys, shoes, boxes, dying plants, anything that can distract the viewer's eye.

Another way to simplify the background is by using a backdrop, and you don't need to purchase a professional one from the camera store. Get creative and look around your house for solid colored blankets, throws, sheets, even fabric remnants, which work well as backdrops, as shown in 8-12. Pictures of a baby lying on a sofa or on a bed offer perfect scenarios for using a white sheet. It's a large, inexpensive backdrop and also reflects light, filling in the shadows beneath the baby.

ABOUT THIS PHOTO Mia is 11 months old and had fun rolling around on the floor with my silky fabric remnants. Taken at ISO 400, f/8.0, 1/200 sec. with a Canon EF 17-35mm f/2.8 lens.

CHAPTER

Photographing a baby propped up in a colorful car seat or baby carrier is common, but also presents a challenge. While these seats enable the baby to sit securely and upright, they don't provide the most photogenic background. Often the fabric covering is very bright and colorful and has the manufacturer's nametag located near the infants head. This is very distracting. You can easily fix the problem by placing a soft-colored

solid blanket or throw under or around the baby, as shown in 8-13. Choose a background color that enhances the baby's eye color. Have a friend or family member hold the backdrop or blanket behind the baby and zoom in to eliminate anything distracting in the background, as in 8-14 and 8-15. What makes these photos so special is that the blanket used as a backdrop has a special meaning — Max's mom knitted it herself.

ABOUT THIS PHOTO I covered the busy print on Max's chair by placing a solid-colored blanket over the top, behind his head. Taken at ISO 200, f/4, 1/125 sec. with a Canon EF 24-105mm f/4 L IS lens.

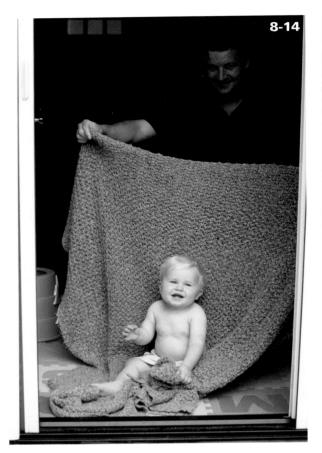

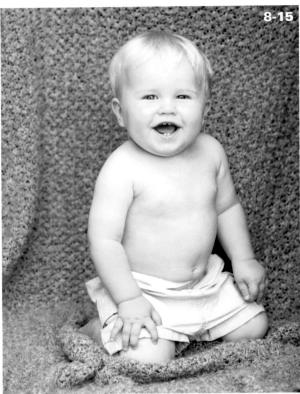

ABOUT THESE PHOTOS An easy way to simplify the background is by using a solid colored blanket or sheet as a backdrop, as in 8-14. Notice how the blue blanket used enhances Max's beautiful, blue eyes, and when zooming in for the picture, as in 8-15, it eliminates distractions. Taken at ISO 200, f/5.0, 1/100 sec. with a Canon EF 24-105mm f/4L IS lens.

PREPARE THE BABY

Given many successful baby photographs are taken at close range, do yourself a post-production favor and make sure the baby is completely clean before beginning the photo shoot. When you look at an image up close, you will see dirty fingernails, boogers, eye goop, stray blanket fuzz, and forgotten food that you wished you had taken the time to wipe off. It's possible to fix these problems later in an image-editing software program, but after retouching the twentieth image

with dirty fingernails, you might change your mind. One way to begin the photo shoot is in the sink or bathtub. This activity is multitasking at its best. You can capture poignant, timeless shots and clean the baby at the same time — just make sure you have help.

CHOOSETHE RIGHT CLOTHING

The simplest outfit for a baby is nothing at all. Naked babies are cuter than a bee's knee; however, not all photo opportunities call for bare

CHAPTER

bottoms. The clothing selection for a baby's photo shoot is similar to the background selection: soft, light, solid colors, as in 8-16. No busy patterns, stripes, logos, or food-stained clothing that distracts your eye away from the subject. Soft texture knits, silk, angora, faux fur, or anything that denotes softness enhances your photo.

POSITION THE BABY

I am an advocate of natural "poses," which aren't really poses at all, just thoughtful positioning.

You need to consider the environment you are working within, the age of the baby, and your light source when positioning a baby for a photo shoot. Do not force a baby into any dangerous, uncomfortable, or contrived pose or position. Any images created in this manner look phony and forced and you could possibly go down in family history for baby endangerment. You can set up a backdrop, safely place the baby in the picture-taking area, and encourage a reaction with various tricks of the trade, such as tickling them with a feather, playing with their favorite

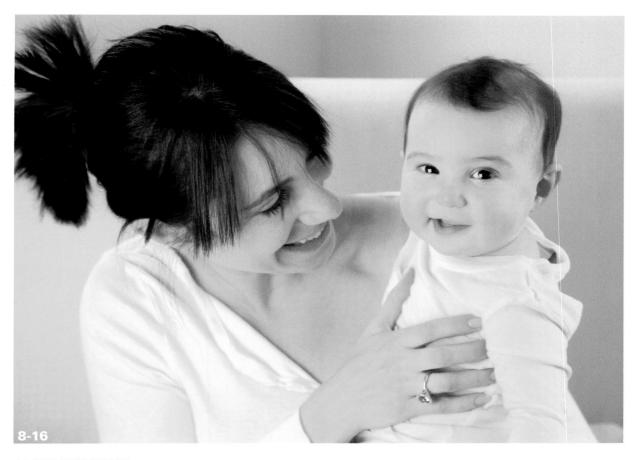

ABOUT THIS PHOTO Noa looks pretty in pink. The soft, solid color outfit allows your eye to focus on her sweet expression, instead of a busy patterned fabric. Taken at ISO 200, f/5.0, 1/60 sec. with a Canon EF 24-105mm f/4L IS lens.

toys, or even feeding them yummy treats. You then follow the action with your camera poised and ready to go or you patiently wait for the moment to occur. You are only the adult here; in baby photography, the baby rules.

PLAY WITH PROPS

You don't have to use props, but they can be fun to experiment with, especially if they have significant meaning or convey a message. Blankets, stuffed animals, favorite toys, flowers, Easter eggs, holiday wrapping paper, there are so many options. And props don't have to be inanimate

objects. Friendly family pets and even other babies can make a photo shoot much more interesting. Just remember: The prop must be shown in a natural way with the baby or it will look contrived. In the series of photos shown in 8-17, 8-18, and 8-19, you can see that little Max was thrilled to play with bubbles in the backyard. My assistant held a diffuser over Max to soften the harsh sunlight as Max's dad turned on the bubble machine. I was able to capture some really authentic expressions — the kind that can only be captured by entertaining your subject with props.

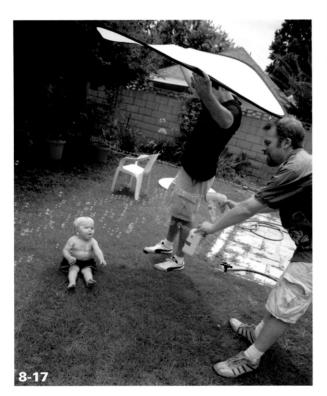

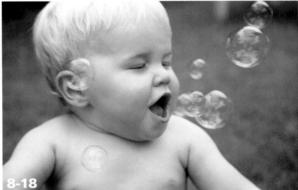

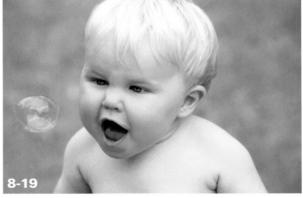

ABOUT THESE PHOTOS With a little help (8-17), I used bubbles as a prop as I photographed Max in the backyard. Taken at ISO 200, f/5.0, 1/100 sec. with a Canon EF 24-105mm f/4L IS lens. Max had so much fun playing with the bubbles that he forgot I was there with my camera (8-18 and 8-19). Taken at ISO 200, f/4.0, 1/800 sec. with a Canon EF 24-105mm f/4L IS lens.

CHAPTER

One of my friends, Denise George, is an international photographer who has lived throughout Europe and Asia. She had an interesting photo challenge while working in Hong Kong — taking images of a couple's baby for their "We're Moving" note card. She could have forced Charlotte to hold up a "We're Moving" sign, but given she was only 11 months old, that would

appear unnatural. Instead, Denise considered all the possible objects that would convey "moving" and chose moving boxes as a prop in the photograph. She then placed Charlotte into the cardboard box "set" and let her play. You can see the results in the photograph in 8-20. Very natural, very effective, and very cute!

ABOUT THIS PHOTO Using window light as her main light source and cardboard boxes as a prop, Denise achieved her objective — a beautiful baby shot that conveys the visual message "We're moving." © Denise George. Taken at ISO 400, f/5.6, 1/125 sec. with a Nikon ED 80-200mm f/2.8 lens.

USE SOFT LIGHT

Everyone knows that babies are delicate, soft creatures, but did you know that delicate, soft, light can result in beautiful baby images? Soft light is flattering to almost any subject, especially a baby's delicate skin and features. The hard, harsh light produced by an on-camera flash or open, midday sun flattens out the shape and form of a baby's face, casts harsh shadows, and eliminates the natural light and ambiance in the scene. So how do you find or create the most beautiful and effective light for your photographs?

You can achieve a beautifully lit scene by following the suggestions outlined in the following sections.

FIND SOFT LIGHT

Indirect light is soft and even and can be found inside with window light, in an open doorway, under a skylight, or outside in open shade. For example, 8-21 was taken at mid-afternoon when one-year-old TJ was sitting in a highchair on the porch outside, in open shade. Notice how the light on his face is even and soft and not too bright. This way, he can show us his baby-blue

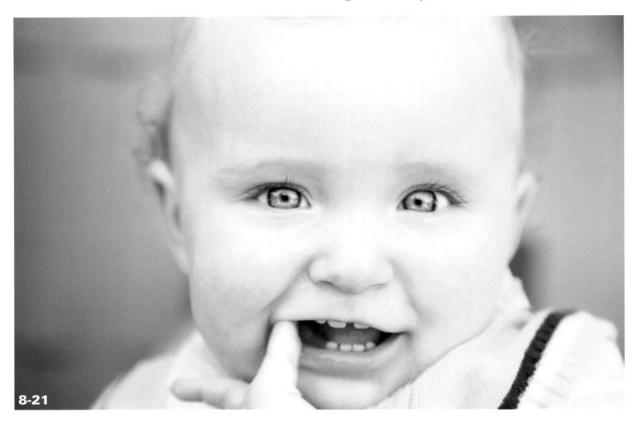

ABOUT THIS PHOTO Taken mid-afternoon in open shade allowing for soft, even light. Taken at ISO 200, f/5.0, 1/100 sec. with a Canon EF 24-105mm f/4L IS lens.

CHAPTER

eyes without squinting. Locations such as these, with soft, indirect light, are good places to take pictures because they provide even lighting and eliminate harsh shadows and bright highlights.

As an exercise, look around your house, inside and out, during different times of the day, and locate areas that provide soft light.

CREATE SOFT LIGHT

One way to achieve soft light is by turning off your on-camera flash and using natural light. Although studies have shown that a camera flash at close range apparently does not damage a baby's eyes, my thought is, why take a chance? Not to mention, a harsh on-camera flash can startle and irritate a baby. If you turn off the flash, you have an opportunity to capture photographs that are more natural looking and depict the true ambiance of the scene.

Suppose that you've turned off your flash and now it's a little too dark on one side of your subject's face. You can control natural light by reflecting it back into your scene with a reflective object. Professional reflectors come in white, silver, and gold, but homemade reflectors can also do the job. Use a car reflector, a whiteboard, or cover a baking sheet with aluminum foil. By reflecting light, you are filling in the shadows and creating a *catch-light* in your subject's eyes. This method is called *bouncing light*.

For more information about light and controlling the light, refer to Chapter 3.

If it's too dark to turn off your on-camera flash, try using an external flash. External flash units allow you to point your flash in almost any direction. By directing your flash towards the ceiling, it bounces off the ceiling, diffuses, and falls softly upon your subjects below. This method works best if the ceiling is not more than 12 to 15 feet high, because the flash may not reach that far. The color of the ceiling will reflect back onto the baby, so make sure it's a light color and doesn't look unnatural. Reflected white light is more flattering than other colors, especially on a baby.

note

Catch-light is the twinkle of light found in your subject's eyes. If your

subject is lacking a catch-light, you can create a twinkle by bouncing soft light back into their face. A catch-light draws attention to the eyes and livens up the face.

Placing your subject in direct sunlight can create harsh shadows across the face and squinted eyes. It's not the optimum lighting situation, but there are those rare occasions that require a photograph outside in midday sun. A solution for eliminating shadows is to force your camera's flash to fire while shooting outside in bright light and fill in those harsh shadows on the baby's face. A good rule-of-thumb is to stand about 6 to 9 feet away and use your camera's zoom or long lens to get in close and fill the frame with your subject. This ensures the flash reaches the baby yet won't overexpose the baby's face with intense light. Consult your camera manual to check your camera's flash range.

p tip

Turn off your flash and use a fast shutter speed (1/250 second or

higher) to capture the action and produce sharper images. Newborns can move unexpectedly, and older infants and toddlers are always on the move. If the light is too low and you cannot use a fast shutter speed, try increasing your ISO.

SEIZETHE MOMENT

You've probably heard the expression "carpe diem," Latin for "seize the day." In photography, it's a reminder to observe and capture those fleeting moments in life. Some moments unfold

quietly on their own; others need some coaxing to get started. Either way, it is necessary to be technically prepared and visually attentive to recognize and capture human nuances that comprise a meaningful photograph. In 8-22 and 8-23, you can see twins, TJ and Riley, celebrating their first birthday with very different expressions and reactions to the festivities.

Isolating your subject from the background requires a shallow depth of field. For more on DOF, refer to Chapter 1.

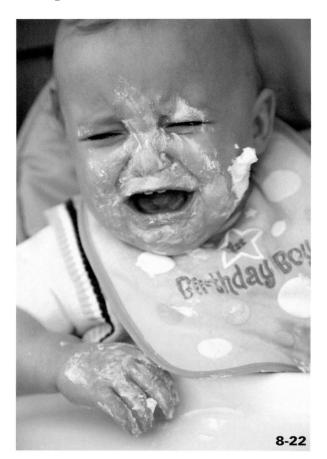

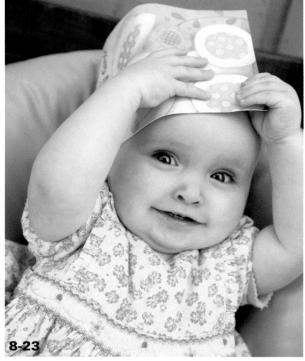

ABOUT THESE PHOTOS Twins, TJ and Riley, have different personalities and a wide range of expressions. Taken at ISO 200, f/5.0, 1/100 sec. with a Canon EF 24-105mm f/4L IS lens.

CHAPTER

CAPTURE SOMETHING MEANINGFUL

Relationships, emotions, and reactions — they come in many shapes and forms, and if you capture any of them in a photograph, you have created an interesting visual image. It's possible to photograph myriad emotions if you are prepared and patient when shooting pictures of a

baby. Keep your camera ready — a telling expression or emotion could occur at any time, as shown in 8-24 and 8-25.

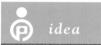

Design a special birth announcement using an image of a baby's feet or hands.

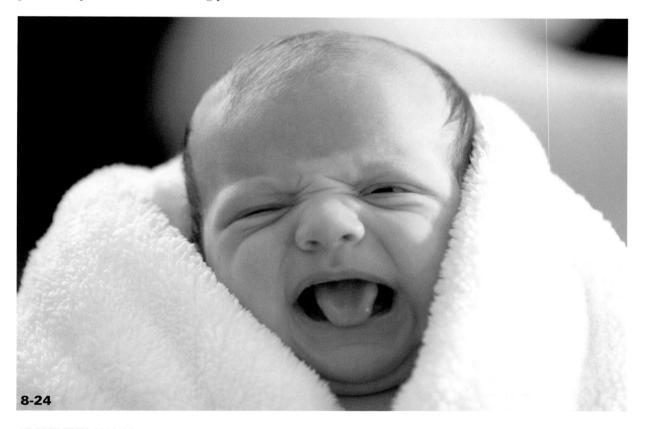

ABOUT THIS PHOTO Every expression can't be happy. Shot in the afternoon, inside a home with a lot of indirect window light, three-month-old Poppy was being held after a feeding and was ready for a nap. Taken at ISO 400, f/4.0, 1/250 sec. with a Canon EF 70-200mm f/2.8 lens.

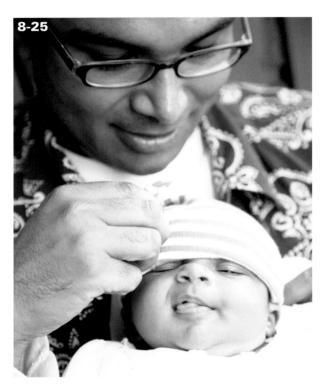

ABOUT THIS PHOTO A new father shares a tender, poignant moment with his six-week-old daughter, Anya. I shot this outside, in mid-afternoon open shade. Taken at ISO 400, f/4.0, 1/250 sec. with a Canon EF 24-105mm f/4L IS lens.

FOCUS ON THE EYES

The eyes are the first place people look when viewing a portrait, so make sure the baby's eyes are in focus in your image. To ensure sharpness, use the autofocus lock. Focus on the baby's eyes and press the shutter button halfway down to lock in the focus. Continue holding the button until you compose your shot, and then depress the shutter completely to take the shot.

USE CONTINUOUS SHOOTING MODE

Babies are often in constant movement. This is where your action photography skills come in handy. To capture a sequence of images in rapid succession, use your camera's continuous drive mode. By using continuous drive mode you won't miss any moments-between-the-moments and the action will be contained within your sequence of images. Remember to keep taking pictures even after you think the moment has passed. This is often when magical, unexpected things happen.

REMEMBER THE DETAILS

A baby's fingers and toes are tiny for only a short time, so don't miss the opportunity to photograph these details. Set your camera to the macro mode and get in close to fill the frame. Closeness represents intimacy in an image and creates visual impact. In 8-26, Anya's six-week-old hands are delicate and expressive. Notice how I used the Rule of Thirds to compose the shot and was careful not to crop out any of her fingers.

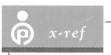

Learn more about creative composition techniques in Chapter 4.

All parents want a photograph portraying their relationship with their child. Hands and fingers are one of the many ways to communicate this special connection, as shown in 8-27.

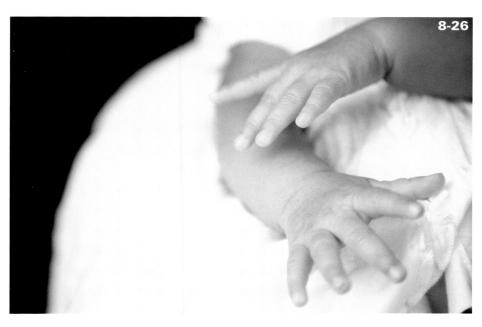

ABOUT THIS PHOTO Close-up shots of a baby's hands are precious and important details to photograph. Taken at ISO 200, f/4.0, 1/320 sec. with a Canon EF 24-105mm f/4L IS Iens.

ABOUT THIS PHOTO
The bond between a parent and child is a meaningful moment to capture in a photograph. Taken at ISO 400, f/2.8, 1/180 sec. with a Canon EF 70-200mm f/2.8 lens.
© Workbook Stock/Erin Manning

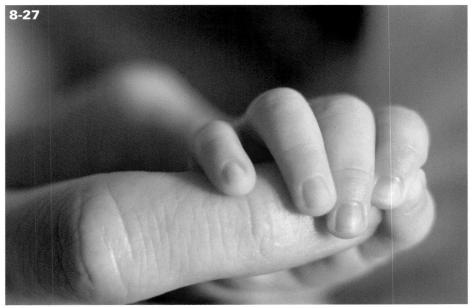

Assignment

Capture a Real Moment

For this assignment, spend time with a baby and document her morning or afternoon routine. Experiment with different angles, and concentrate on capturing natural, candid moments. The baby does not have to be looking into the camera. Choose your favorite image, post it online at www.pwsbooks.com, and tell others why you like it.

To complete this assignment, I captured an image of Natalie having her lunch. I crouched down at a low angle next to Natalie's highchair and waited for the action and expressions to begin. She was focused on eating her lunch, which made it easier for me to capture her natural movements and expressions. By taking a lot of photographs in Continuous mode I was able to capture a real moment in her daily routine. The photo was taken at ISO 800, f/2.8 at 1/250 sec. with a Canon EF 17-35mm f/2.8 lens.

© Workbook Stock/Erin Manning

Remember to visit www.pwsbooks.com after you complete this assignment and share your favorite photo! It's a community of enthusiastic photographers and a great place to view what other readers have created. You can also post comments and read other encouraging suggestions and feedback.

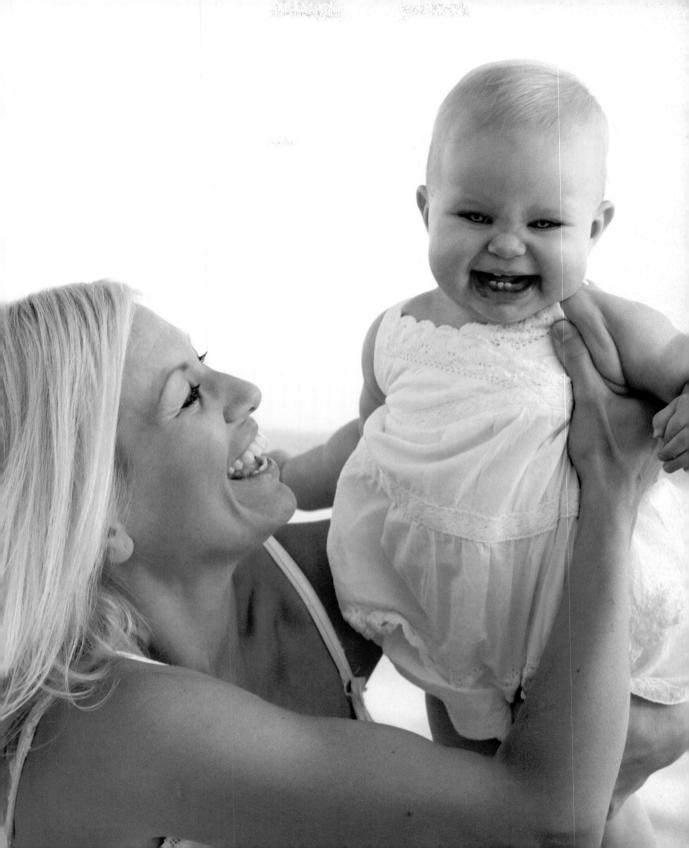

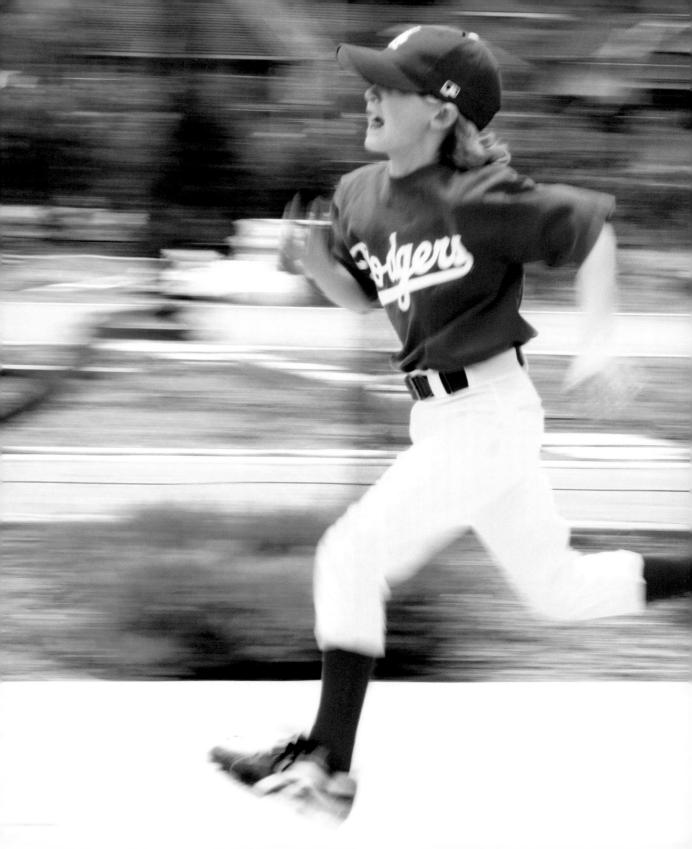

USE YOUR CAMERA AND LENS
FREEZE THE ACTION
BLUR THE MOTION

Action captured in a photograph denotes movement and life, giving an image a dynamic feel. Some action images freeze a moment in time, and others blur reality with a dream-like aesthetic. The first step in learning how to capture and create these effects is knowing the options available with your particular camera and lens, which is covered first in this chapter. Beyond that, you lean about the techniques for capturing motion, whether you want it crisp or blurred for effect.

USEYOUR CAMERA AND LENS

If you are using a compact digital camera, your ability to capture fast-action photographs like the pros is very limited. Although you can use a few settings to capture action with your compact camera, to get those close-up, fast-action, blurred-background, professional shots, you need a digital single lens reflex (dSLR) camera and a fast lens. Whichever type of camera you use, you can creatively capture action, provided you understand its limitations and the options. The next sections provide tips for capturing action with a compact digital camera and a dSLR.

COMPACT CAMERAS

Compact cameras have an action (or sports) mode that automatically adjusts the exposure settings to capture action with a faster shutter speed. The optical zoom feature allows you to get a little closer to the action, and you have the freedom to experiment and take as many pictures as you want. Just delete the ones you don't like. Here are

a few pointers for optimizing your action-shot chances when shooting with a compact camera:

- Use the optical viewfinder instead of the LCD viewfinder when you're photographing action. When people or objects move too quickly, the LCD viewfinder cannot render what the camera sees quickly enough, and your subject becomes a blur. This makes it difficult for you to follow your subject in action. Use the optical viewfinder instead to track your subject. *Tracking* (also known as *panning*) means keeping your camera fixed on your subject as he or she moves against the background. Tracking can result in spectacular pictures in which your subject is in focus against a blurred background, creating an impression of movement, as shown in 9-1.
- Set your camera to action mode to achieve the best results when you're photographing people in motion. Action mode automatically increases the aperture to let in more light and uses a faster shutter speed to capture a moving subject.
- Prefocus your shot. Your camera needs time to focus, and you might experience a slight delay when you fully press the shutter button in one move. By holding the shutter button halfway down while tracking your shot and then fully pressing the shutter to capture the shot, you can time your shots and minimize the impact of any shutter lag. Another way to focus your shot is to prefocus on a point you anticipate your subject is going to cross and then fully press the shutter when the moment occurs.

GHARTER S

ABOUT THIS PHOTO

As Nyle rode his skateboard down a long incline, I tracked his movement by looking through the optical viewfinder and following him with my camera. Taken at ISO 250, f/32, 1/15 sec. with a Canon EF 70-200mm f/2.8 lens.

■ Get closer to the action by using your camera's optical zoom. Most compact digital cameras have 3x optical zoom. The more optical zoom you have, the farther away from the action you can be. If you plan to take a lot of pictures of soccer games or baseball, you may want to invest in a camera with 10x to 12x optical zoom.

Just to show you specifically what I mean, check out 9-2 and 9-3. Both photos are taken from the

same location, and the subject is in the same location. In 9-2, I used a 3x optical zoom. I can get three times closer to him with a 3x optical zoom lens, but it's still not close enough to capture his expression. In 9-3, I used a 12x optical zoom, which enables you to zoom in closer to your subject to capture expressions and detail, which is especially useful if you are in the stands and still hope to get good pictures of the action on the field, for example.

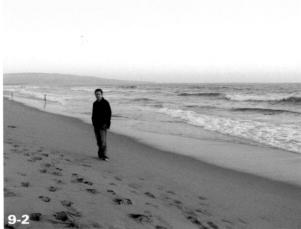

ABOUT THESE PHOTOS Michael was positioned at quite a distance from me. With a 3x optical zoom on my compact camera, I was able to get closer, as in 9-2. Using a 12x optical zoom allowed me to get really close, as in 9-3, without physically moving. Taken at ISO 100, f/3.7 with a Leica V-Lux1 compact digital camera.

dSLRS

Compact cameras are everywhere; they conveniently capture moments that might otherwise go unrecorded. This phenomenon has inspired a greater interest in photography than ever before. After you learn how to manage your compact digital camera, you might be ready for the next level

of photography and all the photographic possibilities a dSLR camera offers. Higher quality images, more control, and the ability to interchange your lenses are some of the important benefits of using a dSLR camera. Following are the basic settings to use when capturing action shots with your dSLR:

Set your camera to Continuous mode, compose your shot, and hold your finger down on the shutter button to take multiple shots in succession. This setting enables you to catch every movement and expression within multiple images.

In 9-4, I used the Continuous Mode setting to capture a sequence of movement.

Priority mode (TV). This setting gives you complete control over the shutter speed. Set a fast shutter speed (1/250 or more) to freeze the action or use a slow shutter speed (1/60 or less) to blur the action. This is a great setting when your exposure time is more important than your depth of field. In this mode, even if

the light varies, the shutter speed won't change. The camera keeps up with the changing light by adjusting the aperture automatically.

- Use Predictive Autofocus. Trying to focus on your subject when he or she is moving can be challenging. You can use the prefocusing techniques used with the compact digital cameras, but to take advantage of your dSLR features, use your dLSR's Predictive Autofocus. This might be the time to whip out that camera manual to find the setting in vour menu system. On vour lens, make sure the focus mode switch is set to AF. On your camera, set the Mode dial to TV for Shutter Priority and find your camera's AF button; then adjust to set it on AI Servo, or Predictive Autofocus. This focusing mode is for moving subjects when the distance keeps changing. The best way to use this feature is to press the shutter button halfway down to activate the AF system, and then fully press
- the shutter button when the decisive moment arrives. This gives the AF system time to acquire the subject and do its predictive calculations.
- Adjust your camera's ISO speed. An ISO rating measures the light sensitivity for your digital camera's imaging sensor. Similar to film speed, your camera's ISO works in unison with the shutter speed and aperture to create the right exposure for your shot. If you are shooting in a low-light situation and don't want to use a flash, raise the ISO to 400 or higher to increase the amount of light affecting the camera sensor. A higher ISO means that you can use a faster shutter speed and capture more of the action. Just be aware that higher ISO levels can create noise in your image, which is the digital equivalent to film grain, as shown in 9-5. Digital noise appears as random discolored pixels, also known as artifacts, throughout your image.

ABOUT THESE PHOTOS I used Continuous Mode to capture all the action when Jack threw his fastball. Taken at ISO 320, f/32, 1/30 sec. with a Canon EF 24-105mm f/4L IS lens.

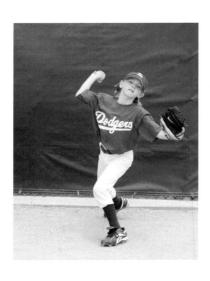

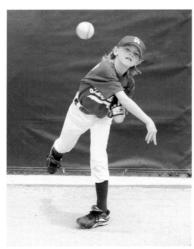

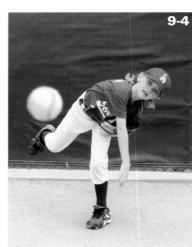

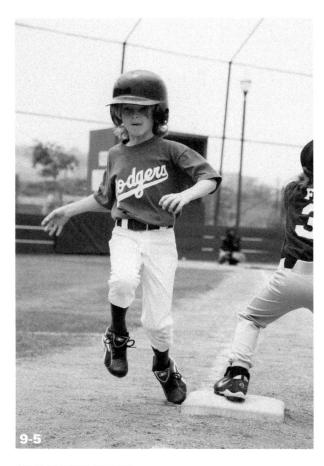

ABOUT THIS PHOTO Using a high ISO enabled me to use a faster shutter speed, but this tradeoff results in more digital noise in the image. Taken at ISO 1000, f/6.3, 1/800 sec. with a Canon EF 24-105mm f/4L IS lens.

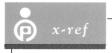

You can find more information on dSLRs in Chapter 1. I cover lenses in more detail in Chapter 2.

LENS SPEED

Every lens has a limit to how wide it can open up and how much light it allows in to create an exposure. This limit is called the *maximum*

aperture. The maximum aperture of every lens is listed as part of the lens identification. For example, a 28-135mm f/4 lens has a maximum aperture of f/4. The smaller the number, the wider the maximum aperture. In this case, a 28-75mm f/2.8 lens lets in more light than an 18-55mm f/3.5-5.6 lens.

A lens that lets in more light allows you to use faster shutter speeds — the shutter does not have to be open for long periods of time because enough light is passing through the lens to get a correct exposure. Because lenses with wide maximum apertures let you use faster shutter speeds, they are commonly called "fast" lenses. If you want to capture fantastic-looking action shots, you're going to need a fast lens.

Zoom lenses can either have *variable* or *constant* maximum aperture. When a zoom lens has a variable maximum aperture (for example, f/3.5-5.6), the maximum opening of the lens changes as you zoom. When you have your lens zoomed all the way out, your widest aperture possible is f/5.6. When the lens is zoomed all the way in, your maximum aperture changes to f/3.5. The problem with variable maximum aperture lenses is that when you zoom, your exposure settings change. Because the lens lets in less light at the telephoto setting, this affects the shutter speed that you are using, slowing it down.

A constant aperture has one maximum aperture and does not vary (for example, f/2.8). By comparison, a zoom lens with a constant maximum aperture does not change, no matter how much you zoom. You can distinguish these lenses because they indicate only one number for maximum aperture (for example, 28-105mm f/4). If you want your shutter speed to be consistent when you're taking action photos, use an action lens with a constant maximum aperture.

CHAPTER

Most dramatic sports shots are taken with the lens wide open or one stop from open. Photographers do this for two reasons:

- You need all the shutter speed you can get, which means you shoot at maximum aperture.
- The background in many action shots is not controlled and can be very distracting if it's in sharp focus. A wide aperture isolates your subject from the background with a shallow depth of field, as shown in 9-6.

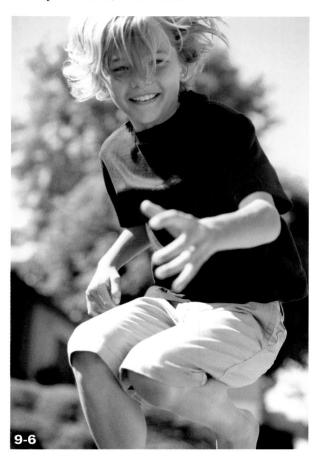

ABOUT THIS PHOTO I used a fast shutter speed and a wide aperture to freeze Nicolas's jump in mid-air and blur the background. Taken at ISO 250, f/3.2, 1/800 sec. with a Canon EF 24-105mm f/4L IS lens.

LENS FOCAL LENGTH

All lenses come in different focal lengths, and this length is a measure of how far away you can be from your subject and still get a close-up. The farther away you are from any action, the longer the lens you need to capture the shot. A telephoto lens allows you to stand on the sidelines of your favorite sporting event and capture nice close-up shots of the players in action. As a general rule of thumb, each 100mm in lens focal length gives you about 10 yards in coverage.

In figure 9-7, I was standing behind a fence near the outfield and was able to capture this action image due to my long focal length lens (70-200mm).

The best action lens is going to fall into the telephoto focal length, which means it will be anywhere between 100 and 300mm. Fast telephoto lenses contain a lot of glass, are larger and heavier than slower, variable maximum aperture lenses, and consequently come with higher price tags.

FREEZETHE ACTION

Our eyes cannot capture a millisecond moment and freeze it in midair, but a camera can capture that moment and freeze it forever in a photograph. With stop-action photography, the purpose is to freeze the subject so the viewer can see it clearly. Stop-action is effective only when the viewer realizes that the subject was moving when the picture was made. To enhance your action photo, include a point of reference in the image that conveys a story. What is your subject doing? Is there anything in the background that gives the viewer more information about your subject? For example, if you are shooting a pole jumper, include the pole and perhaps the jump point; when shooting a volleyball player, include the ball and the net.

ABOUT THIS PHOTO It's easier to get closer to your subject and capture the action by using a long focal length lens. Taken at ISO 100, f/3.5, 1/180 sec. with a Canon EF 70-200mm f/2.8 lens.

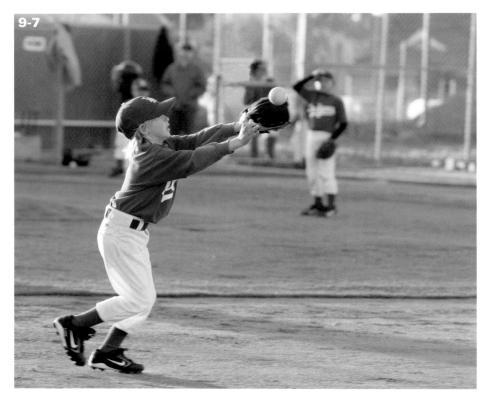

Another way to stop action is to take the picture at the peak of action. Shoot when the basketball players are at the highest point of their jump. Make your exposure the instant the action is suspended. Photograph a child the moment his swing pauses to reverse its direction. Stopping action at its peak is possible with a medium shutter speed, but your timing must be perfect.

Use your shutter speed to your advantage for action shots. Following are some examples of shutter speeds used in different action situations:

Swimmer: 1/125

Runner: 1/250

Skateboarder: 1/500

Cyclist: 1/500

Car at 50 mph: 1/750

Skier: 1/1000

Water droplets: 1/2000

SHAPTER S

Capturing your subject in action is affected by three things:

- How fast the subject is moving. Faster movement requires a faster shutter speed to stop the action.
- How far the subject is from the camera. The closer your subject, the faster your shutter speed needs to be to capture the action. For example, when you're driving on a highway, the scenery on the side of the road near the car appears to move rapidly, but the distant view you see through the windshield appears to move slowly.
- Direction of your subject's movement in relation to the camera. A person in motion

perpendicular to your frame creates a lot more blur than motion toward or away from your camera. For example, if your subject is running across the frame, your image requires a faster shutter speed than if the subject is running toward the camera.

Timing the decisive moment is very important when you're trying to capture your subject in action. You must anticipate any action that is about to occur in your scene and press the shutter before that action happens. If you can see the action with your naked eye, you missed the shot due to the delay between the image hitting your optical nerve and the shutter closing. Figure 9-8 illustrates how a fast shutter speed can freeze the action.

ABOUT THIS PHOTO Jack is running fast, and a fast shutter speed captures that movement in relative sharpness. Taken at ISO 320, f/6.3, 1/800 sec. with a Canon EF 24-105mm f/4L IS lens.

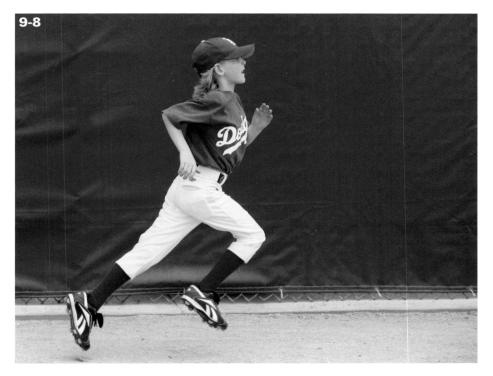

ABOUT THIS PHOTO Using a flash to photograph Nicolas on his trampoline enabled me to freeze his jump in mid-air and produce a sharp image. Taken at ISO 200, f/4.5, 1/200 sec. with a Canon EF 17-35mm f/2.8 lens.

FAST SHUTTER WITH FLASH

With shutter speeds of 1/4000 or faster, it's easy to stop action in your photographs; however, the challenge with using a fast shutter is that it also reduces the amount of light passing to the image sensor. Remember, the combination of shutter

speed, aperture, and ISO all work together to create the right exposure for your scene. In low light, you have to open up to maximum aperture (f/2.8) or increase your ISO speed (400+), or both. Even then, you might not have enough light to render a good exposure.

CHAPTER

Good news! There is a workaround for these limits; your camera's electronic flash or an external flash can stop the action when you don't have enough light to use a fast shutter speed. And, if you do have enough light, using a flash to stop the action works better to freeze action than your camera's highest shutter speed. Why? Your camera's shutter speed may top out at 1/4000 second, but most flash units can emit short bursts of light in durations as short as 1/50000 second.

With flash adding so much to your scene, you don't have to do much with your aperture and ISO speed; the camera does it for you.

Check your manual to find out your flash range. Most on-camera flash emits light for up to 12 feet; after that, the light falls off and doesn't reach your subject. Make sure that you are not too far away to fully flash your subject and freeze

the action. Figure 9-9 illustrates how flash can help to capture your subject in mid-air.

BLURTHE MOTION

Motion blur denotes movement in your images and can create a dream-like feeling to an image that a stop-action photo could never achieve. Although blurred images are not an exact science, it's possible to keep some of your image in focus while allowing other parts to blur around the edges. You can use different techniques to achieve an interesting blurred effect in your images. Each effect has its own unique approach and result. You may end up with a lot of experiments and throwaway shots, but you might also capture the stunning image of the century. The motion blur captured in 9-10 denotes movement and was captured using a slow shutter speed.

ABOUT THIS PHOTO Jack's movement is recorded as a blur by using a slow shutter speed. Taken at ISO 320, f/22, 1/50 sec. with a Canon EF 24-105mm f/4L IS lens.

SLOW SHUTTER WITH TRIPOD

All motion blur incorporates a slower shutter speed than you would use for a fast action shot, but if you are using a shutter speed slower than 1/60, you need to stabilize your camera on a tripod. Otherwise, your entire picture, not just the subject's movements, may be blurry from camera shake.

To record image blur from subjects in motion, yet keep your background in sharp focus, do the following:

■ Stabilize your camera on a tripod and use a slow shutter speed.

- Find an interesting, or dramatic, background in which people are in movement.
- Set your camera to Shutter Priority (TV) and use a slow shutter speed (1/4 second or slower).
- Turn on your camera's self-timer or use a remote shutter release and start taking pictures.

Use different shutter speeds to alter the effects. You can create some interesting images with people in motion. Abstract colors and ghost-like

ABOUT THIS PHOTO Using a Neutral Density filter in bright afternoon sunlight allowed me to use a slower shutter speed and record the motion blur in the image. Taken at ISO 250, f/32,1 sec. with a Canon EF 70-200mm f/2.8 lens and a 3-stop Neutral Density filter.

СНАРТЕЯ

images depict human movement in unique ways, as seen in 9-11 where I had Michael stand still on the stairs while the crowd moved in a blur around him.

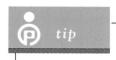

When experimenting with motion blur, use a range of shutter speeds for varying degrees of image blur.

PANNING

Panning with the action keeps the subject in focus and blurs the background, creating streaks all around your subject that indicate motion and speed. To achieve this effect, here are a few essential tips:

- Ensure a steady stance by keeping your feet firmly planted, and twist from your waist to follow the moving subject with the camera.
- Press your shutter button halfway down and track your subject — don't let him run out of your viewfinder's frame.
- When you decide the moment is right, fully press the shutter release. Because the camera keeps pace with the moving subject, the subject is sharp, and the background is blurred.

Panning requires some practice. If you are shooting with a compact digital camera, follow these basic steps:

- 1. Prefocus on the spot where you plan to photograph your subject by pressing the shutter button down halfway.
- 2. As your subject approaches, follow the action through your camera's optical viewfinder.
- 3. Fully depress the shutter button when your subject reaches the spot on which you originally focused.

When panning with a dSLR, follow these general steps:

- 1. Set your camera to Shutter Priority (TV).
- 2. Turn on your Predictive Autofocus.
- 3. Set the camera to Continuous mode.
- 4. Press the shutter halfway down to activate the focusing, and then follow the action through your viewfinder.
- 5. Fully press the shutter button and keep holding your finger down on the shutter to enable the multiple-shot Continuous mode to fire away.

Continuous mode tells your camera to take many sequential images prior to recording them to your memory card. Capturing multiple images in quick succession gives you more chances for recording the winning shot. Check your camera manual to confirm the maximum number of images your camera can capture in each burst sequence.

Using a tripod that pivots smoothly can also assist you in following the action. If you have a willing subject, ask the subject to run back and forth in front of the camera so you can adjust your tripod setup and practice keeping him or her in the frame.

Take a lot of photographs and experiment by using various shutter speeds from 1/60 second and slower — and just like a good golf or tennis player, follow through with your panning motion even after you release the shutter. In 9-12, you can see an example of panning with the action. I followed Nyle's fast descent down an incline and pressed the shutter button simultaneously to create a blurry, streaked effect in the background.

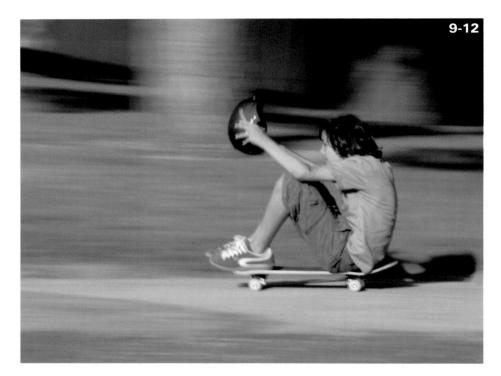

ABOUT THIS PHOTO Panning the pace of Nyle's skateboard with the camera while pressing the shutter button enabled me to create streaks in the background and keep him in relative focus. Taken at ISO 250, f/32,1 sec. with a Canon EF 70-200mm f/2.8 lens.

ZOOMING

To give motion to a static subject, shoot with a zoom lens and change the focal length by quickly zooming in or away from your subject during the exposure. This technique takes practice but can transform a lifeless scene into something dramatic and exciting. The effect creates light streaks radiating from the subject.

You must use a slow shutter speed to allow enough time to zoom in or out during the exposure. Depending on the effect you'd like to achieve, you can handhold the camera or mount it on a tripod to hold it steady and maintain the composition you want while zooming (see 9-13 for an example of zooming).

SLOW SHUTTER WITH FLASH

There are two basic ways a camera captures a flash photo in low light:

- The camera uses a fast shutter speed to minimize camera motion blur, and the flash illuminates your subject, leaving the background dark.
- The camera uses a slow shutter speed to capture the ambient background light. The flash illuminates your subject with a softer flash, and depending on movement in the scene, might record various amounts of image blur. This technique is called *slow sync*, slow shutter sync, or "dragging" the shutter.

9

ABOUT THIS PHOTO I twisted my zoom lens from the telephoto focal length to the wide-angle focal length as I pressed the shutter button to create this "zoom" effect. Taken at ISO 200, f/13, 1/40 sec. with a Canon EF 24-105mm f/4L IS lens.

Compact digital cameras have a Night Scene setting that enables you to illuminate your subject with flash while using a slow shutter to record more of the ambient light in your scene. Use this setting when taking pictures at parties or other low-light events. It allows you to illuminate your subject's face while also capturing the beautiful golden glow of candle light or other ambient light that would otherwise be obscured in darkness with a normal flash setting. For nighttime images without blur, carry a mini-tripod for

stabilizing slow shutter shots anywhere you go. In 9-14, you see an example of how a slow shutter records ambient light in the room while the oncamera flash illuminates your subject's face.

Digital SLR cameras enable you to use a slow shutter with flash by using Mode dial settings of Shutter Priority (TV), Aperture Priority (AV), and Manual (M) — you can't use it in Program (P) mode or most of the creative modes (icon modes).

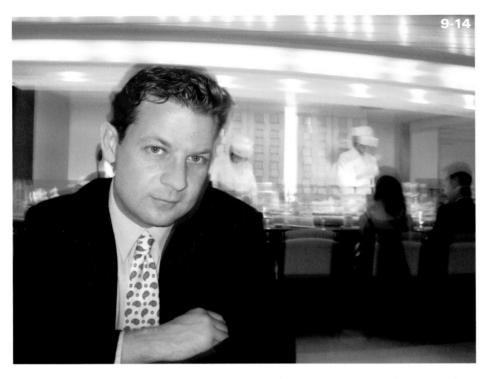

ABOUT THIS PHOTO I used the night scene mode on my compact camera to capture the ambient light in the room and softly illuminate Michael's face. Taken at ISO 100, f/2.6, 1/4 sec. with a Canon PowerShot A540 compact camera.

Sometimes slow shutter sync is used to provide a dynamic motion effect in flash photos. A photo taken with flash and a slow shutter speed can provide an interesting mix of a flash-illuminated subject and ambient-light-illuminated motion blur. The effect is difficult to predict but can be very striking and exciting when it works.

Some high-end dSLR cameras have a *second-curtain sync* function. This setting is found in your Custom Functions menu. When shooting with second-curtain sync, the flash fires at the end of the shutter opening, as opposed to the standard first-curtain sync flash that fires at the beginning of the shutter opening. Second-curtain sync is a technical feat performed by your camera and flash that captures a blurred light trail following

movement by your subject. In 9-15, the flash illuminates the golfer while the slow shutter speed combined with the second-curtain sync function captures the path of the golf club and the golf ball.

You might end up with a lot of images you won't like when you're experimenting and photographing people in motion. Don't be discouraged. It isn't easy to capture people when they are moving around. Even professional action photographers have to sort through a lot of images to find just the right shot. Take a lot of photos and take time to review all of your images on the computer — you might be surprised to find a few artistic and magical moments.

ABOUT THIS PHOTO Using flash with a slow shutter speed and second-curtain sync enables you to record motion blur in a unique way. Taken at ISO 100, f/14, 1/30 sec. with a Canon EF 24-105mm f/4L IS lens.

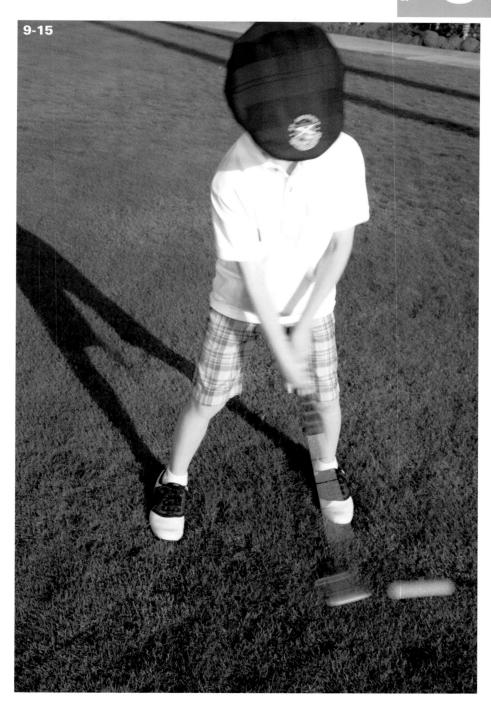

Assignment

Freeze the Action by Using a Flash

Attend a kids sporting event, go to the park, or even watch people in your backyard to capture your subject in action by using your flash. Choose the most eye-catching image, post it online at www.pwsbooks.com, and share your experience with us. How many different shutter speed settings did you use? How many images did you take?

To complete this assignment, I asked Nyle to show me all the tricks he knows with his skate-board. By using a flash, experimenting with shutter speed settings, and taking a lot of pictures, I had a few good images in the group. This is my favorite shot because I captured Nyle in a dynamic position in mid-air. By using the flash, I have very little motion blur in the image. Taken at ISO 100, f/22, 1/50 sec. with a Canon EF 24-105mm f/4L IS lens.

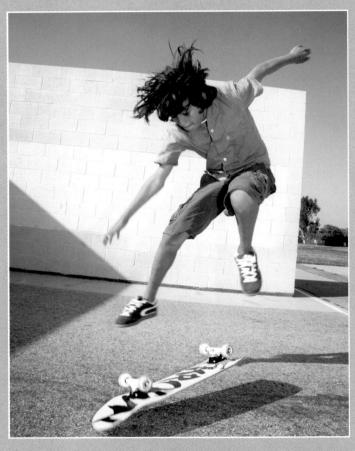

Remember to visit www.pwsbooks.com after you complete this assignment and share your favorite photo! It's a community of enthusiastic photographers and a great place to view what other readers have created. You can also post comments and read encouraging suggestions and feedback.

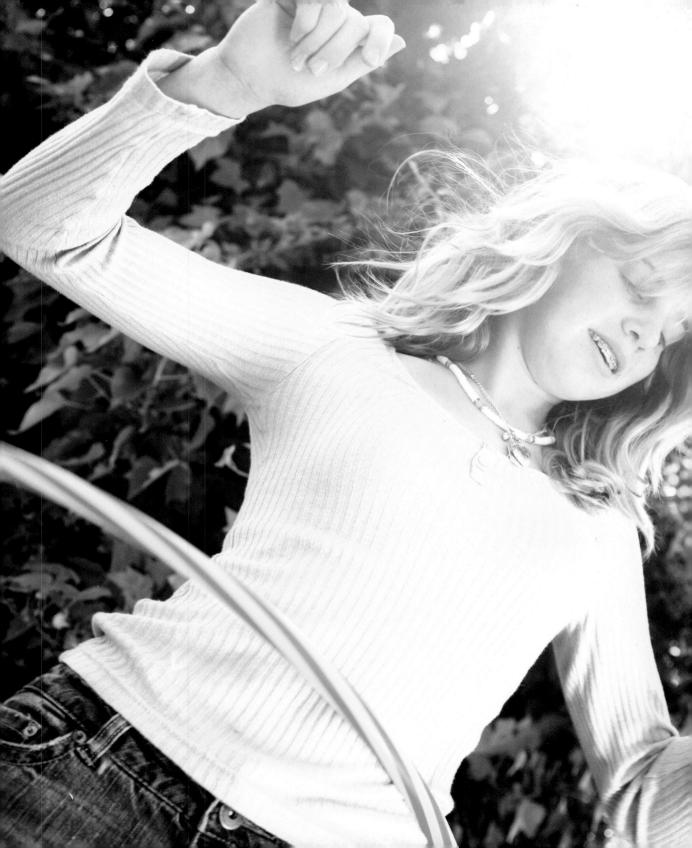

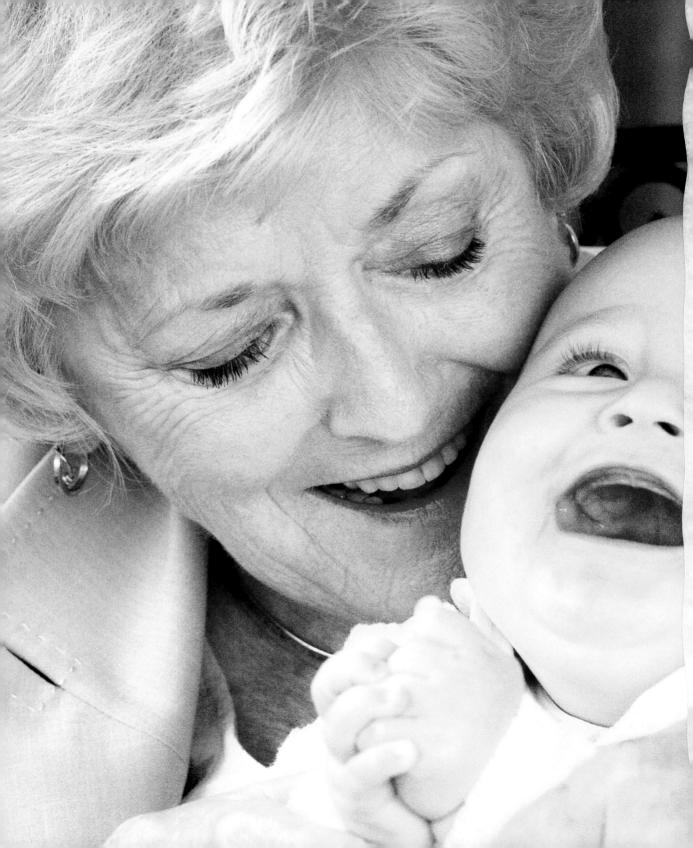

Manage Your Images
Enhance and Repair Your Images
Share Your Images

Technology is always evolving, but the need to document and share precious life moments is constant. With a laptop, mobile phone, or wireless camera, you can share your images from anyplace (see 10-1). After you take oodles of digital images and import them onto your computer, you have many ways to organize, enhance, and share your images. Although the array of options can be complicated and overwhelming, if you follow a few of these tips and suggestions, the bewildering "after the shot" path can become easier to navigate.

MANAGEYOUR IMAGES

When you begin downloading digital images onto a computer, keeping track of all those files can become very confusing. Even if you begin with one folder and place all your images within it, you have not established a method for researching and accessing those images in a detailed manner.

Fortunately, computer software, DVD burners, online servers, and printers make it very simple to

ABOUT THIS PHOTO The contrast of man and technology in nature is a classic theme. I like how small the subject is in relation to the outdoors. Taken at ISO 200, f/5.6, 1/125 sec. with a Canon EF 17-35mm f/2.8 lens.

import, view, organize, and save your digital images — all you need to do is incorporate them into your digital-image routine. By using these tools, you can thoughtfully assemble, easily control, and readily share your image collection.

Many computer software programs enable you to import, view, organize, enhance, and save your images. Image-editing and image-organizing software programs may share similar features but place more emphasis in a particular area. For example, if you intend to get more involved in editing and enhancing your images, an image-editing program is going to be more robust and give you more options. If your image-enhancements are minimal, an image-organizing program might be sufficient.

IMAGE-ORGANIZING SOFTWARE

Quite a few image-organizing software programs are available for free online or come already installed on your computer. In the spirit of keeping things simple, this chapter covers two options: Picasa and iPhoto.

■ Picasa. For Windows users, Picasa is a free software download from Google that helps you locate and organize all the photos on your computer. This software collects and organizes all the images on your computer, scanning the images and automatically sorting them by date while you watch. You can also edit and add effects to your photos with a few simple clicks, and then share your photos with others through e-mail and prints, and online — and it's free. Go to http://picasa.google.com and download the software to begin.

iPhoto. For Mac users, iPhoto includes a photo-organizing and viewing software program, and it comes bundled with every Apple computer. iPhoto allows you to import, organize, edit, and retouch your images with a userfriendly, intuitive interface. Some additions to this program include slideshows set to music, Web galleries, easy image e-mailing features, and photocasting. Photocasting is the Apple/Mac version of an RSS Web feed (Really Simple Syndication). RSS makes it possible for people to keep up with their favorite Web sites in an automated manner that's easier than checking them manually all you need to do is subscribe online. An example of the thumbnail view in iPhoto with organizational folders to the left is shown in 10-2.

IMAGE-EDITING SOFTWARE

An image-editing software program is used primarily for editing and enhancing your images; however, it can also perform some of the same functions as an image-organizing program. It helps you organize and search for images by the general *metadata* (data that describes your images; also see the sidebar later in this chapter) stored in every image captured by a digital camera. Accessing this metadata and adding your own customized *keywords* (significant words that describe the images) to your images allows you to search for specific photographs by date, name, camera type, and shutter speed, just to name a few criteria. The possibilities are endless when you add your own descriptions and keywords to

10-2

ABOUT THIS FIGURE An example of the iPhoto window with organizational folders.

METADATA Metadata is stored within digital images captured by a digital camera and is a record of the settings that were in effect when the digital image was created. Information included is the date, time, pixel resolution, shutter speed, aperture, focal length, ISO, white balance, metering pattern, and whether the flash was fired. This information is saved in a standard format called Exchangeable Image File (EXIF).

create a custom digital-filing system. You may never waste another minute looking for those hard-to-find images, because the software program does it for you. An example of the information (metadata) automatically captured in every digital image you take is shown in 10-3.

Many available software programs enable you to acquire, view, organize, enhance, and save your images. Image-editing and image-organizing software programs may share similar features but place more emphasis in a particular area. Digital cameras are often packaged with proprietary image-editing software that delivers a limited amount of control and creative options. These programs are fine for minimal editing tasks, such as adjusting contrast and brightness and cropping and rotating, but the best way to optimize your digital-image experience is to use a more robust software program such as Adobe Photoshop Elements.

When you initially launch Photoshop Elements, the Welcome screen opens. This is a convenient starting point for tasks in the software program. The Windows and Macintosh versions of Photoshop Elements differ in their presentations, but a good way to navigate through either platform is to position your mouse over one of the icons on the Welcome screen so a description flag pops up. The information provided inside the pop-up flag indicates the specific tasks that will be performed when you click the icon. The platforms work as follows:

■ Macintosh. To acquire new images from your digital camera using the Macintosh platform, click Browse with Adobe Bridge from the Welcome screen and connect your camera to your computer. Click the Folders tab and drag the images from your camera folder to a designated folder under the Folders tab, as shown in 10-4.

ABOUT THIS FIGURE This screenshot is an example of the metadata information stored in every digital image.

10-4

■ Windows. To acquire new images from your digital camera using the Windows platform, click the View and Organize Photos button to open the Organizer. Next, the Photo Browser workspace opens by default, and you can click the Get Photos button and locate the images you want to import.

You can import images from a variety of places: digital cameras, media card readers, scanners, DVDs or CDs, and mobile phones; or you may already have existing image folders on your computer's hard drive. Follow the directions provided by the camera, media card reader, or mobile phone manufacturer to ensure your images are imported correctly onto your computer. After you have imported your photos and launched the Photo Browser, your image files display as thumbnails, making it easy for you to organize, find, and view your images. Photoshop Elements also enables you to tag, or add keywords to, your images with visual identifiers so you can easily find images by people, places, and events.

ENHANCE AND REPAIR YOUR IMAGES

The two editing workspaces within Photoshop Elements are the Quick Fix workspace and the Standard Edit workspace. If you are new to digital imaging, Quick Fix is a good place to start enhancing your photos — many of the basic tools for enhancing your images are located here. You can easily correct red-eye, make a variety of color and tonal enhancements, crop, and sharpen your images with a few simple mouse clicks.

The image-editing examples in this chapter use Photoshop Elements;

however, most image-editing software packages contain similar features for you to work with. If you don't use Photoshop Elements, you can still use the information here as a guide when working with your chosen software.

QUICK FIX WORKSPACE

An example of the Quick Fix workspace is shown in 10-5. This workspace contains simple tools and commands to quickly fix common problems.

10-5

The menu bar located on the right of the window contains all the automatic enhancement commands necessary to improve your image. Try using one of the Auto control buttons in each section. If the control doesn't achieve the desired effect, click the Reset button and try another one. The slide controls also allow you to make slight adjustments. Play around and experiment in the Quick Fix workspace.

Notice that I have chosen the Before and After view to compare my changes with the earlier version, by using the drop-down menu in the lower-left corner of the window. This is one of the many tools that help you adjust and control your image enhancements.

FULL EDIT WORKSPACE

As you develop your skills, start exploring the Full Edit workspace. With features similar to the

professional version of Photoshop, the Full Edit workspace is a more powerful image-editing environment than the Quick Fix workspace. The toolbar contains many options for editing and enhancing your images, such as image defects correction, lighting and color correction commands, and tools to add text and painting on your images.

The workspace may also be called Standard Edit workspace, depending on your platform and version of Photoshop Elements.

In the Full Edit workspace, as shown in 10-6, you can further edit and enhance your images with more customized control. To learn what each tool does, explore the toolbar (on the left) by moving your pointer over the various tools and reading

10-6

ABOUT THIS FIGURE An example of the Full Edit workspace in Photoshop Elements. the Tool tips that pop up. No clicking yet, just slowly move your pointer over each tool.

If yourToolTips do not appear when your mouse is hovering over an

icon, choose Edit ❖ Preferences on a PC or Photoshop Elements ❖ Preferences on a Mac and make sure the ShowToolTips check box is selected.

EDITING BASICS

The Photoshop Elements Full Edit workspace introduces the concept of *layers*. Layers are the backbone of any robust image-editing program because of the flexibility and control they give you in the editing process. Think of layers as stacked, transparent sheets of glass on which you can make independent changes to an image until you decide to combine, or merge, the changes.

By using layers, you have many more options and more control when you edit your images. For example, you can easily maneuver between each independent layer to make adjustments, turn off the visibility of that layer, discard a botched enhancement attempt, and save all the layers for future editing without altering your original image.

By changing a layer's hierarchy or opacity, you can modify the way each layer interacts with the layers below it in the Layers palette. Using layers is the key to advancing in the world of digitally altered photos and for creating various effects.

Don't panic if this seems like too much information — it begins to make sense as you move through the process. Begin with this simple rule in every image-editing effort: Create a *duplicate layer*, also known as a copy of your original image, and make any changes to your image on this layer.

- 1. Choose Layer

 □ Duplicate Layer, as shown in 10-7. The Duplicate Layer dialog box appears.
- 2. Accept the default duplicate layer name "background copy" or customize the layer and give it a different name. The new duplicate layer appears in the Layers palette, which is located to the right of your screen by default.

By creating a duplicate layer, your original image is preserved. By building on your knowledge over time, your comfort level increases as do the infinite creative possibilities with your images.

An example of a Layers palette with two layers, the background (original) and a background copy, is shown in 10-8. Background copy is highlighted, indicating that it's an active layer. You can perform any alterations on this active layer without affecting the original image (which is beneath it in the Layers palette). This is called nondestructive editing. When you make changes to the duplicate, you can't damage the original. If you don't like what you create on the Background copy layer, delete it. Right-click the layer and choose Delete Layer from the pop-up menu on a PC or click the layer to activate it and then click the Trash icon in the Layers palette.

When you are finished editing your image, you first need to save it as a PSD (Photoshop Document) file so you preserve your work and have the option to make changes at a future time. Next, you need to consolidate your layers so you can print and share your images online. When you duplicate your image and work in layers, the file size increases exponentially; this makes it difficult to print. Due to the large file size, it's also virtually impossible to share online. For these

10-7

ABOUT THIS FIGURE Before you begin editing and enhancing any of your images, it's a good idea to create a duplicate background layer in your Layers palette so you can work on a copy of your image.

reasons, you must flatten your image file and save it under another name, or add an additional identifier in the file-naming process. Merging and flattening are permanent actions, and you should do them only when you are finished editing the photo.

When saving your images for online sharing and printing, you need to save your image file with a different file format because a PSD file is not compatible with other software like a JPEG and a TIFF file are.

10-8

ABOUT THIS FIGURE An example of the Layers palette in Photoshop Elements.

- 1. Choose File ⇒ Save As to open the Save As dialog box.
- 2. Select a file format by clicking the Format drop-down menu (see 10-9). Choose JPEG if you intend on using the image for onscreen and online purposes. JPEG is a compressed

file format that reduces the size of the image for online purposes. Choose TIFF if you intend to print the image. TIFF uses *lossless* compression — no resolution is lost when saving to this format. This is a critical factor when archiving images and printing.

CROPPING

The Crop tool enables you to crop out parts of your image. This is useful if you want to remove clutter in the background, focus on one area of your image, and/or create more visual impact with an existing image. For example, trimming areas from a photo can change the prominence of particular objects. Along with removing unnecessary image content, cropping reduces the file size of the final image. This can be important if you are using the image on a Web site, where a smaller file size results in faster downloading.

You can also use the Crop tool to add extra space around your image to give it a distinctive framed appearance. To add extra space, you must first increase the area of the image window so that the Crop tool can extend beyond the boundaries of the image. Clicking and dragging the Crop tool outside the boundary and then applying the crop in this manner increases the canvas size.

Unlike other adjustments in Photoshop Elements, cropping an image affects all of the layers in the image, including layers that are currently not selected or visible. The example in 10-10 shows the bounding box that's created when the Crop tool is used on an image.

To crop a photo, follow these steps:

- 1. Click on the Crop tool to select it. It is identified in 10-10.
- 2. Click and drag inside the photo to define the cropping boundary.
- 3. Click the Commit button to apply the change. The Commit button is denoted by a green check mark located in the Options toolbar above your image on a Mac or in the lower-right corner on a PC.

To add extra space around your photo, follow these steps:

- 1. Click and drag out the corner of the image window to add extra space around the photo.
- 2. Click on the Crop tool to select it, and then click and drag to define the cropping area.
- 3. Click and drag the handles to extend the cropping area outside the boundary of the photo. The handles are the squares that appear along the crop boundary; they allow you to adjust the size of the crop selection area.
- 4. Click the Commit button to apply the change.

ABOUT THIS FIGURE The Crop tool enables you to trim your image and focus on a certain area, creating an image with greater impact.

Keep in mind that cropping eliminates pixels, which affects the resolution of your image and therefore its quality. Viewing an image online requires less resolution (72 to 96 pixels per inch [ppi]) as opposed to printing an image, which requires a higher resolution (240 to 300 ppi) to maintain image sharpness.

The more pixels in your digital image, the higher your image resolution. Image resolution determines how much detail you see in your images and how large an image you can successfully print.

ADJUSTING THE COLOR BALANCE, SATURATION, AND CONTRAST

You can adjust the color balance, saturation, and contrast of an image using the Color Variations

dialog box. As you make successive adjustments to your image, you can simultaneously compare your after image with your before image. You can use the Color Variations feature to adjust the color or exposure of a flawed image that was shot with a digital camera or digitized with a scanner. Comparing the difference between your before and after photos is easy within this window and gives you a clear visual indication of where you were and where you're going with your image enhancements. You can also use the Color Variations feature to match up the appearance of two different photos so that they have similar color content and overall lighting.

The settings in the Color Variations dialog box allow you to affect a specific range of colors in your image; for example, you can change only the colors in the darkest or lightest parts of the image. They also enable you to adjust the degree of change, so you can intensify or lighten the amount of change you apply. To adjust the hue and saturation:

- 1. Choose Enhance ➡ Adjust Color ➡ Color Variations. The Color Variations dialog box opens, and you can quickly adjust the colors in your image.
- **2. Select the Midtones radio button.** A series of thumbnails appears.
- 3. Click on the Increase or Decrease color thumbnails until you see what you like in

- your After image. Experiment and have some fun with this feature.
- 4. Increase the brightness of the image by clicking Lighten, and decrease the brightness of the image by clicking Darken.
- 5. Click OK when you are finished to activate the changes.

You can use the Lighten and Darken options in the Color Variations dialog box (see 10-11) to adjust the general contrast in your images, but to execute more specific contrast control, use the Levels feature, which is explained in the next section.

10-11

ABOUT THIS FIGURE Using the Color Variations feature is an easy way to adjust the hue, saturation, and contrast in your image. In this experiment, the After image has an overly red tint.

While the Color Variations dialog box is open, you can undo the changes that you apply in several ways. You can click the Undo button to undo the most recent adjustment. You can also click an Increase or Decrease thumbnail to undo a previous Decrease or Increase command. You can click Reset Image to revert the image to its original state before you open the dialog box.

USING LEVELS TO ADJUST CONTRAST

A good technique for improving many digital photographs is to look for ways to enhance the *contrast* in the images. By definition, contrast is the difference between the darkest and lightest areas in a photo — the greater the difference, the higher the contrast. Photos with low contrast can appear a bit muddy or blurred, lacking any clear distinctions between details in the images.

Photoshop Elements includes several useful tools for adjusting image contrast; one of the best is the Levels dialog box, shown in 10-12. To open the Levels dialog box, choose Enhance Adjust Lighting Levels.

The histogram represents the various levels of tonality in your image. It looks like a mountain range, but is really a graphical representation of how many pixels of each tone (shadows, midtones, and highlights) are present in an image. If your image is dark, the mountains are higher on the left side. If the image is very light, the mountains are taller on the right side of the histogram.

Three sliders are located underneath the histogram. Each slider controls a section of tones within your image. The slider on the left controls the dark pixels in your image; the middle slider controls the midtone pixels in your image; and the slider on the right controls the light pixels in your image.

10-12

ABOUT THIS FIGURE An example of the Levels dialog box in Photoshop Elements.

By making a few adjustments to the shadows, midtones, and highlights in a photo, you can quickly achieve contrast that was previously lacking. For example, in figure 10-13, the colors were a little too dark. So, I moved the highlights slider (the right slider) slightly to the left and aligned it with the beginning of the most significant portion of information in the histogram (see 10-12). The need to optimize the tonality or dynamic range of your image is the first step in nearly all image-editing tasks. The results of the slight adjustment are shown in 10-14. What a difference a small adjustment can make!

p tip

Sharpening filters can also help improve the appearance of contrast

in your photos. The most popular filter for sharpening images in Photoshop Elements is Unsharp Mask. Using this filter takes a bit of experimentation using the three available controls. To apply the filter, choose Filter \Leftrightarrow Sharpen \Leftrightarrow Unsharp Mask on a Mac and Enhance \Leftrightarrow Unsharp Mask on a PC. This opens the Unsharp Mask dialog box, in which you can make and preview adjustments.

ABOUT THESE PHOTOS I adjusted the contrast in the Levels dialog box, enabling me to work with the midtones and highlights in the image. The result is a brightened, clear after photo in 10-14, as opposed to the darker, muddy before photo in 10-13. Taken at ISO 400, f/4.0, 1/100 sec. with a Canon EF 24-105mm f/4L IS lens.

WHITENING TEETH

Zoom tool

You can quickly improve any portrait photo by lightening the teeth of a smiling subject. This technique involves using the Zoom tool to enlarge the image and the Dodge tool to slightly lighten your subject's teeth. Be careful not to make the teeth too white and the enhancement unrealistic.

In this example, Gina's teeth are beautiful and need very little correction (as shown in 10-15), but

there is always room for improvement (as shown in 10-16) as long as it doesn't look unnatural.

To whiten teeth, follow these steps:

- 1. Click the Zoom tool to enlarge your image in the workspace. This allows you to see what you're working on in great detail.
- 2. Click the Dodge tool, located near the bottom of the toolbar, beneath the Sponge tool.
- 3. Choose Midtones in the Range drop-down menu located on the Options bar.

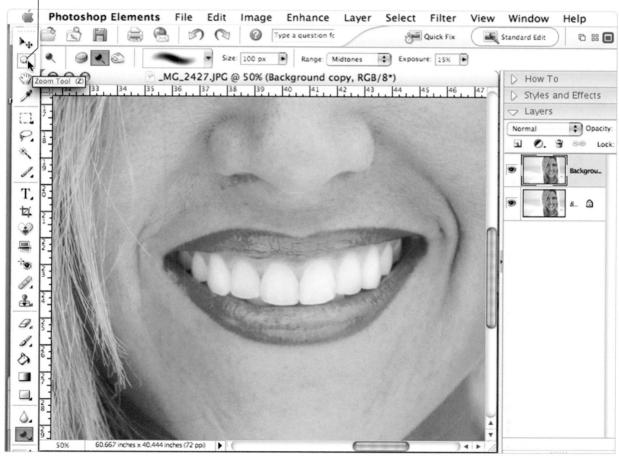

10-15

ABOUT THIS FIGURE I used the Zoom tool to enlarge the image. The teeth look okay in this before shot, but I've whitened them slightly for a subtle enhancement in 10-16.

- 4. Select an Exposure level of approximately 20%.
- 5. Choose a Brush size that is no larger than your subject's teeth.
- 6. Move the Brush tool across the teeth one or two times. Take care not to overbrush, or your subject's teeth might look unnaturally white.

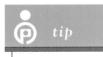

Hue is the actual color, such as red or green, and saturation is the intensity or purity of a color.

REMOVING RED-EYE

If you have taken pictures of people in low-light situations with an on-camera flash, you've probably noticed that eerie red-eye effect in your images. Red-eye occurs when the on-camera flash

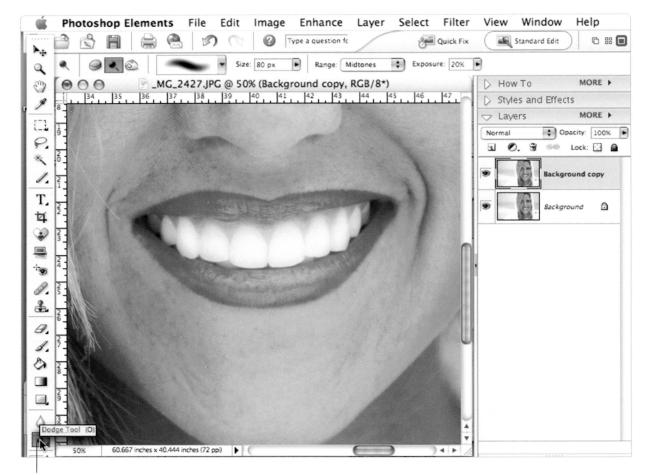

Dodge tool

10-16

ABOUT THIS FIGURE I used the Dodge tool to slightly lighten Gina's teeth in this after image. The Dodge tool is near the bottom of the toolbar, beneath the Sponge tool.

10

reflects off of the back of the inside of a subject's eye — it's not very attractive. Until recently, it was difficult to eliminate red-eye in your images, but with the image-editing software programs available today, you can remove red-eye easily by simply clicking the Auto button in the Options toolbar. The software program searches for the red-eye in your image and eliminates it automatically. This is a good general fix, but you have more control over the red-eye removal if you use the Red Eye Removal tool and follow these steps:

- 1. Select the Red Eye Removal tool. Your pointer becomes a crosshair when moved over the image.
- 2. In the Options bar, choose 50% in both the Pupil Size and Darken Amount fields. You may have to adjust this number if your redeye adjustments are not successful.
- 3. Place the crosshair over the red-eye area and click. Photoshop Elements samples the reddish pixels in the area and adjusts them, based on a predefined darkness value, as shown in 10-17. The Red Eye Removal tool

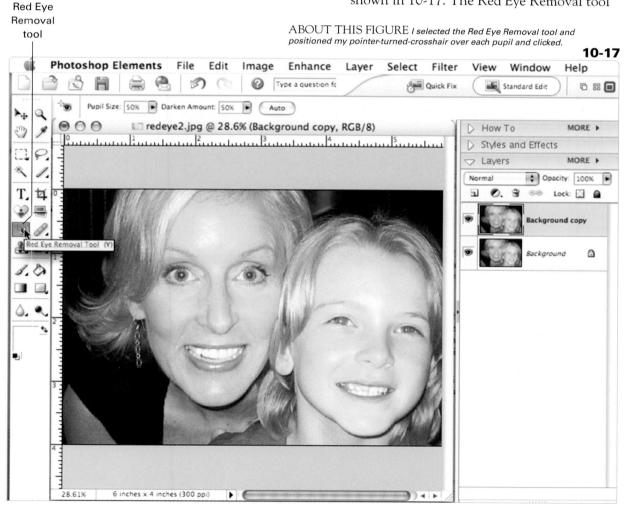

changes the hue of the affected eye, eliminating those glowing red eyes in your images, as shown in 10-18.

REMOVING IMPERFECTIONS

Some of your photos may contain imperfections that need correction or enhancement — some retouching. Attending to the subtle details of an image can improve its overall appearance and

produce rave reviews from your subjects and your viewers. Photoshop Elements provides several tools to correct imperfections. The most commonly used tool for retouching in Photoshop Elements is the Healing Brush tool, which is sometimes referred to as the "zit zapper" by complexion-conscious models and actors. It makes removing imperfections in your images fast and easy. It's almost like a visit to the dermatologist!

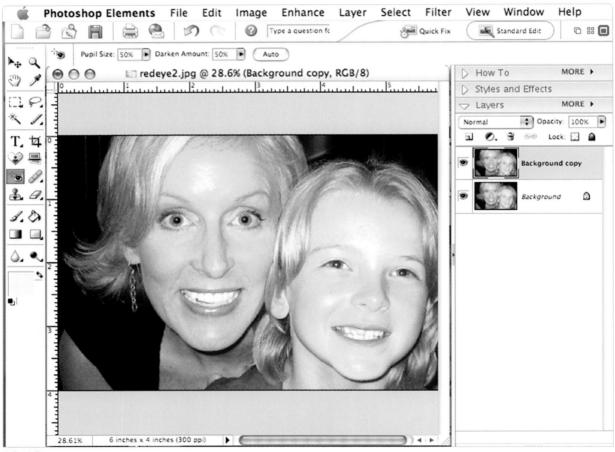

10-18

ABOUT THIS FIGURE Here is the result of using the Red Eye Removal tool on my image — no more red-eye!

CHAPTER 1

There are two healing tools in the toolbar: the Spot Healing Brush and the Healing Brush. They both use other pixels on your image to blend and smooth over the spots you target. The Spot Healing Brush tool works instantly to clear up small spots. The Healing Brush tool requires a little more work but gives you more control.

To remove spots with the Spot Healing Brush, follow these steps:

- 1. Enlarge the area of your image you want to work on with the Zoom tool. The closer you can get in and still see the overall area of the image, the easier your work is.
- 2. Select the Spot Healing Brush tool. If the Spot Healing Brush tool icon is not visible, click the small triangle in the corner of the Healing Brush tool icon and select the Spot Healing Brush tool from the fly-out menu.
- 3. Choose a brush size in the Options toolbar. A brush size slightly larger than the spot you want to fix works best.
- 4. Select a Type option in the Options toolbar. Proximity Match is the default option; it uses the pixels around the edge of your image imperfection and blends them together for a smooth, natural-looking retouch. You can also try the Create Texture in the Type option and decide which effect looks more natural.
- 5. Click just outside the spot on your image and drag over it with your pointer. Poof! The spot instantly disappears. It looks like magic, but it's actually the software program automatically mixing together pixels surrounding your spot.

To remove spots with the Healing Brush, follow these steps:

- 1. Enlarge the area of your image you want to work on with the Zoom tool. The closer you can get in and still see the overall area of the image, the easier your work is.
- 2. Select the Healing Brush tool, as shown in 10-19.
- 3. Choose a brush size in the Options toolbar. A brush size slightly larger than the spot you want to fix works best.
- 4. Select the Sampled option in the Options toolbar.
- 5. Press and hold the Alt key on a PC or the Option key on a Mac and click in an area near your spot to sample an area. Your pointer icon should look like a cross inside of a circle, like a target. Sampling an area of your image means to pick up pixels in one area of your image so you can place them somewhere else in the image.
- 6. Release the Alt/Option key and brush over the spot to be fixed with your pointer. Poof! The spot disappears again. This time the software program used the pixels you picked up or sampled, along with other pixels surrounding your spot.

It may be necessary to tone down the intensity of the retouching you just performed. Removing every blemish, sunspot, and under-eye circle is tempting, especially if you are enhancing a picture of yourself, but the resulting look can be quite unnatural, and everyone knows the image has been retouched.

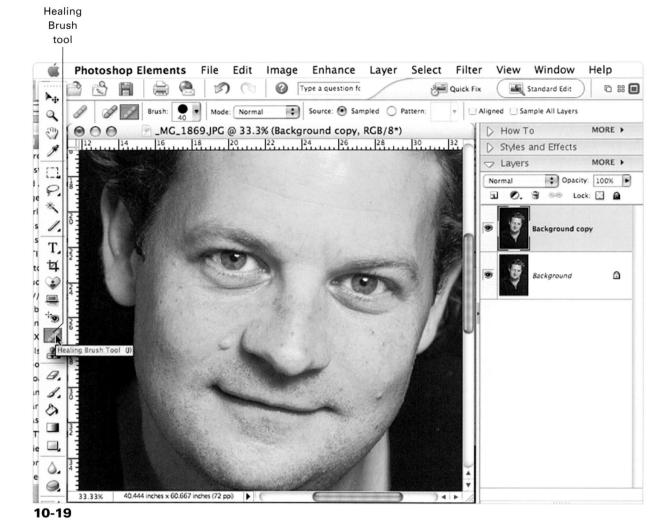

ABOUT THIS FIGURE A digital image can be a little too revealing, especially close-up. Michael is a handsome guy, but you can slightly enhance this image to improve the overall look.

Try using this opacity technique for an improved yet authentic-looking portrait photograph. To tone down your improvements with the Healing Brush tools, try the following:

1. Click on the Opacity slider in your Layers palette, as shown in 10-20.

ABOUT THIS FIGURE The Healing Brush tool eliminates all the imperfections on Michael's face, but now he doesn't look like himself, and the image has an unnatural quality.

2. Adjust the slider to approximately 40%. The imperfections pull back ever so slightly, resulting in a natural yet enhanced image (see 10-21).

Some people prefer to use the Healing Brush tool instead of the Spot Healing Brush tool, because it can produce a smoother effect. Experiment and see what works best for you.

10-21

ABOUT THIS FIGURE By using the Opacity slider in the Layers palette, you can tone down the retouching by reducing the Opacity in the Layers palette. Now Michael looks real, but improved.

SHAREYOUR IMAGES

Shoeboxes of images (see 10-22) stored on shelves or under the bed are a thing of the past. Now that you've captured all those special life moments with your digital camera or scanner and have enhanced them using an image-editing software program, it's time to share them with the

world — or at a minimum, your immediate friends and family. From creating slideshows, to e-mailing images, to using photo-sharing Web sites, to printing photos, you have many ways to show off your images. All it takes is some inspiration, dedication, and a very small amount of perspiration.

ABOUT THIS PHOTO Looking at old photos stored in shoeboxes or photo albums is a classic pastime, but don't you wish you could quickly and easily share your favorite images with others? Taken at ISO 200, f/4.0, 1/100 sec. with a Canon EF 17-35mm f/2.8 lens.

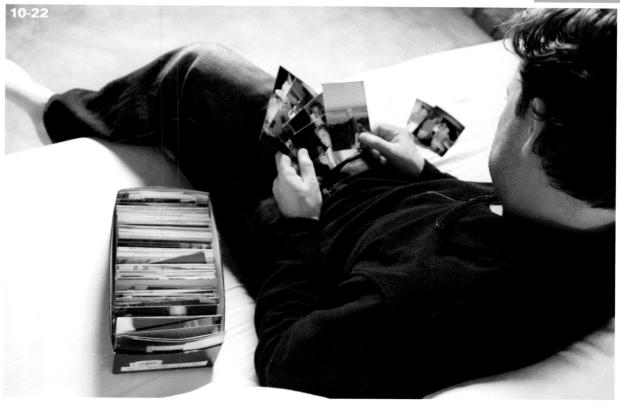

SLIDESHOWS

A fun way to share your photographs is to create and view them in a slideshow on a computer screen, TV monitor, or projector. Many slideshow applications are in the marketplace, and some are more robust than others. Most image-editing and image-organizing software programs also include the ability to create slideshows in varying degrees of sophistication. This is all great if you plan on hauling your computer around with you to present your slideshow creation, but what if this isn't possible or convenient?

If your goal is to create a slideshow of images set to music and you plan to show it with a DVD player, your software requires that capability. After you create your slideshow, you need to export it in a format that can be easily viewed. I've found that many people, when given a CD or DVD with homemade image content, aren't clear on whether they can view the content on their TV monitors with a DVD player or whether they must view it on their computer screens. How many grandparents sit down in front of the TV to view the new images of their grandkids only to discover that their DVD players won't recognize

UNDERSTANDING IMAGE FILE FORMATS Most digital cameras capture images as JPEGs, the standard algorithm for the compression of digital images. For simplicity, I concentrate on working with the JPEG format in this book. When you are saving your images, you may notice other mysterious file formats in the drop-down list in the Save As dialog box. The following list provides a short description of each file format to introduce you to the differences. This is a basic introduction, but as you continue to learn more about image-editing software programs, the purpose of these formats will begin to make more sense.

- JPEG (Joint Photographic Experts Group). The standard format for digital photos.
- TIFF (Tagged Image Format File). The industry standard graphics file format.
- PSD (Photoshop Document). A native file format for Photoshop and Photoshop Elements.
- BMP (Bitmap). A Windows image format.
- GIF (Graphics Interchange Format). A format for Web images with limited colors.
- RAW (unprocessed camera sensor converted data). A unique format that must be converted to a standard graphics format before the image can be used.

the discs? Save yourself a lot of future frustration by finding out how people want to view your slideshow and then explore the capabilities and limitations of your software.

I like using Boinx FotoMagico for slideshows because it allows you to easily add your photos into a dynamic, moving slideshow presentation with music and transition effects that rival professionally created slideshows (available for as little as \$49). It's a universal application that works on both PCs and Intel-based Macs, and it also has the capability to export to iPod, DVD, or HDTV formats. This makes it super simple to create slideshows that everyone can view, without the frustration of the mysterious proprietary format issues. An example of the FotoMagico workspace is shown in 10-23.

There are also many other software programs on the market that you can create a slideshow in or that are dedicated to slideshow creation, including iPhoto, Microsoft Photo Story, ACDSee, MAGIX PhotoStory, and Picasa. If you plan to create slideshows, try what you have available to you or you can get free before investing in software. That way you know what features you want and need before stepping up to other options that likely have more features.

p idea

Digital photo frames are gaining in popularity, are easy to use, and pro-

vide a unique way to showcase your digital images, from any room in the house. Most of these frames accept media cards, and some have the capability of connecting wirelessly to your modem at home to receive images from online photo-sharing sites.

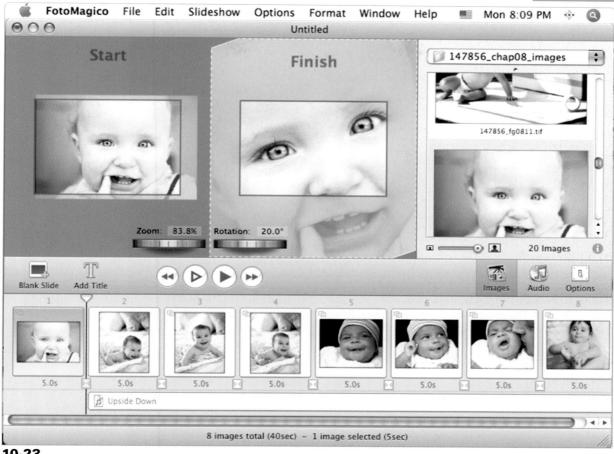

10-23

ABOUT THIS FIGURE An easy-to-use, feature-packed slideshow program is Boinx FotoMagico.

E-MAIL

If your digital camera is set to capture images at the highest resolution, your image files are going to be too large to send successfully via e-mail. because most e-mail providers reject attachments greater than 3MB to 5MB (megabytes) in size. Digital cameras measure their resolution in megapixels (MP) and produce image file sizes measured in megabytes. If you have a 4MP to

10MP camera set at the highest resolution, your images are 12MB to 30MB in size and far too large to send via e-mail, even with IPEG file compression. If your large files do manage to squeeze through the e-mail provider barrier, your friends and family may become annoyed when they are forced to wait for your large attachment to download, and then the file fills up their hard drive space.

To make matters more difficult, if you plan on printing images larger than 4 × 6 inches, it's necessary to shoot your images at the highest resolution because printers require more pixels to produce quality prints. The more pixels an image has, the more detail that can be seen; this is expressed as *resolution*. Commercial and inkjet printers require a resolution of 200 to 300 pixels per inch (ppi) to successfully print your images.

The solution to the e-mailing and printing file size dilemma is to save your original, high-resolution image and then create a copy of that image and downsize it for e-mailing purposes.

Fortunately, computer screens only require a resolution of 72 to 96 ppi to display a quality image. The high-resolution image file is your printing image, and your low-resolution image file is your e-mailing image.

Everyone has a different file-naming approach, but a filename example for high-resolution and low-resolution versions of the same image might be flower_h.jpeg for high resolution and flower_l.jpg for low resolution.

A pixel is one square of information in a digital photograph. Digital photos are comprised of millions of these tiny squares. A megapixel is one million pixels.

To reduce your image file size for e-mail purposes, Choose File ➡ Attach to Email. Photoshop Elements automatically reduces your file to an agreeable size and attaches it to a new, outgoing message in your e-mail client.

You don't have to worry about designating your file size with this feature; Photoshop Elements does it for you. With this method, you can e-mail images quickly; your friends and family can

download your images easily; and your image maintains quality for onscreen viewing.

You can also customize your image size in Photoshop Elements by adjusting the image size.

- 1. Choose Image

 Image Size on a Mac or
 Image

 Resize

 Image Size on a PC. The
 Image Size dialog box opens.
- 2. With the Resample Image check box selected, enter a new height or width for the image. If you have the Constrain Proportions check box selected (which I highly recommend), the other dimensions automatically adjust to maintain the proportions of the image, as shown in 10-24.

10-24

ABOUT THIS FIGURE Designate your exact image file size in the Image Size dialog box.

A good rule of thumb for e-mail attachments is to reduce your image size to less than 1MB prior to sending. For example, an image size of 640×480 pixels, set at a resolution of 72, gives you an 8.8×6.6 -inch viewable screen image. This image file

size is 900 k (kilobytes), just under 1MB, so it's large enough to see and small enough to successfully send over e-mail.

Now your friends and family are going to be happy to receive quality images at a file size their e-mail provider does not block or reject, and you are going to be happy to show off your images.

PHOTO SHARING WEB SITES

Photo sharing Web sites are a handy place to upload your digital images and easily share them with family and friends. Most photo-sharing Web sites enable you to order prints, note cards, calendars, coffee cups, purses, jewelry, or just about anything else you would like to customize with your images.

One of the major benefits of using a photo-sharing Web site is you're able to share your images with others without sending your images as e-mail attachments. Your viewers simply click a link to instantly see your images online. And after your friends and family view the images, they are able to order prints, or any of the other customized gifts, pay for them online, and have them shipped directly to their home or office.

It would be impossible to list every Web site that offers photo-sharing services, but here are a few well-known entities:

- Free photo-sharing sites. These are permission based; that is, only your designated viewers have permission to see your image albums or order products. You can create image albums for online sharing with password protected viewing, as well as ordering prints.
 - > www.shutterfly.com
 - > www.kodakgallery.com.

- also permission based and offer all the basic print sharing and ordering features as the free sites, but with more features. These features include video, RSS feeds, slideshows set to music, mobile phone image uploads, long-term image storage, GPS (Global Positioning System) image tracking, and more.
 - > www.phanfare.com
 - > www.smugmug.com

note

RSS is an XML-based vocabulary that specifies a means of describing

news or other Web content that is available for feeding (distribution or syndication) from an online publisher to Web users. RSS is an abbreviation for describing one of three different standards, which include RDF Site Summary (RSS .9 and 1.0), Rich Site Summary (RSS 0.91 and 1.0), and Really Simple Syndication (RSS 2.0).

Web sites, such as www.flickr.com, on which you can publicly showcase personal photographs that online members can view and discuss. Some people also use these community sites as a repository for photo blogs.

Photo-sharing Web sites are very popular, and due to constant technological improvements, can change very quickly. Conduct your own online search to explore different Web site offerings and find one that suits your needs.

PRINTING

Even though the world has gone digital, and many images are showcased on a computer monitor, iPod, cell phone, projector, or TV screen, nothing can compare to holding a print in your

hand, or flipping through a beautifully printed photo album. The tactile sense of paper and ink and the ability to peruse images at leisure, from anywhere, can be preferable for many picture viewers. Perhaps the future is filled with hologram image walls, or digital screens in every nook and cranny, but for now, framed prints in various sizes still adorn most people's homes and offices.

Photo-sharing Web sites, retail photo kiosks, home inkjet and laser printers, and mini travel-printers are all capable of printing with inks and photo-quality papers that rival the local photo lab. You have so many options!

Photo-sharing Web sites allow you to upload your digital images, share them with friends and family, and order prints and professional-looking photo albums online. These prints are promptly shipped to your home or office, sometimes faster than the local photo lab.

Retail photo kiosks enable you to print your images without the aid of a computer. You simply remove the media card from your camera, insert it into the kiosk, and follow the onscreen prompts to order your prints. Print pickup is often immediate or a few hours later.

Home inkjet and laser printers are less expensive options for printing photographs and offer more features than ever. Whether connected to a computer or a digital camera, you can view and print images in a variety of sizes. After you stock up on paper and ink, you become your own photo lab and image/craft creator, all in the comfort of your own home. If long-term archival image quality is an issue, be sure to read the literature that comes with your printer inks and papers regarding longevity.

Mini travel printers, such as the one shown in 10-25, produce $4-\times 6$ -inch standard prints, postcards, and even stickers. These handy devices can go with you anywhere, such as birthday parties and scrapbooking gatherings, and can even fit in your suitcase. I like to bring my mini printer to parties and print out all the funny pictures from the evening for my friends.

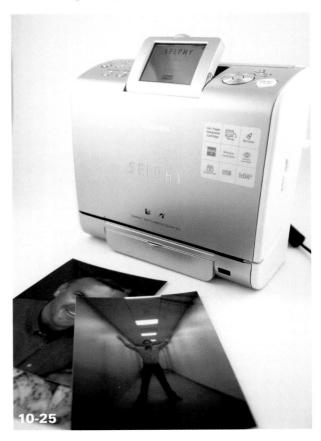

ABOUT THIS FIGURE Mini travel printers are easy to bring along, and they produce beautiful photo-quality prints.

BACK UP YOUR DIGITAL PHOTO COLLECTION TO A DVD

Not archiving (copying) or backing up images in case of a corrupted image file, computer crash, or natural disaster can be a huge mistake. Play it safe and back up your image files. The older your hard drive is, the more likely it is to fail. To avoid losing all or part of your digital photo collection, you should keep your photos well organized with an image manager. Have a procedure in place for periodically archiving them to another hard drive or to removable media such as a DVD or an external hard drive.

note A DV

A DVD holds 4.7GB of digital photos or slightly more than seven

CDs. Using a 6-megapixel camera to shoot in the RAW format, you can archive around 750 digital photos or the equivalent of about 20 rolls of 36-exposure film on a single DVD.

One of the easiest and safest ways to archive your digital photos is to burn, or write, them to a DVD. To do that you need a DVD burner — a DVD drive that both reads and writes DVD discs — and software to manage the process. One excellent software product for archiving digital photos to a DVD is Roxio Easy CD & DVD Creator. It is a feature-rich product that enables you to easily archive just a few files or many files that require multiple DVD discs. It also comes with software for printing disc labels and jewel and DVD case inserts.

Because it is not certain how long a DVD disc will safely store your digital photos, and because a single scratch can prevent you from retrieving photos, you should take all precautions to protect your archives. Redundancy is a good strategy: one backup is good, but multiple backups give you increased security. Store your CDs or DVDs in a special box or folder — preferably off premises. Be sure to back up your image folders regularly. Pick a consistent time, perhaps every Sunday, to copy your image files to an external hard drive or burn a CD/DVD.

Post a reminder to change the date on your image folder before burning it to a CD or DVD; that way, you know what date you last backed up your files. An external hard drive is also very convenient to use because after you connect the drive to your computer via a USB or FireWire connection, it appears as another hard drive right on your desktop. It's easy to drag your files over to the hard drive and copy them.

•

note

Some early DVD drives and DVDburning software may write to discs

in a format that some of the more current DVD drives cannot read. Be careful to use a DVD drive and software that enables you to read your discs in new DVD drives and on computers with current operating systems.

Assignment

Use Your New Photo-Editing Skills

Select a portrait photograph you've taken in the past and use your new photo-retouching skills to naturally enhance the image. Post your improved image online at PhotoWorkshop.com and tell us about the before and after.

To complete the assignment, I took the photo shown here and I adjusted the contrast and saturation, as well as removed small imperfections in the photo using the Spot Healing Brush tool to create a more flawless image. Taken at ISO 400, f/4.0, 1/125 sec. with a Canon EF 24-105mm f/4L IS lens.

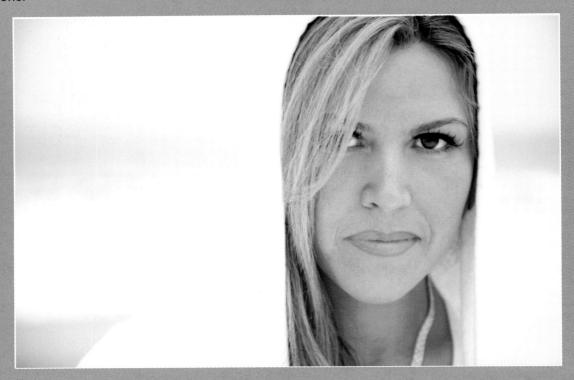

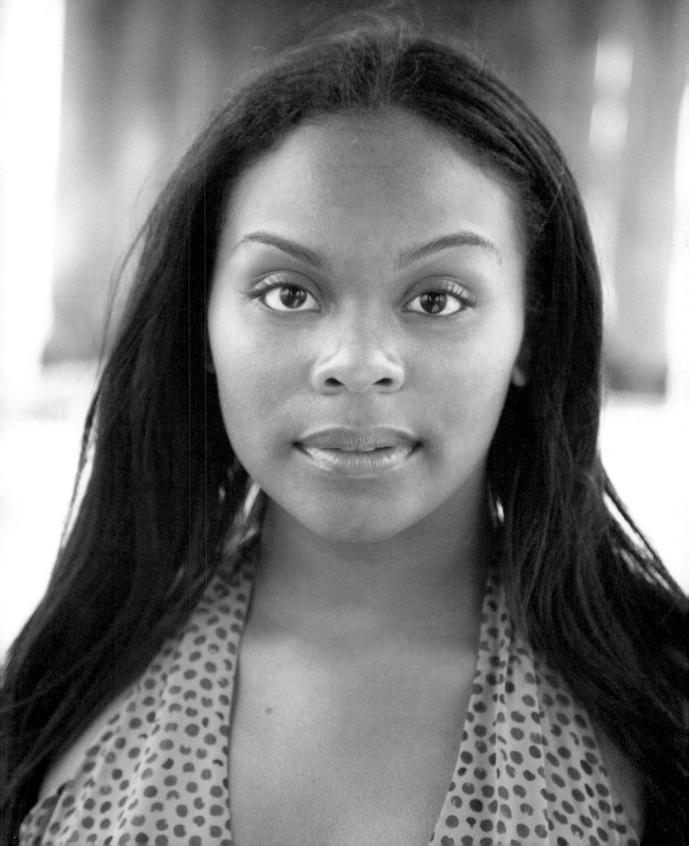

PERIODICALS

Books

Organizations

PHOTOGRAPHY WORKSHOPS

PHOTOGRAPHIC EQUIPMENT AND REVIEW SITES

PHOTO-SHARING WEB SITES

IMAGE-ORGANIZING AND SLIDESHOW SOFTWARE

Online Learning

PERIODICALS

There are many magazines and other publications out there to choose from. Here are a few of my favorites that I hope you find useful as resources as well.

DIGITAL PHOTO PRO

www.digitalphotopro.com

A publication designed largely for working digital photo professionals. However, its in-depth reviews, how-to articles, and detailed explanations are useful to any photographer interested in expanding and improving his or her skills.

MAC LIFE

www.maclife.com

Written for both new and veteran users, Mac Life provides exclusive, authoritative information and advice for readers who want to get the most out of their Macs, iPods, and third-party hardware, software, and services. The magazine also delivers informative feature articles showcasing the latest hardware and software, an expanded "how-to" section, and candid reviews of the latest gear.

PC PHOTO MAGAZINE

www.pcphotomag.com

A magazine devoted to digital photography and related technologies.

PHOTO DISTRICT NEWS

www.pdnonline.com

PDN provides useful photography news ranging from marketing and business advice to legal issues, photographic techniques, new technologies, and more.

POPULAR PHOTOGRAPHY

www.popphoto.com

This magazine offers illustrated, instructional articles and covers all facets of photography — both amateur and professional as well as art and technique. You can also find helpful reviews of cameras and accessories.

BOOKS

If you are looking to expand your photography knowledge base, these books are some of my longtime favorites.

DESIGN BASICS

Lauer, David and Pentak, Stephen. *Design Basics*. Wadsworth Publishing, 6th edition, 2004.

This book helps with getting great ideas. As the title implies, this book helps you understand visual theory simply, logically, and completely. I used this book in school years ago and I still refer to it often.

HENRI CARTIER-BRESSON: A PROPOS DE PARIS

Cartier-Bresson, Henri. Henri Cartier-Bresson: A Propos de Paris. Bullfinch, 1998.

This book offers an inspiring look at the photos from one of the masters of photography.

MATTERS OF LIGHT & DEPTH

Lowell, Ross. Matters of Light & Depth. Lower Light Management, 1999.

From the basics of lighting to advanced lighting techniques, this book is a great resource if you're interested in expanding your knowledge of lighting.

PHOTOSPEAK: A GUIDE TO THE IDEAS, MOVEMENTS, AND TECHNIQUES OF PHOTOGRAPHY, 1839 TO THE PRESENT

Mora, Gilles. Photospeak: A Guide to the Ideas, Movements, and Techniques of Photography, 1839 to the Present. Abbeville Press, 1st edition, 1998.

When you understand the bigger picture, it helps you take better photographs. This book is alphabetically arranged, providing a simple reference guide to the "ideas, movements and techniques of photography." Impress your friends and family with your knowledge of the photographic timeline.

ORGANIZATIONS

While you may not be ready to dive into joining a professional organization just yet, there may come a time when you will benefit from what these organizations have to offer. This listing is just a few of the more well-known groups — there are many others.

ADVERTISING PHOTOGRAPHERS OF AMERICA

www.apanational.com

The Advertising Photographers of America (APA) establishes, endorses, and promotes professional practices, standards, and ethics in the photographic and advertising community.

AMERICAN SOCIETY OF MEDIA PHOTOGRAPHERS

www.asmp.org

The American Society of Media Photographers (ASMP) promotes photographers' rights, educates photographers in better business practices, produces business publications for photographers, and helps buyers find professional photographers.

NATIONAL ASSOCIATION OF PHOTOSHOP PROFESSIONALS

www.photoshopuser.com

The National Association of Photoshop Professionals (NAPP) is a trade association and a resource for Adobe Photoshop education, training, and news. It is led by a world-class team of Photoshop experts, authors, consultants, trainers, and educators whose focus is to ensure that NAPP members stay on the cutting edge of Adobe Photoshop techniques and ahead of their competition.

PROFESSIONAL PHOTOGRAPHERS OF AMERICA

www.ppa.com

The Professional Photographers of America (PPA) seeks to increase its members' business savvy as well as broaden their creative scope. It aims to advance their careers by providing them with all the tools for success.

UNITED STATES DIGITAL IMAGING GROUP (USDIG)

www.usdig.org

United States Digital Imaging Group (USDIG) is open to all professionals involved in digital imaging, such as photographers, designers, prepress providers, and so on. Each chapter's bi-monthly meeting features a power user or industry expert discussing a specific element of their digital workflow. The intention is to help attendees develop their knowledge of "best practices" in digital imaging and to provide a forum for discussion with colleagues.

WOMEN IN PHOTOGRAPHY INTERNATIONAL

www.wipi.org

Women in Photography International (WIPI) promotes the visibility of women photographers and their work through a variety of programs, exhibitions, juried competitions, and publications. The group's aim is to serve the needs of photographers, photo educators, photography students, gallery owners, and photographic organizations around the world.

PHOTOGRAPHY WORKSHOPS

These workshops are a year-round source of experiential learning and creativity for image makers of all skill levels. I've only listed a couple here, but there are many more around the country. Search the Web to find one that fits your interests and skill level.

THE MAINE PHOTOGRAPHIC WORKSHOPS

www.theworkshops.com

SANTA FE WORKSHOPS

www.santafeworkshops.com

PHOTOGRAPHIC EQUIPMENT AND REVIEW SITES

Even if you do not choose to purchase photographic equipment online, the Internet is a great source of information including competitive pricing and equipment reviews. The sites listed here are just a smattering of what is out there, but I have found them to be most useful.

B&HPHOTO

www.bhphotovideo.com

B&H Photo is a very good place to purchase cameras, equipment, and accessories. They stand behind their products, and many professional photographers purchase their cameras and equipment here.

CNET.COM

http://reviews.cnet.com

CNET.com offers information, product comparisons, and shopping for digital cameras all in one place.

DP REVIEW

www.dpreview.com

On DP Review you can find news on new products from a variety of major camera manufacturers, as well as thorough reviews on a variety of cameras and equipment.

EPINIONS.COM

www.epinions.com/Digital_Cameras

Epinions covers many different products, but there are many reviews of digital cameras from other consumers.

FROOGLE.COM

www.froogle.com

Froogle.com allows you to shop for and compare digital cameras all on one site.

PHOTO-SHARING WEB SITES

Whether you just want to post a few pictures for your family on the other side of the country to see

or you want to have a gallery to showcase your photography, there is a site for you on the Web.

FREETO JOIN

These Web sites allow a secure and easy way to view, store, and share your photos with friends and family. Most also provide free editing, creative tools, and specialty photo products.

Kodak Gallery

www.kodakgallery.com

Shutterfly

www.shutterfly.com

Snapfish

www.snapfish.com

SUBSCRIPTION BASED

A subscription-based Web site charges a monthly or annual fee and allows you to upload, store, share, and order prints and other specialty photo products. Some sites are now offering video, music, and long-term image storage with no advertising.

Phanfare

www.phanfare.com

Photoworkshop

www.photoworkshop.com

Smilebox

www.smilebox.com

SmugMug

www.smugmug.com

PHOTO COMMUNITIES

A community-based Web site enables others to look at your posted photos and comment on

them. These sites make it easy to link your images to Web sites and blogs for online photo sharing.

Flickr

www.flickr.com

Fotki

www.fotki.com

Picturetrail

www.picturetrail.com

IMAGE ORGANIZING AND SLIDESHOW SOFTWARE

There are many ways to organize photos and many software products to choose from for organizing and creating slideshows. This list offers just a quick look at some of the more widely used solutions.

ADOBE PHOTOSHOP LIGHTROOM

www.adobe.com/ap/products/photoshoplightroom

You can organize thousands of images in Lightroom. You can also use this software to develop, protect, and showcase large volumes of your digital pictures, while saving valuable time in your workflow.

APERTURE

www.apple.com/aperture

Aperture is an all-in-one, post-production tool for serious photographers. Aperture makes it easy to import, manage, edit, catalog, organize, adjust, publish, export, and archive your images more effectively and efficiently.

BOINX FOTOMAGICO

www.boinx.com

Boinx FotoMagico allows you to easily add your photos into a dynamic, moving slideshow presentation with music and transition effects that rival professionally created slideshows. It's a universal application that works on both PCs and Intelbased Macs. It also has the capability to export to iPod, DVD, and HDTV formats.

IPHOTO

www.apple.com/ilife/iphoto

iPhoto (for Macs) includes a photo-organizing and -viewing software program. It comes bundled with every Apple computer. iPhoto allows you to import, organize, edit, and retouch your images with a user-friendly, intuitive interface.

PICASA

http://picasa.google.com

Picasa is a free software download from Google for Windows PC users that helps you locate and organize all the photos on your computer. This software collects and organizes all the images on your computer, scanning the images and automatically sorting them by date, while you watch. You can also edit and add effects to your photos with a few simple clicks and then share your photos with others through e-mail, prints, and online — and it's free.

ONLINE LEARNING

There are some great tutorials on the Web on a variety of photography subjects, and there are also many sites that offer useful educational material. Here are two of my favorites.

LYNDA.COM

www.lynda.com

Lynda.com is provider of educational materials and video training for creative designers, instructors, students, and hobbyists.

TOTAL TRAINING

www.totaltraining.com

Total Training offers video-based software training titles for anyone wanting to learn tips and techniques.

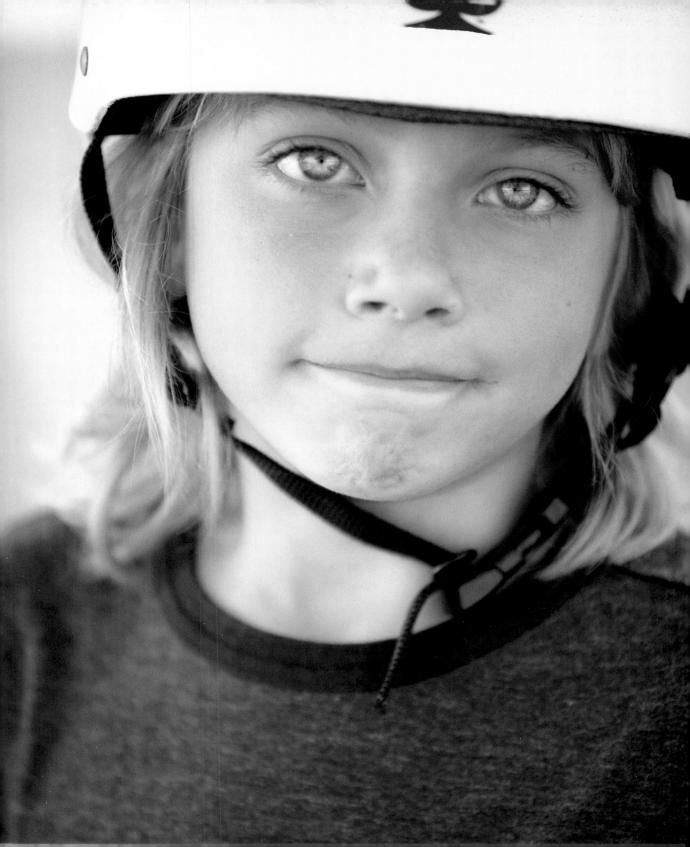

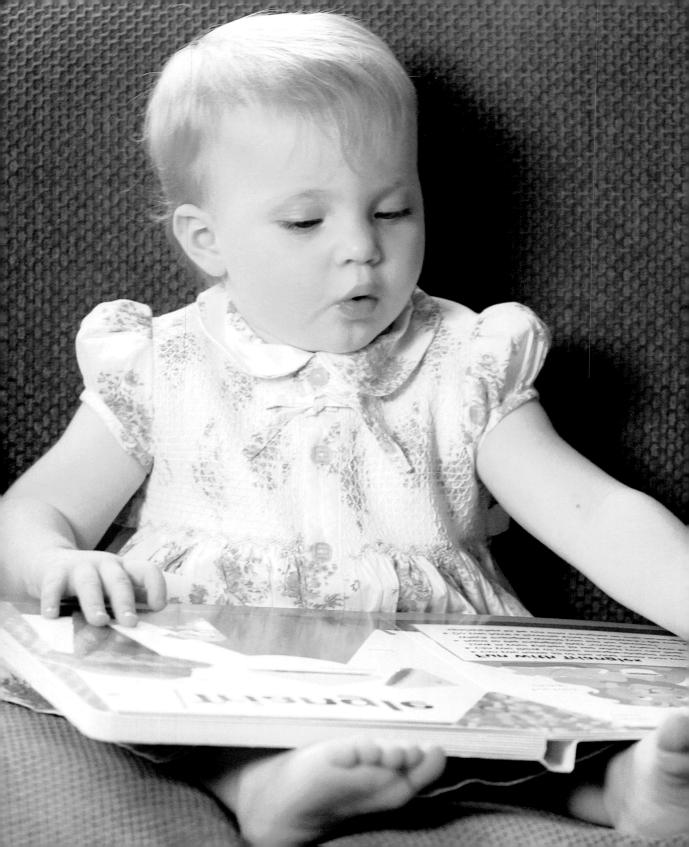

ambient light The natural light in a scene.

aperture A circular opening inside the lens that can be adjusted to control the amount of light reaching a camera's sensor prior to the image being taken. The aperture diameter is expressed in f-stops; the lower the number, the wider the aperture. The aperture and shutter speed work together to control the total amount of light reaching the sensor. See also *f-stop* and *shutter speed*.

Aperture Priority In Aperture Priority (AV), you select the aperture desired, and the camera sets the shutter speed as needed. This setting works great for controlling the depth of field in portraits.

backlight The light coming from behind the photo subject. See also *directional light*.

ballhead A type of tripod head. This spherical ball is mounted to the platform of a tripod, and when you attach it to your camera, it allows you to adjust your camera in a fluid, multidirectional way, until you lock it in place to keep it from moving. Protruding from the top part of the ball is a shaft that holds the quick release clamp or platform.

battery grip A device that you can mount on the bottom of your digital single lens reflex (dSLR) camera that extends your battery life because it provides more power.

bounce card A white, gold, or silver card used to provide soft indirect lighting by bouncing light off the card. It can also be used to gently brighten shadow areas.

bounce light The light bounced into a reflective surface (such as a wall, ceiling, or reflector card) to illuminate a subject with softer light, reducing harsh shadows. The color of the reflective surface determines the color of the light bounced into the subject.

brightness The brightness (light/dark) of an image, the intensity of a light source or color luminance.

card reader A device that allows you to transfer images from a memory card to your computer. Instead of connecting your camera to the computer to download your images, you simply plug a card reader into your computer's USB or firewire port.

catch-light A reflection of light represented by a twinkle in the eye.

color cast The predominance of a particular color which affects the entire image. A color cast changes the hue of an image while keeping the saturation and brightness intact.

color temperature See Kelvin and color cast.

color wheel A color wheel is a chart that illustrates color relationships. Harmonizing colors are located near each other on the color wheel; complementary colors are located opposite each other on the color wheel. See also *complementary color* and *harmonizing color*.

complementary color Colors that lie opposite each other on an artist's color wheel. When they appear together, their intensity increases.

continuous drive mode A camera mode that allows continuous shooting of sequential images in quick succession. This mode works well with sports and active children.

continuous light A light source that is on all the time, allowing you to see how the light falls upon your subject in the scene.

crop factor A cropped field of view results because some certain dSLR cameras have a sensor smaller than the 35mm photographic film frame. They only capture part of the information projected by a lens and make images appear as though you are shooting with a longer lens. To

compute the focal length, you must know your dSLR crop factor or multiplier; this information is included with your camera. The three most common multipliers are 1.5, 1.6, and 2.0. For example, if you attach a 100mm lens to a dSLR with a 1.5 crop factor, it actually capture images as a 150mm lens (100mm \times 1.5 = 150mm). See also focal length multiplier and dSLR crop factor.

diffuser A translucent material placed between the light source and your subject to soften the harsh light in your scene. See also *flash diffuser*.

digital zoom The method of making a subject appear closer by cropping away the edges of a scene within the camera.

directional light The direction the light comes from. See also *backlight*, *sidelight*, and *top light*.

dSLR crop factor A digital camera without a full size sensor can enhance the lens focal length, resulting in a "cropped," or reduced, field of view in your images.

dynamic range The range between the darkest parts of an image and the lightest parts of an image.

external flash A flash unit that connects to the camera with a cable, or is triggered by the light from the camera's internal flash.

field of view In photography, the total angle of view that is visible through the camera lens.

filters Pieces of glass or optical resin that you place in front of the lens to affect the image in the camera.

flash An on-camera or off-camera device that emits a burst of light, artificially illuminating your scene.

flash diffuser A flash accessory that consists of a white, translucent plastic or fabric cover that slips over the head of your flash unit. The flashed light passes through the translucent cover and is diffused and softened by the time it reaches your subject.

flash sync speed The fastest shutter speed at which the flash can fire and still capture a complete image.

focal length multiplier Many dSLR cameras have a sensor smaller than the 35mm photographic film frame and only capture part of the information projected by a lens. This results in a cropped field of view, which makes images appear as though you are shooting with a longer lens. See *crop factor* and *dSLR crop factor*.

format An action that prepares and optimizes a memory card for use with your specific camera. Formatting is also the best way to clear the images off of your memory card after you transfer them to a hard drive or portable storage device, or burn them onto a CD/DVD.

f-stop The designation for each step in the aperture. The smaller the f-stop or f-number, the larger the actual opening of the aperture; the higher numbered f-stops designate smaller apertures, letting in less light. See also *aperture* and *shutter speed*.

golden hour A time that occurs in the early morning or near sunset when the angle of the sun is low in the sky and just above the horizon. Golden hour light is considered to be very beautiful, soft light.

graduated neutral density filter A filter that is immensely helpful in landscape photography, particularly during sunrise and sunset. The bottom of this filter is clear, the top is a neutral gray, and the middle is a smooth gradation between the two. The gray part, the neutral density, simply lets less light in. This filter is used to darken a bright sky, bringing the exposure closer to that of a shaded foreground.

harmonizing color Harmonizing colors are next to each other on the color wheel. For example, green and blue, yellow and orange, and red and violet harmonize nicely. Use these colors in an image to convey a sense of peace and balance.

high key When the dominant value relationships in an image are medium to light.

histogram A visual representation of the range of tones from dark to light in a photo, which often looks like a mountain range.

hue Hue is the actual color of an object.

image sensor A computer chip that electronically captures the light rays coming through the lens of a digital camera and creates a digital image.

incandescent light Light from tungsten light bulbs is the most common source of light in most homes. This very warm light can be used in a lot of photographic situations, but incandescent lights are limiting because of their relative low light output.

ISO speed A rating of a digital camera sensor's sensitivity to light. Digital cameras use the same rating system for describing the sensitivity of the camera's imaging sensor as film manufacturers do for film. Your digital camera has a manual control for adjusting the ISO speed, or it can adjust the ISO automatically depending on the lighting conditions. Generally, as the ISO speed increases, the image quality suffers.

JPEG A standard for compressing image data developed by the Joint Photographic Experts Group. Compression is applied to a jpeg image when it is captured and stored on a memory card. Due to this compression, JPEG format does not give you the same amount of editing capabilities as the RAW format does. See also lossy compression.

Kelvin The color of light is described as color temperature and measured in Kelvin (K), named

after the nineteenth-century physicist William Thomson, 1st Baron Kelvin. Ranging from 1000K to 10,000K, lower temperatures describe light that is warmer or redder in appearance; midrange temperatures refer to light that is white, or neutral; and the higher readings indicate that light has a cooler, or bluer, appearance. Average noon daylight has a color temperature of 5500K. For example, a common tungsten light bulb has a color temperature of 2800K.

LCD An acronym for liquid crystal display, an LCD is a low-power monitor that is often used on the back of a digital camera to display settings and for viewing images.

leading line A compositional element in an image that draws your eye into and through an image.

light quality Generally defined as how hard or soft the light is. Bright sunlight is hard light, but an overcast day typically has soft light.

lossy compression A type of compression used in the JPEG file format. Pixel values are averaged out in the process, and you may lose some detail and color in the image. See also *JPEG*.

low key When the dominant value relationships in an image are medium to dark.

luminosity The brightness of an area determined by the amount of light it reflects or emits.

macro lens Available in various focal lengths, a macro lens allows you to photograph your subject from a very close distance without distortion.

macro photography True macro photography happens when the image on the sensor is equal to or bigger than the subject that is being photographed. The ratio of 1:1 means the image size on the sensor is equal to the subject size. Getting closer would make the ratio of the image to the subject 2:1, meaning the image is twice as big as the subject.

megabyte (MB) A measurement of data storage equal to 1024 kilobytes (KB).

megapixel Abbreviated as MP, a digital camera's resolution is measured in megapixels. One megapixel is equal to one million pixels.

memory card A small, thin, reusable device that is inserted into a slot in a digital camera to electronically record and store digital images.

metering modes Known as Matrix, Center-Weighted, and Spot (the name depends on the camera manufacturer). These metering modes tell the camera's light meter to analyze the light in your scene in different ways.

monochromatic color A monochromatic color scheme uses variations in lightness and saturation of a single color.

neutral density filter A dark filter that attaches to a lens in order to control the amount of light reaching the camera's sensor.

noise The degradation of a digital image, usually noted by random discolored pixels. Most noticeable in the even areas of color in an image, such as shadows and sky, noise results from shooting in low light with a high ISO.

optical zoom The amount of zoom that can be achieved through the optics of a lens.

panning An action photography technique where the camera follows a moving subject. The subject remains sharp and clear, while the background is blurred, giving a sense of motion to the photo.

photo floods Similar to household lights, photo floods emit a golden color cast and are often used as construction or utility work lights. They produce a generous amount of light, but the bulbs have a fairly short life span and put out a lot of heat.

pixel An abbreviation for picture element, digital images are comprised of millions of these tiny, tile-like, colored squares. One million pixels are the equivalent of one megapixel.

polarizing filter A filter modifies the light as it enters the lens, removing the glare and reflections from the surface of glass and water. It can also darken the sky and increase color saturation.

RAW capture RAW image files contain *all* the uncompressed data of the image photographed. RAW files are not standard image file formats, and the file extensions for RAW files vary by camera manufacturer. To edit RAW image files, you must first convert the files in the computer. RAW works well for difficult exposures or when you want to maximize the information captured for the best possible image.

red-eye The red glow from a subject's eyes caused by an on-camera flash reflecting off the blood vessels behind the retina. Red-eye occurs in low-light situations due to the enlargement of the pupil.

red-eye reduction A camera feature that can reduce red-eye in low-light situations. The camera emits one to two preflashes before the picture is taken using the actual flash. This constricts your subject's pupil and can help reduce the amount of red-eye in your images.

reflector A tool for redirecting light; usually a white or metallic cloth, a reflective umbrella, or a light-reflecting board.

resolution The more pixels in your digital image, the higher your image resolution. Image resolution determines how much detail you see in your images and how large an image you can successfully print.

saturation Saturation is the color intensity of an image. A color with high saturation will appear brighter and more vibrant than the same color with low saturation.

second curtain sync The firing of the strobe at the end of the exposure instead of the beginning of it. The first blade of the shutter opens to begin the exposure; light builds on the sensor creating the exposure; and just before the second blade comes down to the end of the exposure, the strobe goes off. This does two things — it freezes the subject at the end of the subject's movement and gives the subject a trailing blur.

selective focus An effect that is achieved by using a wide aperture to produce shallow depth of field so that the subject is isolated from its out-of-focus surroundings.

setups Setting up the scene considering the light, location, and composition of the image.

Shutter Priority (Tv) A camera exposure mode that allows you to select a shutter speed and the camera chooses the aperture to correctly expose the scene.

shutter speed A measurement of how long the shutter remains open when the picture is taken. The slower the shutter speed, the more light hitting the sensor. When the shutter speed is set to 1/250 of a second (250), this means the shutter is open for 1/250 of a second. The shutter speed and aperture work together to control the total amount of light reaching the sensor.

sidelight Light that illuminates the side of the scene, emphasizing the shape and texture in a scene. See also *directional light*.

slave A light-sensitive trigger device used to synch strobes and flashes without an electronic synch cord.

SLR An acronym for single lens reflex, which means that the light from the image comes through the lens and bounces off a mirror in front of the shutter into the viewfinder until the shutter release is pressed. At that time, the mirror flips up; the shutter opens, exposing the digital

sensor, and then closes; and the mirror flips back down.

spot meter Unlike an evaluative or centerweighted meter, which averages the scene to get the right exposure, a spot meter allows you to select a very small part of the scene and find the exposure for just that area. This is particularly useful when you need to find the exposure of your subject and he is surrounded by large amounts of light or dark.

standard lens Also known as a normal lens, the focal length representative of the field of view of human sight. In 35mm format, it is approximately 50mm.

strobe Also known as a *stroboscopic lamp*, a strobe is a repeating flash that can be set to flash at a selected rate.

telephoto lens A lens designed for photographing distant objects. Similar to a telescope, it magnifies your subject and narrows your field of view.

top light A subject lit from above is lit with top lighting. However, top or front lighting has a tendency to look flat and uninteresting. See also directional light.

total zoom The combination of the optical and digital zoom on a compact digital camera, which creates a number of magnification. Optical zoom is the amount of zoom within the capabilities of your lens. Digital zoom digitally zooms and crops inside your camera. When purchasing a camera, keep in mind that the optical zoom is optimum, and that you can achieve the digital zoom with most image-editing software applications.

transmitter A dedicated electronic device attached to your camera that can control an unlimited number of flashes so they fire in succession.

TTL An acronym for through the lens, this type of metering is for both ambient and flash

exposures. TTL metering uses a meter inside the camera to measure the light after it passes through the lens. It is very accurate metering and is on virtually every dSLR.

tungsten/incandescent light A metal filament used in most light bulbs that emits a reddish/yellow light, creating a colorcast in a photograph.

UV filter A filter used to reduce the amount of ultraviolet light entering your lens, which may cause an image to appear hazy. UV filters are also used to protect the surface of a camera lens.

white balance A camera function that compensates for different colors of light being emitted by different light sources. Auto white balance (AWB) works well in most lighting situations, although it can vary depending on the camera and type of light in your scene. White balance presets offer a choice of white balance options designed for specific lighting conditions. Custom white balance is useful when your scene is

illuminated by mixed light sources, such as daylight coming in through a window blended with a fluorescent or tungsten light.

wide-angle lens A camera lens that has a shorter focal length than a normal or standard lens, and covers a wider angle of view. A wideangle lens comes in handy when you can't move far enough away from a subject to get everything in the picture, as well as for grand scenic vistas. Wide-angle lenses also provide a deep depth of field, so that all the elements seen through the lens appear in sharp focus. Great for special effects, when close to a subject with a wide-angle lens, the subject appears huge in comparison to the background. The disadvantage is these lenses may distort subjects at the far edges of the image by making them appear wider than they actually are, and when used at its widest setting, this lens may create dark edges in the corners of your images.

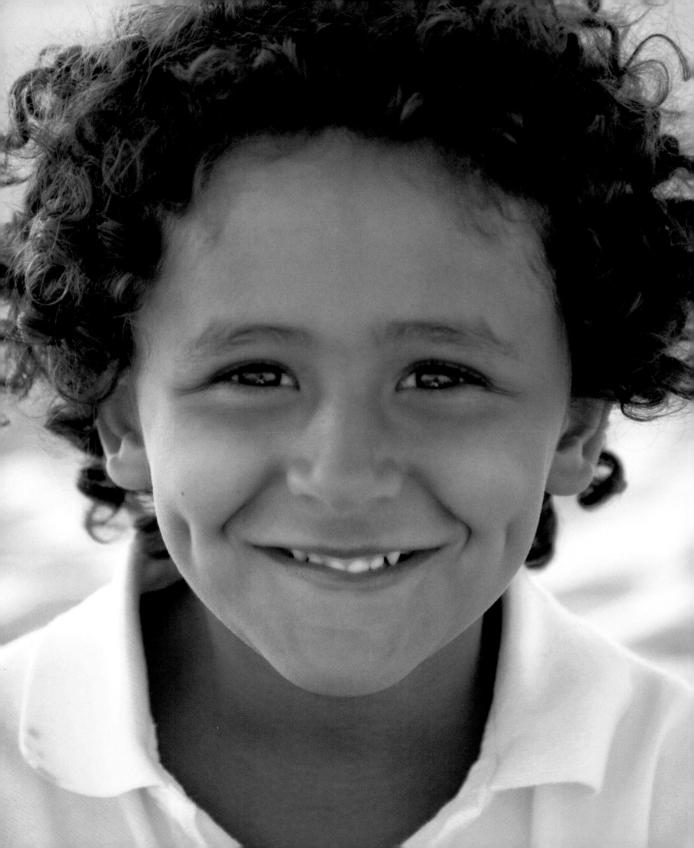

A	anniversaries, formal group posing, 114–116
A (Automatic) mode, 15	Aperture, software, 227
ACDSee, slideshows, 214	aperture priority (Av) mode
action blurs, ND (neutral density) filters, 30	defined, 232
action shots	dSLR cameras, 16
compact cameras, 170–172	group photos, 127
dSLR cameras, 172–174	Aperture Value (AV) mode, formal group
focal lengths, 175	posing, 116
freeze frames, 175–179	apertures. See also f/stops
lens speed guidelines, 174–175	constant maximum, 174
motion blurs, 179–185	defined, 232
shutter speeds, 176	DOF (depth of field control), 17
subject capture factors, 176–177	f-stop numbering conventions, 17–18
	lens selection element, 17–19
telephoto lenses, 175–176	lens speed, 19, 27
zoom lens, 174, 182 Adobe Bridge image acquisition 193, 194	maximum, 174
Adobe Bridge, image acquisition, 193–194 Adobe Photoshop Elements	variable maximum, 174
	zoom lenses, 174
Adobe Bridge image acquisition, 193–194 color balance, 201–202	archiving, image backups, 219
	archways, framing structure, 69
contrast adjustments, 201–204	arms, photo shoot posing, 100
e-mail attachments, 216–217	artifacts, noise, 112
Full Edit workspace, 196–197	attachments, e-mail images, 215–217
image cropping, 200–201	Automatic (A) mode, use guidelines, 15
image sizing, 216	automatic white balance (AWB), color compensa-
imperfection corrections, 208–212	tion, 55
layers, 197–198	Av (aperture priority) mode
levels, 203–204	defined, 232
merging/flattening image files, 198–200	dSLR cameras, 16
nondestructive editing, 197–198	group photos, 127
PSD (Photoshop Document) file format,	AV (Aperture Value) mode, formal group
197–198	posing, 116
Quick Fix workspace, 195–196	r8,
red-eye removal, 206–208	В
saturation, 201–202	_
Standard Edit workspace, 195–197	B & H Photo, 226
supported image import sources, 194	baby shots. See also kid shots
tags (keywords), 194	age accommodations, 150–153
teeth whitening, 205–206	age approximations, 148, 150–153
Unsharp Mask filter, 203	background isolation, 162
Adobe Photoshop Lightroom, 227	backgrounds, 154–156
Advertsing Photographers of America (APA), 225	camera introduction, 148
ambient light, 232	comfort guidelines, 148–153
American Society of Media Photographers	continuous mode, 164
(ASMP), 225	detail capturing, 164–165
angle views	environment, 148–150
kid photos, 140–141	eye focus, 164
light directions, 49–55	hygiene, 156
photo shoot posing, 99	lighting, 160–162
point of view factors, 78–80	continued

baby shots (continued)	С
macro lens, 29	camera bags, 39
moment in time, 162–165	camera levels
parental relationships, 164–165	kid photos, 141–142
posing, 157–158	photo shoot posing, 99
props, 158–159	camera media (memory cards)
shutter speeds, 162	capacities, 40
stress, 150	formatting before using, 40
temperature considerations, 149	photo-viewers, 40–41
timing issues, 148	purchasing, 40
wardrobes, 156–157	speed ratings, 40
backdrops	candid shots
baby shots, 154–156	group photos, 120–123
background distraction elimination, 87–88	9
group photos, 111	moment in time, 101–102
use guidelines, 38–39	telephoto lens, 28
backgrounds	caps, LCD viewfinder, 42–43
baby shots, 154–156	car seats, baby shots, 155
backdrops, 87–88	card readers, 32, 232 Cartier-Bresson. Henri
environmental portrait incorporation, 88–89	,
group photos, 111–112	event significance, 4 Henri Cartier-Bresson: A Propos de Paris, 224
motion blurs, 180	
selection, 86–88	casual group photos, posing, 117–120
backlight, 51-55, 232	catch-light defined, 232
backups, image management, 219	eye twinkle, 92, 112
ball-head, tripods, 33, 232	
batteries	CDs, image backups, 219
battery grip, 32, 232	Center-weighted metering mode, exposure control, 60
energy conservation techniques, 15	children. See also kid photos
recharging, 31–32	developmental stages, 133
battery grip	involving in the shoot, 134–136
defined, 232	Chinese lantern
dSLR cameras, 32	continuous light source, 38
birthdays, formal group posing, 114–116	front lighting, 51
Bitmap (BMP), image format, 214	circular polarizing filters, 30
blurs. See also motion blurs	close-up shots, Macro mode, 15
ND (neutral density) filters, 30	clothing. See wardrobes
shutter drag, 120	CNET, 226
Boinx FotoMagico, slideshows, 214–215, 227	color balance, Photoshop Elements image adjustments
bounce card diffusers	201–202
defined, 232	color cast
flash attachment, 37	defined, 232
bounce light, 232	white balance adjustments, 37
bouncing light, reflectors, 161	color temperature
	Kelvin scale, 55
breathing, photo shoot posing, 99	light sources, 37
brightness, 232 buildings, selective focus lens, 20, 29	Color Variations dialog box, 201–203
	color wheel
burning, backup DVDs, 219	defined, 232
	color relationships, 73–74

colors	converging lines, attention capture, 68–69
complementary, 73–74, 232	creativity
harmonizing, 74, 234	backdrops, 39
light characteristic, 55	dSLR camera, 17
commemorative shots, formal group posing, 114–116	crop factor
compact digital cameras. See also digital cameras; dSLR	defined, 232–233
cameras	focal length multiplier, 20–21, 26–27
action shot techniques, 170-172	Crop tool, 200–201
action shot tracking, 170	curved lines, viewer image guide, 67
macro mode, 29	our ou mice, siewer mage guide, of
mini-tripods, 34	D
Night Scene mode, 183	_
optical zooms, 171	depth of field (DOF)
overview, 15–16	focal length adjustments, 87
panning techniques, 181	formal group posing, 116
pre-focus, 170	lens selection element, 17
Quickpod extender, 35	light intensity factor, 55
viewfinder for action shots, 170	zone of sharpness, 75
complementary colors	Design Basics (David Lauer and Stephen Pentak), 224
defined, 232	design elements, composition technique, 9
color relationships, 73–74	detail shots, macro lens, 29
composition element, 73–74	developmental stages, children
composition	age accommodations, 150–153
complementary color, 73–74	kid photo, 133
concepts, 8–10	diagonal lines, viewer image guide, 67–69
framing, 69–73	diffusers
lines, 67–68	bounce card, 37
patterns, 74–76	defined, 233
repetition, 74–76	light control technique, 57–58
Rule of Thirds, 64–67	light manipulation technique, 93–94
self-portraits, 104–105	use guidelines, 35–37
simplicity, 64–65	digital cameras. See also compact digital cameras; dSLR
comps (tear sheets), 85	cameras
constant maximum aperture, zoom lens, 174	batteries, 14–15
contemporary effects, selective-focus lens, 29–30	compact, 15–16
continuous light	dSLR (digital SLR), 16–21
constant light source, 36	media cards, 14, 40
defined, 232	MP (megapixel) measurement, 13
fluorescent lights, 38	multi-focusing points, 66
household lights, 38	digital photo frames, photo sharing, 214
photo floods, 38	Digital Photo Pro magazine, 224
tungsten lights, 38	digital zoom
continuous mode	defined, 233
action shots, 15	versus optical zoom, 16
baby shots, 164	dioptric adjustment lenses, 41
defined, 232	direction, picture planning element, 4–5
dSLR camera action shots, 172–173	directional light, 233
group photos, 121, 127	directions of light angles, 49–55
panning shots, 181	distortion, wide-angle lens, 20
contrast, Photoshop Elements image adjustments, 201–204	distractions, background elimination techniques, 86–87
, E	Dodge tool, Photoshop Elements teeth whitening, 205–206

DOF (depth of field)	transmitters, 37
focal length adjustments, 87	TTL (through the lens) metering, 37
formal group posing, 116	external hard drives, image backups, 219
lens selection element, 17	eyes
light intensity factor, 55	baby shot focus, 164
zone of sharpness, 75	bouncing light, 161
doorways, framing structure, 69	catch-light, 92, 112
DP Review, 226	focus point, 84
dSLR (digital SLR) cameras	S S S S S
shutter speeds, 19	F
battery grip, 32	
continuous mode, 172–173	face powder, people photography, 44
crop factor, 20–21, 26–27, 233	facial exercise, photo shoot relaxation technique, 96–97
dioptric adjustment lenses, 41	facial expressions, 100
focal lengths, 20–21	facial features, sidelight enhancements, 49–50
interchangeable lens benefits, 26-27	field of view, 233
ISO speed adjustments, 173	file formats, images, 214
lens mount, 29	files, naming conventions, 216
lenses, 17–21	fill flash, light manipulation, 94–95
overview, 16–17	fill frames
panning techniques, 181	composition technique, 9
Predictive Autofocus, 173	kid photos, 142–143
second-curtain sync function, 184	film cameras, lens interchangeability, 26–27 filters
slow shutter w/flash modes, 183	
TV (Shutter Priority mode), 172–173	defined, 233
dSLR crop factor, 233	graduated ND, 30
DVDs, image backups, 219	ND (neutral density), 30
dynamic range, 233	polarizing, 30–31 UV (ultraviolet), 30
	flash
E	bounce cards, 37
ears, photo shoot posing, 100	defined, 233
elevation, point of view shifting, 78–79	diffusers, 37
e-mail, image sharing, 215–217	
	external, 36–37
enhancements, lighting concepts, 11	indoor group photos, 114
environmental portraits	light bursts, 36
backdrops, 38	light control technique, 58–59
location, 88–89	light manipulation technique, 94–95
tripods, 32 wide-angle lens, 20, 28–29	motion blurs, 182–185
Epinions, 226	red-eye situations, 37
Evaluative metering mode, exposure control, 60	second-curtain sync function, 184
Exchangeable Image File (EXIF) format, metadata, 192	slaves, 37
	soft light techniques, 161
experimentation, composition development, 9	stop-action shot shutter speed guidelines, 179
exposure compensation, light control, 16, 60	transmitters, 37
exposures, metering modes, 59–60	flash diffuser, 233
external flash	Flash mode, use guidelines, 16
advantages, 36–37	flash-off mode, group photos, 128
defined, 233	flash sync speed, 233
hot-shoe attachment, 36	Flickr, 227
stop-action shots, 179	fluorescent lights, continuous light source, 38

focal length	golden hour
action shots, 175	backlighting, 51–53
background distraction, 86–87	defined, 233
defined, 28	photo shoot enhancements, 92
DOF (depth of field control), 17	sunrise/sunset light, 12–13
lens display information, 28	graduated ND filters
lenses, 20–21	defined, 232
macro lens, 20, 29	landscape portraits, 30
mm (millimeter) measurement, 27	graduations, 114–116
multipliers, 20–21, 26–27, 233	Graphics Interchange Format (GIF), image format, 214
prime lens, 27	group photos
selective focus lens, 20, 29–30	aperture priority mode, 127
standard lens, 20, 28	backgrounds, 111–112
telephoto lens, 20, 28	candid shots, 120–123
wide-angle lens, 28–29	casual posing, 117–120
X factors, 16	continuous mode, 121, 127
zoom lens, 27	expectations, 110–111
focal length multiplier, 233	flash-off mode, 128
focus points	formal portrait posing, 114–116
baby shots, 164	indoor flash, 114
dioptric adjustment lenses, 41	ISO settings, 111–112, 128
eyes, 84	landscape mode, 15, 127
framing techniques, 69–73	lighting, 112–113, 121
Rule of Thirds, 64–66	locations, 111–112
selective focus, 80	multiple shots, 113
formal group photos, posing, 114–116	portrait mode, 128
format, 233	preparations, 110–113
Fotki, 227	relationship building, 113–114
framing	relationship capturing, 123–127
attention focus, 69–73	self-timers, 127
composition technique, 9	shutter priority mode, 127
kid photos, 140-143	subject knowledge, 110
freeze frames, action shots, 175–179	subject positioning, 113–120
front light, image enhancements, 51–52	surprise anticipation, 113
Froogle, 226	white balance, 128
f-stops. See also apertures	,
defined, 21, 233	H
lens selection element, 17-19	
numbering conventions, 17–18	hair, photo shoot guidelines, 88–89
Full Edit workspace, 196–197	hands, photo shoot posing, 100
full-length shots, photo shoot posing, 97–101	harmonizing colors
8 , 1	color relationships, 74
G	defined, 234
	harsh-light conditions, diffusers, 36
George, Denise, international photographer, 159	head shots
GIF (Graphics Interchange Format), image format, 214	photo shoot posing techniques, 97–101
gigabyte (GB), media card capacity measurement, 14, 40	portrait mode, 139
glare reduction, polarizing filters, 30–31	heads, tripod element, 33
glass shots, 30–31	Healing Brush tool, 208–212
	Henri Cartier-Bresson: A Propos de Paris (Henri Cartier- Bresson), 224

high key, 234	K
histogram, 234	Kelvin scale, color temperature measurement, 55, 234
horizontal lines, viewer image guide, 67	keywords
hot-shoe, external flash attachment, 36	· · · · · · · · · · · · · · · · · · ·
household lights, continuous light source, 38	Adobe Photoshop Elements tags, 194
hue, 206, 234	image organization, 191
hygiene, baby shots, 156	kid photos. See also baby shots
riygierie, baby siloto, 150	angle experimentation, 140–141
I .	camera levels, 141–142
I	developmental stage considerations, 133
image intent, picture planning, 4	directing the shot, 132–136
image management	fill frames, 142–143
backups, 219	framing, 140–143
image-editing software, 191-194	involving in the shoot, 134–136
image-organizing software, 191	macro lens, 29
sharing images, 212–218	"real" moments, 137–139
image quality, dSLR camera, 16	subject relaxation techniques, 132-133
image sensor, 234	kiosks, photo printing, 218
Image Size dialog box, 216	knife, multi-tool, 43
images	Kodak Gallery, 227
cropping, 200–201	The second secon
file formats, 214	I .
keyword organization, 191	1 1
metadata, 191–193	landscape mode
point of view factors, 78–80	group photos, 127
incandescent light, 234	subject focus, 139
indirect lighting, baby shots, 160–162	use guidelines, 15
Infinity mode	landscape portraits, graduated neutral density filters, 30
group photos, 127	landscape shots, wide-angle lens, 29
	laser printers, photo sharing, 218
subject focus, 139	Lauer, David (Design Basics), 224
use guidelines, 15	layers, Photoshop Elements image-editing, 197–198
inkjet printers, photo sharing, 218	LCD (liquid crystal display)
intensity, light characteristic, 11, 55	battery conservation, 15
iPhoto	defined, 234
Macintosh image-organizing software, 191–192, 228	viewfinder caps, 42–43
slideshows, 214	LCD viewfinder caps, 42–43
ISO sensitivity	leading lines
dSLR camera action shots, 173	defined, 234
dSLR camera advantages, 16	viewer image guide, 67–69
group photos, 111–112, 128	lens cloths, cleaning supply, 43
long focal length adjustments, 87	lens mount, dSLR point of connection, 29
ISO speed, 234	lens pens, cleaning supply, 43
	lens protection, UV filters, 30
J	lens speed, action shots, 174–175
jewelry, photo shoot guidelines, 89	lens tissues, cleaning supply, 43
Joint Photographic Experts Group (JPEG)	lenses
defined, 234	apertures, 17–19
image format, 214	dioptric adjustment, 41
merging/flattening image files, 198–200	DOF (depth of field), 17 dSLR cameras, 17–21, 26–27
jungle gym pars, framing structure, (U. 7)	uoln cameras, 17–21, 20–27

fast = high quality, 27	liquid crystal display (LCD)
filters, 30–31	battery conservation, 15
focal length, 20–21, 28–30, 175	defined, 234
macro, 20, 29	viewfinder caps, 42–43
maximum aperture, 174	locations
perspectives, 77	environmental portraits, 88–89
selective-focus, 20, 29–30	group photos, 111–112
shutter speeds, 19, 27	light finding techniques, 92
standard, 20, 28	light planning, 92
telephoto, 20, 28	lossy compression, 234
wide-angle, 20, 28–29	low key, 234
zoom, 27	low-light conditions
Levels dialog box, contrast adjustments, 203–204	monopods, 35
light	red-eye, 37
baby shots, 160–162	tripods, 32
backlight, 51–55	Lowell, Ross (Matters of Light and Depth), 224
bouncing, 161	luminosity, 234
color temperatures, 55	Lynda.com, tutorials, 228
concepts, 11–13	
continuous, 36, 38	M
diffusers, 57–58, 93–94	Macintosh
exposure compensation, 60	Adobe Bridge image acquisition, 193–194
flash, 36, 58–59, 94–95	iPhoto, 191–192
front direction, 51–52	macro lens
golden hour, 12–13, 92	defined, 234
group photos, 112-113, 121	detail shots, 29
intensity, 55	
metering modes, 59–60	focal length, 20, 29 macro mode
overhead, 92	
photo shoots, 92–95	compact digital cameras, 29
quality, 48	use guidelines, 15
reflectors, 56–57, 93	macro photography, 234
shape factors, 38	MAGIX PhotoStory, 214
sidelight direction, 49-50	The Maine Photographic workshops, 226
strobes, 36	makeup, photo shoot guidelines, 88–90
subject flattering techniques, 12-13	Manual mode, dSLR camera, 17
sunrise/sunset, 12–13	Matrix mode, evaluative metering, 60
top direction, 53, 55	Matters of Light and Depth, (Ross Lowell), 224
what-you-see versus what-you-get, 13	maximum aperture, lens speed, 174
light metering, backlight, 51	media cards, image capacities by size, 14
light quality, 234	media cards. See memory cards
light reduction	megabyte (MB)
neutral density (ND) filters, 30	defined, 235
polarizing filters, 30–31	media card capacity measurement, 14, 40
light sources, color temperatures, 37	megapixel (MP)
linear polarizing filters, 30	defined, 235
lines, composition element, 67–68	resolution measurement, 13
lines of convergence	memory cards
attention capture, 68–69	capacities, 40
selective focus lens, 20, 29	defined, 235
	formatting before using, 40

photo-viewers, 40-41	Night Scene mode, slow shutter w/flash, 183
purchasing, 40	night shots, tripods, 32
speed ratings, 40	noise
men, photo shoot posing, 99	defined, 235
message, picture planning, 4	high ISO speed downside, 112
metadata, image information, 191–193	nondestructive editing, image layers, 197–198
metering modes	normal lens. See standard lens
defined, 235	notebooks, visual inspiration storage, 85
exposure controls, 59–60	notebooks, visual hispiración storage, es
	\circ
Microsoft Photo Story, slideshows, 214	U
millimeter (mm), focal length measurement, 27	off-center subjects, composition, 9
mini-tripods, compact digital cameras, 34	optical zooms
moment in time	compact camera action shots, 171–172
baby shots, 162–165	defined, 235
candid shots, 101–102	versus digital zoom, 16
image capture, 4	outdoor shots
monochromatic color, 235	reflectors/diffusers, 35-36
monopods, sports photographers, 34–35	sidelight enhancements, 49
Mora, Gilles (Photospeak: A Guide to the Ideas, Movements,	overhead light
and Techniques of Photography, 1839 to the Present),	avoiding, 92
224–225	harsh images, 53, 55
motion blurs. See also blurs	overweight subjects, photo shoot posing, 99
backgrounds, 180	c · et · e · egite cas jecus, prices crice c pecing, · ·
panning, 181–182	P
pre-focus, 181	•
self-timers, 180	P (Program) mode, 15
Shutter Priority mode (TV), 180–181	panning
shutter release, 180–181	compact cameras, 170
slow shutter speeds, 179–181	defined, 235
slow shutter w/flash, 182–185	motion blurs, 181–182
tripod uses, 180, 181	Pattern mode, evaluative metering, 60
movement, photo shoot relaxation, 96	patterns, composition, 74–76
MP (megapixel), resolution measurement, 13	PC Photo magazine, 224
multi-focusing points, digital camera enhancement, 66	Pentak, Stephen (Design Basics), 224
multipliers, focal length, 20–21, 26–27	people. See also subjects
multi-tool knife, photography accessory, 43	face powder, 44
music, baby shots, 149	observing, 4–8
made, subjected, 215	photographer's feedback, 6
N	perspective
N	framing techniques, 70, 72
National Association of Photoshop Professionals (NAPP),	point of view, 78–80
225	selective focus lens, 20
natural frames, composition, 9	standard lens, 77
natural light	telephoto lens, 77
baby shots, 161	wide-angle lens, 20, 77
group photo, 112–113	zoom lens, 77
photo shoot, 92	Phanfare, 227
neutral density (ND) filters	Photo District News, 224
action blurs, 30	photo floods
defined, 235	continuous light source, 38
night flash mode, ambient light, 139	defined, 235
	defined, 200

photo shoots	posing
backgrounds, 86–88	baby shots, 157–158
candid shots, 101–102	casual group photos, 117-120
hair, 88–89	formal group portrait, 114–116
lighting, 92–95	people direction, 5–8
locations, 88	postures
makeup, 88–90	group photo positioning, 113–120
natural light enhancements, 92	photo shoots, 97–101
point of view variation, 102–103	Predictive Autofocus
props, 89, 91–92	dSLR camera action shots, 173
relationship building techniques, 95–102	panning shots, 181
self-portraits, 104–105	pre-focus
subject research, 84–85	compact camera action shots, 170
visual references, 85	motion blurs, 181
wardrobes, 88–89	prime lenses, single focal length, 27
photocasting, iPhoto capability, 191	printing, photo-sharing, 217–218
photographer's feedback, people direction, 6	Professional Photographers of America (PPA), 225
photography vests, 41–42	Program (P) mode, use guidelines, 15
photo-sharing Web sites, 217	props
Photoshop Browser, image acquisition, 194	baby shots, 158–159
Photospeak: A Guide to the Ideas, Movements, and Techniques	photo shoots, 89, 91-92
of Photography, 1839 to the Present (Gilles Mora), 224-225	PSD (Photoshop Document) format, 197–198, 214
Photoshop Document (PSD) format, 197-198, 214	1
Photoworkshop, 227	0
photo-viewers, purchasing, 40-41	Control of the Contro
physical attributes, subject observation, 4	quality, light characteristic, 48
Picasa	Quick Fix workspace, 195–196
slideshows, 214	quick releases, tripods, 33
Windows PC image-organizing software, 191, 228	Quickpods, compact digital camera extender, 35
picture frames, 69–70	B
Picturetrail, 227	R
pixel	RAW capture, 235
defined, 235	RAW format
image information, 216	dSLR camera, 17
point of view	image format, 214
image angles, 78–80	RDF Site Summary (RSS), 217
photo shoot experimentation, 102–103	"real" moments, kid photos, 137-139
polarizing filters	Really Simple Syndication (RSS) feeds, photo-sharing, 217
defined, 235	Red Eye Removal tool, 206–208
glare reduction, 30–31	red-eye
Popular Photography, 224	defined, 235
portrait mode	low-light conditions, 37
group photos, 128	red-eye reduction, 235
headshots, 139	reflection reduction, polarizing filters, 30–31
use guidelines, 15	reflectors
portrait shots	bouncing light, 161
telephoto lens, 20, 28	catch-light, 92, 112
backdrops, 38–39	defined, 235
reflectors/diffusers, 35–36	light control, 56–57, 93
	use guidelines. 35–36

relationships	Shutter Priority mode (TV)
relationships capturing with creative shots, 123–127	defined, 236
complementary colors, 73–74	dSLR camera action shots, 16, 172–173
group photos, 113–114	group photos, 127
picture planning element, 4	motion blurs, 180, 181
subject/photographer building, 95–102	shutter release
subject/photographer building, 95–102	motion blurs, 180, 181
remote shutter release, 42–43	pre-focusing, 170
removable media, image backups, 219	remote, 42–43
repetition, composition concepts, 74–76	shutter speeds
resolution	aperture factors, 19, 27
defined, 235	baby shots, 162
e-mail guidelines, 216	defined, 236
MP (megapixel), 13	flash shots, 179
resources, 224–228	motion blurs, 179–185
Rich Site Summary (RSS), 217	slow-synch effect, 120
room interiors, wide-angle lens, 28	stop-action shots, 176
Roxio Easy CD & DVD, image backups, 219	*
RSS (RDF Site Summary), 217	tripod use guidelines, 32
RSS (Really Simple Syndication) feeds, photo-sharing, 217	Shutterfly, 227
Rule of Thirds, focus points, 64–67	sidelight defined, 236
	image enhancements, 49–50
S	
Santa Fe workshops, 226	simplicity composition element, 64–65
saturation	subject framing, 70–71
defined, 206, 235	Single Frame mode, use guidelines, 15
Photoshop Elements image adjustments, 201–202	slaves
Save As dialog box, 198–200	defined, 236
scrap (tear sheets), 85	flash triggers, 37
second-curtain sync function	slideshows, image sharing, 213–215
defined, 236	slow sync mode
dSLR cameras, 184	ambient light, 139
selective-focus lens	dynamic motion effect, 184
building photography, 29	reasons for, 120
contemporary effects, 29–30	SLR, 236
defined, 236	Smilebox, 227
focal lengths, 20, 29–30	Smugbug, 227
lines of convergence, 29	
point of view techniques, 80	Snapfish, 227 soft light, baby shots, 160–162
self-portraits	software
Quickpod extender, 35	
self-timer, 104–105	image backups, 219
self-timers. See also timers	image-editing, 191–212
group photos, 127	image-organizing, 191
motion blurs, 180	slideshows, 214–215
self-portraits, 102, 104–105	sources, lighting concepts, 11
setups, scene, 236	spatial relationship, telephoto lens, 28
shooting environment, baby shot guidelines, 148–150	special effects, wide-angle lens, 20
Shutter button, multi-focusing points, 66	speed, dSLR camera, 17
shutter drag reasons for 120	Speedlite flash units, transmitters, 37

candid shoots, 28

sports mode. See also action shots	defined, 236
freeze framing, 139	focal length, 20, 28
use guidelines, 15	perspective, 77
sports photographers	portraits, 28
monopods, 34–35	spatial relationship, 28
telephoto lens, 28	sports photography, 28
Spot Healing Brush tool, 209–212	versus wide-angle lens, 29
spot meter, 236	wildlife shots, 28
spot metering, backlight enhancement, 53	temperatures, baby shots, 149
Spot mode, partial metering, 60	terms, 232–237
Standard Edit workspace, 195–197	three-quarter shots, photo shoot posing, 97-101
standard lens	through the lens (TTL) metering
defined, 236	defined, 236
focal length, 20, 28	external flash, 37
perspective, 77	TIFF (Tagged Image Format File), image format, 198-200
static subjects, zooming shots, 182	214
stop-action shots, techniques, 175–179	timers. See also self-timers
storage media, memory cards, 40	group photos, 127
storytelling, composition, 9–11	self-portraits, 104–105
strobes	timing, baby shot guidelines, 148
defined, 236	top light
light bursts, 36	defined, 236
structures, framing elements, 69	harsh images, 53, 55
subject distance, DOF (depth of field) control, 17	Total Training, tutorials, 228
subjects	total zoom, 236
candid shots, 101–102	tracking, compact cameras, 170
eye focus, 84	transmitters
flattering light, 12–13	defined, 237
frame positioning, 69	flash triggers, 37
group photo positioning, 113–120	travel printers, photo sharing, 218
group shot preparations, 110–113	tree branches, framing element, 69, 71
off-center, 9	trellis, framing structure, 69–70, 72
point of view factors, 78–80	tripods
relationship building, 95–102	environmental portraits, 32
research before shooting, 84–85	heads, 33
Rule of Thirds, 64–66	long focal length requirement, 87
stop-action shot factors, 176–177	low-light conditions, 32
sunrise/sunset	minis, 34
backlighting, 51–53	monopods, 34–35
golden hour, 12–13	motion blurs, 180, 181
photo shoot enhancements, 92	night shots, 32
Swiss Army knife, photography accessory, 43	quick releases, 33
_	Quickpods, 35
	third-leg positioning, 33
Tagged Image Format File (TIFF), 198–200, 214	use guidelines, 32–33
tags, Adobe Photoshop Elements keywords, 194	trust, subject/photographer relationship, 95–96
teeth, whitening, 205–206	TTL (through the lens) metering
telephoto lens	defined, 236
action shot close-ups, 175–176	external flash, 37

tungsten lights	white balance. See also automatic white balance (AWB)
continuous light source, 38	color cast adjustments, 37
defined, 237	color compensation, 55
TV (Shutter Priority mode)	defined, 237
defined, 236	group photos, 128
dSLR camera, 16, 172–173	white bounce card, flash units, 37
group photos, 127	wide angle lens
motion blurs, 180, 181	focal length, 20
motion state, 100, 101	defined, 237
U	environmental portraits, 28–29
	exaggerated spatial relationship, 28
ultraviolet (UV) filters	focal lengths, 28–29
defined, 237	perspective, 77
lens protection, 30	room interiors, 28
underwater camera housings, 42	versus telephoto lens, 29
underweight subjects, photo shoot posing, 99	wildlife shots, telephoto lens, 28
Unites States Digital Imaging Group (USDIG), 225	windows, framing structure, 69
Unsharp Mask filter, 203	Windows PC
	Photoshop Browser image acquisition, 194
V	Picasa, 191
variable maximum aperture, zoom lens, 174	Women in Photography International (WIPI), 225–226
vertical lines, viewer image guide, 67	women, photo shoot posing, 99
vests, photography, 41–42	workspaces, 195–197
viewfinder	
compact camera action shots, 170	Z
dioptric adjustment lenses, 41	
LCD viewfinder caps, 42–43	zit zapper, Healing Brush tool, 208–212
viewpoints, shifting, 78–80	zoom lens
vision correction, dioptric adjustment lenses, 41	constant maximum aperture, 174
visual references, subject research, 85	focal length range, 27
visual storytelling, composition technique, 9–11	perspective, 77
, , , , , , , , , , , , , , , , , , , ,	static subject motion, 182
W	variable maximum aperture, 174
	Zoom tool, Photoshop Elements teeth whitening, 205–206
wardrobes	zooming shots, static subjects, 182
baby shots, 156–157	zooms
photo shoot guidelines, 88–89	digital versus optical, 16
watches, photo shoot guidelines, 89	optical, 171–172
water photography, underwater camera housings, 42	
water shots, polarizing filters, 30–31	
weddings, formal group posing, 114–116	

Develop your talent.

Go behind the lens with Wiley's Photo Workshop series, and learn the basics of how to shoot great photos from the start! Each full-color book provides clear instructions, ample photography examples, and end-of-chapter assignments that you can upload to pwsbooks.com for input from others.

978-0-470-11433-9

978-0-470-11876-4

978-0-470-11436-0

978-0-470-11435-3

978-0-470-11955-6

For a complete list of Photo Workshop books, visit **photoworkshop.com**. This online resource is committed to providing an education in photography, where the quest for knowledge is fueled by inspiration.

PHOTOWORKSHOP.COM

Complete Your Learning Experience

This book series is just part of your photography education.

Take full advantage of this unique opportunity to interact with other photographers from around the world. Now, visit Photoworkshop.com where you can:

- Upload Your Chapter Assignments
- Have Your Images Critiqued
- Rate the Images of Others
- Share Your Progress
- And Much More!